IN THE EYE
OF THE STORM:
AN ART OF
CONSCIENCE
1930-1970

IN THE EYE OF THE STORM: AN ART OF CONSCIENCE 1930-1970

A Chameleon Book

Selections from the Collection of Philip J. & Suzanne Schiller

by Frances K. Pohl

Pomegranate Artbooks, San Francisco, California

A CHAMELEON BOOK

Complete © 1995 by Chameleon Books, Inc.
Text © 1995 by Frances K. Pohl
Artists' Biographies © 1995 by American Federation of Arts

Published by Pomegranate Artbooks
Box 6099
Rohnert Park, California 94927

Pomegranate Europe Ltd.
Fullbridge House, Fullbridge
Maldon, Essex CM9 7LE, England

Produced by
Chameleon Books, Inc.
211 West 20th Street
New York, New York 10011

Creative director/designer: Arnold Skolnick
Printed and bound by O.G. Printing Productions, Ltd., Hong Kong

Pomegranate Catalog No. A810

Library of Congress Cataloging-in-Publication Data

Pohl, Frances K. (Frances Kathryn), 1952–
 In the eye of the storm: an art of conscience, 1930–1970 / by
Frances K. Pohl. – 1st ed.
 p. cm.
 "A Chameleon book."
 Exhibition catalog.
 Includes bibliographical references and index.
 ISBN 0–87654–482–0
 1. Politics in art–Exhibitions. 2. Humanism in art–Exhibitions.
3. Art, American–Exhibitions. 4. Art, Modern–20th century–United
States–Exhibitions. 5. Schiller, Philip J. –Art collections–
–Exhibitions. 6. Schiller, Suzanne –Art collections–Exhibitions.
7. Art–Private collections–United States–Exhibitions. I. Title.
N8236.P5P64 1995
760' .0973' 07473–dc20 95–30599
 CIP

00 99 98 97 96 95 6 5 4 3 2 1

First Edition

Contents

EXHIBITION ITINERARY 6
ACKNOWLEDGMENTS 7
FOREWORD by Philip J. Schiller 9

Introduction 12

The Miner and the Burlesque Dancer:
Work and Gender in the 1930s 15

Prayer Meeting and Lynchings:
African American Struggles for
Self-Definition and Survival 37

The Aestheticization of Politics:
Art Against Fascism 53

No More Money for Modern Art:
Art in a Cold War Era 75

Images of the Other:
Prosperity, Poverty, and the Vietnam War 90

FOOTNOTES 102
ARTISTS' BIOGRAPHIES
 by Andrea Swanson Honoré 105
BIBLIOGRAPHY 124
LIST OF WORKS 125
INDEX 128

EXHIBITION ITINERARY

*In the Eye of the Storm: An Art of Conscience, 1930–1970,
Selections from the Collection of Philip J. & Suzanne Schiller*

The exhibition is organized by the American Federation
of Arts. It is a project of ART ACCESS II, a program of the
AFA with major support from the Lila Wallace-Reader's
Digest Fund. The exhibition program of the AFA is sup-
ported in part by the J. Carter Brown Fund for Exhibitions,
established by the AFA in 1992.

Terra Museum of American Art
Chicago, Illinois
October 27, 1995–January 7, 1996

Greenville County Museum of Art
Greenville, South Carolina
January 24, 1996–March 31, 1996

Sheldon Memorial Art Gallery and Sculpture Garden
University of Nebraska
Lincoln, Nebraska
April 12, 1996–June 23, 1996

Knoxville Museum of Art
Knoxville, Tennessee
July 19, 1996–September 29, 1996

The Parrish Art Museum
Southampton, New York
October 26, 1996–January 5, 1997

Norton Museum of Art
West Palm Beach, Florida
March 8, 1997–April 20, 1997

Frederick R. Weisman Art Museum
Minneapolis, Minnesota
January 23, 1998–March 22, 1998

ACKNOWLEDGMENTS

The exhibition *In the Eye of the Storm: An Art of Conscience, 1930–1970, Selections from the Collection of Philip J. & Suzanne Schiller* was organized by the American Federation of Arts to enable a wide audience to get acquainted with a remarkable art collection. Unique in its focus on art with a social conscience, the Schiller collection represents the intersection of art and politics from the point of view of two perspicacious collectors. The artists represented in this collection actively sought to reform society, either through the images they created or, in some instances, through their associations with political groups and activist stances. Beginning with social realist works produced in the aftermath of the Great Depression and under the federal sponsorship of the Roosevelt administration, the exhibition illustrates a history of the momentous issues and events that concerned America's artists between 1930 and 1970.

We are deeply grateful to Philip and Suzanne Schiller for their generosity in making the collection available to museum audiences and for their insight and assistance every step of the way; it has been a delightful collaboration. We are also indebted to guest curator Andrea Swanson Honoré for her discerning eye and careful selection of the exhibition.

At the AFA I want to acknowledge the efforts of Melanie Franklin, exhibitions assistant, Rachel Granholm, head of education, Donna Gustafson, curator of exhibitions (who oversaw the organization of the project), Michaelyn Mitchell, head of publications, Eve Klein, scheduler, Gabriela Mizes, registrar, Jillian Slonim, director of public information, and Robert Workman, former director of exhibitions.

We also salute the museums that are on the tour: Terra Museum of American Art; Greenville County Museum of Art; Sheldon Memorial Art Gallery and Sculpture Garden at the University of Nebraska; Knoxville Museum of Art; The Parrish Art Museum; The Norton Museum of Art; and Frederick R. Weisman Art Museum.

Finally, our deep thanks to the Lila Wallace-Reader's Digest Fund for their support of this exhibition, the first in the American Federation of Arts' ART ACCESS II program.

Serena Rattazzi
Director
The American Federation of Arts

I would like to express special thanks to my research assistant Rachel Parsons, and to my colleagues Alicia Gaspar de Alba, Victor Silverman, Kenon Breazeale and Phyllis Jackson for reading and commenting on earlier drafts of this essay. I would also like to thank Carl Sesar for his expert editing.

Frances K. Pohl

We wish to acknowledge Alison Schiller, Melissa & Michael Pure, Debbie, Howard, Lauren & Nicole Schiller, our children & grand-children, for the central roles they play in our lives.

Suzanne & Philip J. Schiller

Chameleon books would like to thank: Carl Sesar, editor; Jamie Thaman, copyeditor; Mary Serreze, my production assistant; and Michael Tropea who photographed all the works in this book.

Arnold Skolnick

Photograph by Howard Kaplan

FOREWORD

I am often asked by people who know me why I, a political conservative, have collected hundreds of works involving social commentary. The question assumes a divergence between conservatism and an interest in social issues. My answer is that my conservative views enhance my appreciation of the great social issues that have confronted our country from the Depression and thereafter. Certainly a believer in free market forces would be greatly disappointed, as I am, with the performance of capitalism in the 1930s. Not only were millions of factory workers unemployed, but farmers could not be productive in the face of the drought in the area known as the Dust Bowl.

The issues and events confronting our country between 1930 and 1970 were the most important of this century. Of tremendous concern to me during this 40-year period was the rise of fascism culminating in World War II, a war truly between good and evil. The Cold War, the hysteria of McCarthyism, race and gender relations, the civil rights movement in the sixties, and the Vietnam War—which, aside from whether or not we should have fought it at all, was conducted in a manner that could only result in defeat—were other issues of great significance to me. There is nothing inconsistent in a conservative being interested in these issues. I am a civil libertarian and vitally concerned that all Americans enjoy the same basic rights.

Neither Sue nor I have much background in art appreciation or art history, though I did take a few art courses at the University of Chicago and was always interested in art. During the 1960s and early 1970s, we bought random works by local artists, although looking back, there was a theme of social comment to them even then. In the mid-seventies I bought a Reginald Marsh drawing in Chicago. It was a Chinese ink drawing of a young woman walking down a street. I appreciated the quality and the feel of the drawing. I remember reading a large monograph on Marsh, and I really enjoyed his images of urban life.

Dino D'Angelo, a friend and collector, had introduced me to Marsh's work. About a year later, Dino sent me to see Sid Bergen at ACA Gallery. Sid showed me works by Jack Levine, Jacob Lawrence, Philip Evergood, Ben Shahn, Robert Gwathmey, and others. He introduced me to Terry Dintenfass and Bella Fishkow, who were very helpful. Our first purchase was from Bella at the Forum Gallery. It was the Gwathmey painting *The Custodian*, which was done in the sixties. The imagery had an impact on me. Two people are sitting under the hot sun with the bankrupt symbols of a culture under siege. The heat of the moment is emphasized by the fact that the sun takes up a good part of the canvas; what a strong commentary!

I remember being very excited about these artists and others as well. I started to read monographs on particular

artists and studies of the period. There were a great many reproductions available of various artists' works to help me learn about their subject matter and artistic styles. The fact that so much literature was available on artists who were out of favor with the then movers and shakers of the art world had an impact on me. Obviously the public did not forget this group of artists. In those early days, Sue and I bought some of our favorite works—Jacob Lawrence's *Interior Scene*, Romare Bearden's *Watching The Good Trains Go By*, Jack Levine's *Oak Street*, and Ben Shahn's *Discord* among others. I was interested in their treatment of the Depression and the rise of fascism, and impressed by the depth of feeling that permeated the works of these artists. Although artists like Evergood and Shahn were left-wing and many were Communist sympathizers, I admired their treatment of social issues even though I was approaching the scene from a different perspective.

Certainly, I do disagree with some of the subject matter and how it is presented. For example, Anton Refregier in *Politicians at Work* attempts to show patricians, most notably the British, at work after World War II in dividing up the world. He is one war and thirty years late. However, I do enjoy the imagery and the movement in the picture. In Bernard Perlin's work *Mayor Daley*, the Mayor is pictured as a larger-than-life figure controlling the events of the 1968 Democratic Convention in Chicago. I knew the first Mayor Daley and considered him to be an honest and effective public servant. In attempting to keep public order as he saw it, he became the victim as much as the manipulator of events. Although I disagree with Perlin's treatment of Daley, I particularly like his depiction of the porches evoking the ethnic flavor of Chicago that I remember as a youth.

I respect many of the artists who fought the art establishment's bias against realism. It was not easy for them to do so, and some, such as O. Louis Guglielmi and James Guy, became abstract artists in later years. However, Jacob Lawrence, Jack Levine, Raphael Soyer, and others who never wavered in their realistic presentation are to be commended. They fought the fight for their own private artistic freedoms and worth.

The acquisition of art, or other collectibles, can become a very important part of one's life. I think that knowledge and love distinguish the collector from the acquirer. After reading hundreds of monographs, studies of groups or periods of art, journals of art, auction catalogues, and brochures of dealers' shows, I have gained knowledge about the styles, subject matters, and the relative quality of the works of a great number of artists. It is important to be familiar with representative works of a particular artist and to know which are better executed and of more interest than others. All artists can be uneven, including the great Picasso.

We have only collected works that we are strongly attracted to, and our love for them has always been constant. We have been concerned with quality, but our feeling for a work is the first consideration. We have lived with our art and fortunately we have been able to display most of the works in our collection.

The strong, generally realistic imagery in the collection is a common factor, but the style of work ranges from social realism to magic realism and social surrealism, and the media ranges from oils to watercolors to virtually all examples of the print medium. We started collecting prints in 1984. The impetus came originally from Mary Ryan, but Sylvan Cole played the leading role in the development of our print collection. We were especially interested in the imagery presented in the prints of the 1930s and collected a large number of them. Many of the artists could not handle color, and they may also have lacked certain artistic skills, but their depth of passion and intensity was very much in evidence in stark black and white imagery. Another world was opened to us. It is indeed exciting to come across a previously unknown print, or an artist with whom we are unfamiliar. The range of subject matter in these prints is astounding.

When one truly enjoys something, the passage of time is unimportant. The pleasure we have had in developing this collection has been great. We have gained not only the satisfaction that knowledge brings but also the gratification of building a sizable collection of importance in its own right.

Sue and I are often asked which are our favorite works. This is difficult because we have only bought what we love. Occasionally a work turns out to be a disappointment, but for the most part the works in the collection give us as much enjoyment now as when we bought them. The very important works I mentioned earlier and others, including those by George Tooker, Jared French, and Ivan Albright, are certainly significant. Yet even a small print (5 x 4$\frac{1}{2}$ inches) by Lynd Ward—*Company Town*—which depicts a dejected worker slowly walking home at the end of a workday past a group of identical houses and through a bleak monotonous landscape, is very important to us. It says it all. It is not important to pick one favorite or even a group of favorites; it is important that we derive a great deal of pleasure from living with our collection, even with the very strong images.

We have bought hundreds of works of art from dealers who operate galleries or deal privately, and from auction houses. We acknowledge the assistance of many people who have helped us. In particular, we have developed close friendships with many people in the art world. Jonathan Bergen, who died much too young, was a good friend. John Payson has been of great assistance with this exhibition. Larry Casper has been very helpful in analyzing works at auctions when I could not be present. Bridget Moore and

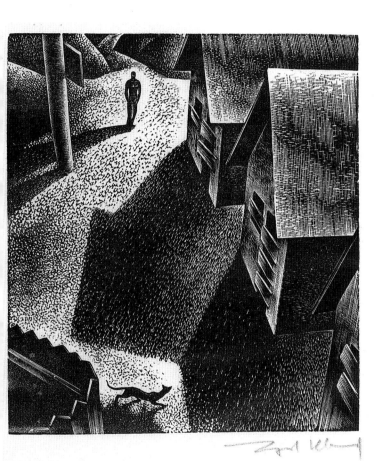

Lynd Ward
COMPANY TOWN, c. 1930
Wood engraving, 5 x 4 1/2 in

Michael Rosenfeld have always been enjoyable and stimulating. Our good friends, Lisa and Bill Landes, who are avid collectors, have been very helpful with this publication. There are many others, too numerous to mention, who have transmitted invaluable knowledge to us and we thank them for it. But in the final analysis, we are responsible for this collection.

The collection has been well known to academics and museum curators, but it is not well known to the public. We have not sought publicity, nor was that our reason for collecting. It is, however, very rewarding that the American Federation of Arts has determined to organize and tour an exhibition from our collection. It is a note of confidence that we very much appreciate. We acknowledge the support and kind words of its director, Serena Rattazzi. It has been very satisfying to work with Donna Gustafson and others of this very significant organization. Our thanks to Bob Workman who has since left the AFA. We also thank John McClure and Ray Marchman of the Northern Trust Company for their support of the exhibition.

Frances Pohl is a wonderful writer, who certainly would never be considered to be a conservative. She has written a thoughtful and extensive history of the period and its relation to the works in the collection. The book will prove to be a valuable reference work. The exhibition and the book together will help to acquaint younger visitors with issues that are not known to them and to reacquaint others who have since forgotten these issues.

We are indebted to Arnold Skolnick, a true character in the best sense, for his overall advice. He has produced a very handsome publication. We thank Andrea Swanson Honoré for her selection of works, her biographies of the artists, and for her all-around great efforts. The photography work of Michael Tropea is excellent.

Our collection is in our home. We thank Doug Nickless for helping us to have comfortable furnishings in a setting where we enjoy both our home and our collection. Marvin Herman was the architect who designed two handsome additions so that there would be more wall space to hang pictures. I would encourage others to begin collections. You should buy what you like but study before you purchase. Pick out a period or a particular subject matter if you wish, and know it well, or be more eclectic if you like.

Lastly, I thank my lovely wife, Suzanne, for her collaboration as a great partner, for allowing me to be her agent to purchase these works of art, and for her patience and tolerance.

Amassing the collection has been a great experience. We continue to add to it. It is our ultimate pleasure to share these works with you the reader and the viewer, and we hope that you are interested, stimulated, and informed.

—Philip J. Schiller

INTRODUCTION

The works in *In the Eye of the Storm: An Art of Conscience* are drawn from the collection of Philip J. and Suzanne Schiller. As such, they represent the aesthetic and social concerns of two individuals. But they also represent, in condensed form, a particular period in history, one marked by a worldwide economic depression, two world wars, a Cold War, and the flowering of the civil rights and antiwar movements in the United States. The artists examined in this book felt compelled to use their energies and talents to create critical visual commentaries on these pressing economic, political and social developments. Their works are for the most part denunciatory rather than affirmative. Instead of celebrating patriotism or military victories, these artists point to the poverty and despair caused by military conflicts. They also document the lives of "common" people rather than public leaders or celebrities, making heroes out of those traditionally dismissed as unimportant by artists, politicians and historians.

In the following pages I will attempt to shed some light on what prompted these artists to produce such an art; what enabled them to feel justified in taking their work out of the studios and into the streets; and what inspired them to believe that one could use art to change the world. In doing so I also hope to explain why their works still hold significance for many people today.[1] The complexity of such an investigation is suggested by a passage from artist Louis Lozowick's 1936 essay "Towards a Revolutionary Art":

> When the revolutionary artist expresses in his work the dissatisfaction with, the revolt against, the criticism of the existing state of affairs, when he seeks to awaken in his audience a desire to participate in his fight, he is, therefore, drawing on direct observation of the world about him as well as on his most intimate, immediate, blistering, blood-sweating experience, in the art gallery, in the bread line, in the relief office. But as already indicated, experience to him is not a chance agglomeration of impressions but is related to long training, to habits formed, to views assimilated and at a definite place and time; to him experience acquires significant meaning by virtue of a revolutionary orientation. In sum, revolutionary art implies open-eyed observation, integrated experience, intense participation and an ordered view of life. And by the same token revolutionary art further implies that its provenance is not due to an arbitrary order from any person or group but is decreed by history, is a consequence of particular historic aevents.[2]

Lozowick's words challenge historians of art to cast a wide net in their efforts to understand the significance of particular works of art—in this case, revolutionary art—a net that encompasses the personal, political, and professional aspects of an artist's life and how it unfolds at a particular moment in time.

This book and the accompanying exhibition begin in

the 1930s, a decade that occupies a particularly powerful symbolic position within public discourse in this country. Whenever the United States economy takes a turn for the worse, political and media commentators immediately express fears of another depression like the Great Depression of the 1930s. There have been other long-term economic crises in the history of this country, but none have seized the public imagination as firmly as the one that began with the stock market crash in New York City on October 29, 1929. Perhaps this is because this depression is closest to us in time. But it is also because the Great Depression of the 1930s was self-consciously and systematically recorded by artists in all the visual and performing arts, a coverage made possible by the federal art projects of President Roosevelt's Works Progress Administration (WPA). This government patronage allowed the images produced by thousands of United States artists to reach a wide and varied audience throughout the nation. Post offices, elementary schools, community centers, state capitols, and mass media magazines were filled with federally sponsored images of the best and worst of the era—heroic workers, public works projects, and the indestructible nuclear family on the one hand; unemployed workers, abandoned farms, and closed factories on the other.

Government sponsorship also affected the day-to-day lives of the artists who enrolled in the various federal programs. It provided many with their first experience of independence from the commercial art market. As Robert Gwathmey stated in 1968:

> Artists have to live, right? Eat, sleep, breathe, build. The great difference is when you have a government as a patron or anyone else as a patron, who made no demands on you at all, there were no enlarged notions of making that extra buck. That was a very free and happy period.[3]

This was, indeed, a decade remembered by the artists who lived through it as a time when, despite economic hardships, people pulled together, shared limited resources, and gained the respect of the federal government for their endeavors. Art was seen as another form of work, not as an expendable leisure-time activity.

Many of the artists discussed in this book either knew each other, studied at the same schools, were represented by the same galleries or walked side by side in strikes and demonstrations. While only a few, like Walter Quirt, Philip Evergood and Louis Lozowick, were members of the Communist Party, most knew, even if only superficially, of the theories of Marx or Lenin, and turned to them for an understanding of the economic and political crises that marked the 1930s and 1940s.[4] Many were represented by the American Contemporary Art Gallery (ACA), studied at the Art Students League, and belonged to the Artists Union and the American Artists' Congress. Many were also first- or second-generation immigrants from Eastern Europe; a number were Jewish, who had fled poverty and anti-Semitism. They came of age as artists in decades marked by economic depression, world military conflict, and the beginning of the Cold War.

While they were drawn to the American dream of democratic individualism—that anyone can achieve success through hard work and individual initiative—their experiences showed them that collective effort was as important as individual initiative. They realized, for example, that to combat the legacy of slavery and achieve full civil rights for African Americans, people needed to come together in a mass movement. This fight for civil rights was an important part of progressive politics during these decades, as was the struggle for fair wages and decent living and working conditions. The degree to which these demands for workers' rights were resisted by industrialists and politicians is revealed in the violence that erupted around attempts to organize industrial unions in the 1930s. Many artists in this exhibition created visual condemnations of lynchings and participated in, or created images of, battles between union organizers and company, municipal, or federal police. As fascism gained strength in Germany, Italy, Spain, and Japan, these same artists turned their critical gazes to the underlying causes of war and to the physical and emotional devastation that engulfed the world from 1939 to 1945.

The military peace negotiated in 1945 that brought an end to World War II did not, in fact, bring an end to international hostilities. Instead, the United States became mired in another type of war, a Cold War, in which the enemy was not simply a political demagogue, but a subversive ideology—communism. The search for communists or "suspected communists" impacted all areas of life.[5] Union leaders were pressured to purge political radicals from the union movement. Actors, directors, and screenwriters were called before the House Committee on Un-American Activities to prove their patriotism. Artists committed to commenting on political struggles or social issues in their work found themselves attacked as "un-American" by politicians like Republican Representative George Dondero of Michigan. The optimism of the New Deal era was gone, replaced by domestic paranoia and fear of an atomic third world war.

The work of the 1950s and early 1960s in this book is clearly less explicit in its political commentary, more symbolic or enigmatic in content, and often more abstract in style. In histories of American art, this period is most commonly described as the heyday of abstract expressionism and color field painting, a time when the formal innovations of modernist art, begun in the middle of the nineteenth century in Paris, climaxed in an explosion of paint in the studios of New York City. While this stylistic development is often seen as the result of the inevitable progression of modernist art away from three-dimensional

renderings of the world toward two-dimensionality or flatness,[6] Ben Shahn offers a different explanation. In a 1951 lecture he stated:

> I shall now unabashedly align the change in the art landscape with the change in the political atmosphere. . . . Repudiation was indeed in the air [in the late 1940s]. The Congress was busily vanquishing the ghost of the New Deal, the Reign of Committees had begun. Relations between the recent allies, the United States and Russia, chilled, provoked by mutual intransigence. Liberalism was in bad odor, both for its New Deal leanings, and for its indulgence of Communism. Suspicion, accusation and renunciation grew.[7]

The implications for artists of these political developments were clear:

> As for the humanistic form of art, that art that necessarily evaluates things according to their human ends, it exists today in a somewhat inhospitable atmosphere, one complicated by the general fear of Communism. At first what was called "social content," and more recently just content at all, have come under curiously bitter attack, as having some subversive connotation.[8]

Such attacks compelled many artists, according to Shahn, to retreat into their studios and concern themselves with aesthetic rather than political revolutions. But even artists like Shahn, who argued for the importance of political engagement on the part of artists, re-examined their aesthetic vocabularies and choice of content, becoming more circumspect in their commentaries on a country fraught with fear and anxiety.

It wasn't until the late 1960s that works of art containing explicit political commentary once again began to appear in large numbers on the streets and in the galleries of major art centers in the United States. The civil rights and anti-Vietnam War movements of this decade galvanized artists, as had the union organizing and anti-fascist drives of the 1930s and 1940s, prompting them to articulate in visual form the political and social transformations taking place around them. Peter Saul and Bernard Perlin, like Walter Quirt and Lucienne Bloch and many others before them, became political watchdogs, naming those incidents and individuals who posed, in their minds, the greatest threat to democracy both at home and abroad. Their works bring this book to a close, but certainly do not mark the end of such politically motivated art. Saul and Perlin and the rest of the artists in *In the Eye of the Storm* are part of a rich history of social commentary art that continues in this country to this very day.

THE MINER AND THE BURLESQUE DANCER: WORK AND GENDER IN THE 1930s

Some saw the stock market crash of October 29, 1929, as punishment for the high living and smug self-confidence of the business lords of the 1920s. Credit had been extended too thin and financial speculation had run rampant in an economy still recovering from the costs of World War I. The result was the collapse of what had been thought to be an unshakable banking system. Republican president Herbert Hoover was either unable or unwilling to undertake the vast relief measures necessary to cope with an unemployed population which, by 1932, had reached 15 million. On July 28, 1932, approximately 200,000 World War I veterans marched on Washington, D.C., in the Veteran's Bonus March. They camped on the lawn in front of the Capitol to reinforce their demand that they be allowed to collect their veteran's benefits. Hoover ordered federal troops to destroy the tents and clear out the protesters. Photographs and film footage of burning tents and clouds of tear gas in front of the Capitol ensured the defeat of Hoover and the victory of Franklin Delano Roosevelt as president of the United States in the elections that fall.

Roosevelt became the hero of the poor and unemployed, enacting a series of relief measures, particularly make-work projects, to restore faith in the "democratic way." Sorely shaken by the stock market crash and closing of many of the nation's factories, and by the drought and downward spiral of farm prices that had begun in the 1920s, many began to question whether a capitalist economy could produce a true democracy. They looked to socialism and the Soviet Union as a possible alternative. Roosevelt's election and the reforms he enacted functioned as an effective way to head off a more serious political revolution.

Many artists working in the United States in the 1930s examined the policies of both the Soviet Union and their own government in their search for solutions to the country's problems. Some joined left-wing cultural organizations such as the John Reed Clubs or formed their own, most notably the Artists Union. They began to voice an affinity with the working class and to see their fates as part of a larger movement, a class struggle against global capitalism. In a 1936 essay for *Art Front*, the publication of the Artists Union, Louis Lozowick wrote,

> In all parts of the world there are signs of incipient and open revolt against the system. The organized working class, joined by growing numbers of intellectuals, farmers and other elements, and guided by the philosophy of Karl Marx, is the only force that can abolish it. Artists, like others, whether they want it or not, whether they know it or not, cannot remain outside of the situation described.[9]

Not all politically progressive artists were as committed to Marxism or leftist politics. Many were strong supporters of nationwide campaigns by workers to unionize, but they saw Roosevelt's reform efforts, not Soviet-style socialism, as the surest way to achieve workers' rights and to bring about change. Artists were able, in fact, to form a union in large part because they now had an employer with whom to bargain over wages and working conditions—the federal government.

The first federal funding for artists was made available in December 1933, with the establishment of the Public Works of Art Project (PWAP). The PWAP was replaced in 1934 by the Section of Painting and Sculpture of the Treasury Department, which was joined the following year by the Treasury Relief Art Project (TRAP) and the Federal Art Project of the Works Progress Administration (FAP/WPA). The Treasury programs produced murals, sculpture, and easel paintings for public buildings and chose artists primarily through open competitions and commissions, while the FAP/WPA provided support for artists based on need.

Holger Cahill, Director of the FAP/WPA, was strongly influenced by the philosopher John Dewey, who considered art to be individual expression arising out of societal experience. Cahill felt that art should belong to everybody, not just a privileged few. This meant that art had to be accessible to the public in general. In order to achieve accessibility artists were encouraged to utilize readily recognizable imagery in their work, and art classes were set up in schools and community centers across the country.[10] Over the next eight years, both the FAP and Treasury programs employed thousands of artists who created hundreds of thousands of works of art—murals, sculptures, paintings, and prints—and taught equally large numbers of individuals how to make or understand art.[11] The majority of the artists included in this book worked at one time or another on one or more of these federal projects.

Many of these same artists were also involved in efforts to establish an artists' union. In the summer of 1933 a number of artists met in New York City and formed the Artists Group of Emergency Work Bureau to agitate for state-sponsored art projects. They wrote numerous letters to Harry Hopkins, the head of the newly created Civil Works Administration (CWA) (and later head of the WPA), arguing their cause, and issued a manifesto declaring that "the State can eliminate once and for all the unfortunate dependence of American artists upon the caprice of private patronage."[12] The forcefulness of their arguments may well have convinced Hopkins to found the PWAP later that year with a grant from his agency. In 1934 the group changed its name to Unemployed Artists Group (UAG) and finally, that same year, to the Artists Union.[13] From November 1934 through December 1937 the Artists Union published its own highly influential journal, *Art Front*.

With the establishment of the Federal Art Project of

the WPA in 1935, the Artists Union became the de facto bargaining agent for the visual artists employed by the government (the Union's slogan was "Every artist an organized artist"). They distinguished themselves from members of the craft unions representing musicians, actors, directors, and writers on the WPA rolls by their aggressive and imaginative demonstrations. Such protests were effective in postponing, for a few years at least, the inevitable cutbacks in WPA funding for visual artists at the end of the decade. During the first few years of the Artists Union's existence, the weekly Wednesday night meetings in New York City, usually attended by two to three hundred members, were an opportunity for artists to both socialize and discuss business.

One artist active in both the Artists Union and the federal arts projects who strove to make art a part of the labor struggle was Philip Evergood. Evergood was employed by both the PWAP and the FAP/WPA, acting at one point as managing supervisor of the FAP's Easel Division. He also became president of the Artists Union in 1937, having proven his mettle in the "291" strike organized by the Artists Union in New York in December 1936 to protest the proposed layoffs of WPA artists (291 individuals were arrested, including Evergood). During Evergood's tenure as president, the Artists Union affiliated with the newly formed Congress of Industrial Organizations (CIO), becoming the United American Artists, Local 60 of the United Office and Professional Workers of America. In 1937 Evergood also joined the ACA Gallery, finding, as had so many other socially conscious artists, a stalwart supporter and sympathizer in the gallery's director Herman Baron.

Evergood's *Spring* was painted in 1934, the year he joined the PWAP and became active in the Artists Union. His involvement in these two organizations shifted his attention away from the biblical subjects, still lifes, and nudes of his earlier paintings to workers, employed and unemployed, in the streets of New York City. Evergood remembers one particular experience during this time that changed his work:

> [O]n a cold winter night . . . I went out for a walk down Christopher Street towards the North River . . . and came to a big empty lot with about fifty little shacks on it, all made out of old tin cans, crates, orange boxes, mattresses for roofs. Most of them were not even as tall as a man; you would have to crawl in on hands and knees. Snow was on the ground, a fire was lit, and a group of Negroes and white men were huddled around the fire. . . . The only food they had was from garbage cans, the only fire they had was from sticks they picked up around the wharves. I went over to the fire and talked to them. . . . They were interesting people, but their tragedy hit me between the eyes because I had never been as close to anything like that before. . . . It seemed to me that I should be involved in my work with this kind of thing. So I . . . got some drawing mate-

rials and came back and sat with them and drew them all night until dawn. I used some of those drawings later for paintings I did on the WPA.[14]

It is not surprising that Evergood had never experienced anything like this before. His mother's family was extremely wealthy and funded his extensive education in England and abroad. His father was a painter who seldom sold a picture. The family lived primarily on the $2,500 a year provided them by his mother's family. During the 1930s he was fortunate enough to obtain employment through the connections of his wife's family and ultimately through the federal art programs. Evergood later wrote:

> When I thought of my background in Eton and Cambridge and that kind of nonsense, which had taken up so much of my life (but which had its value, I think), I felt very moved to shake it off and to be a part of what I was painting, the way Daumier and Courbet and Goya were. It was a feeling that you have to know humanity at the time you live. You can't just sit down at a desk and write a *Nana* unless you've lived it, by God, unless you've damn well sat in a cold basement half the night with down-and-outers and felt their suffering. And to me it meant even more. It meant fighting for them politically, besides putting it down on canvas. It meant sacrificing your good comfortable safety to fight for some of these guys and stick my neck out too.[15]

Spring is one of the paintings that grew out of Evergood's sketches on that cold winter night. Yet it is obviously not a literal translation. It is not a cold winter night but a spring afternoon. The men, both African American and white, are not huddled dejectedly around a fire but are standing around or sitting in the chassis of an old car.[16] Rather than dejected, they appear relaxed, and the figure at the front of the car seems almost self-assured as he appears to gesture at himself. While the wheelless car might suggest the lack of social and economic mobility of these men, particularly in contrast to the cars on the elevated highway, the small white flower in the lower left-hand corner of the work (the source of the painting's title) suggests the beginning of a new era of hope for America's working men.

Evergood's choice of colors and style also functions symbolically within the painting. The heavy, rough application of paint enhances the materiality and energy of the scene. These are physically powerful characters who live and work amid dirt and grime (one is reminded of Vincent Van Gogh's *Potato Eaters* [1885]). The dark tones in the foreground, suggesting dejection and defeat, are countered by the brilliant acid yellows and oranges of the commercial buildings—the site of potential employment—in the background. These yellows and oranges are also reflected in the shirt of the man in front of the car and the left hand of the man seated in the car. Thus the bright new day will be brought about through the labor—the strong backs and hands—of working men. The year after Evergood painted

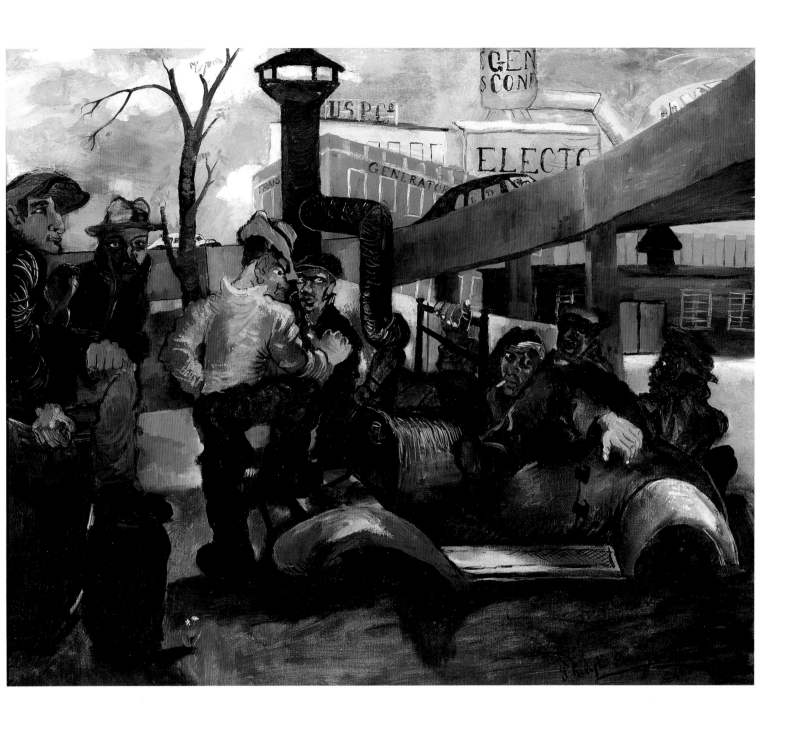

Philip Evergood
SPRING, 1934
Oil on canvas, 25 x 30 in

Philip Evergood
PORTRAIT OF A MINER, c. 1938
Etching, 7 3/8 x 6 1/2 in

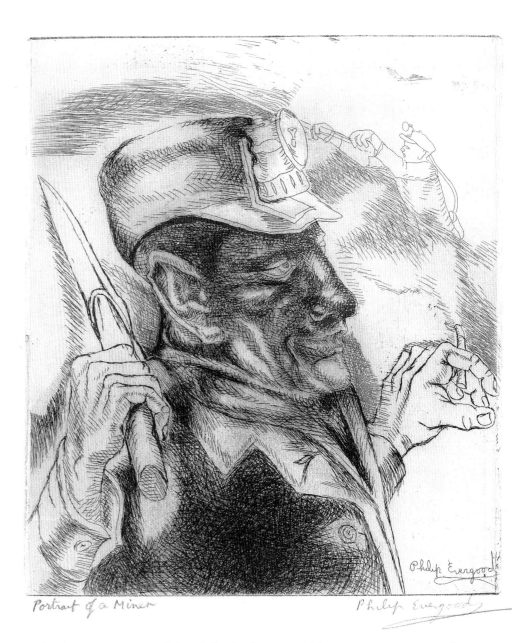

Portrait of a Miner

Philip Evergood

(Opposite)

Thomas Hart Benton
STRIKE, 1933/34
Lithograph, 9 5/8 x 10 3/4 in

Spring, Congress passed the Wagner Act, also known as
the National Labor Relations Act, which affirmed labor's
right to organize and engage in collective bargaining. That
same year John L. Lewis formed the Committee for Industrial
Organization, the precursor to the Congress of Industrial
Organizations (CIO).

Another work by Evergood, his steel etching *Portrait
of a Miner* (1938), contains the same correspondence
between subject matter and style and the same intimation
of the power of the worker. The close, rough crosshatching
of lines on the face of the figure replicates the black dust
and ridged surfaces of the coal mines. The miner holds his
pickax confidently and gazes ahead, ready for work either
in the mines or on the picket line. As a playful touch, in the
background Evergood draws a faintly outlined figure of a
miner seemingly rising out of the smoke of the foreground
miner's cigarette. The background figure reaches to the

left, while the foreground figure appears to carry him in
the opposite direction as he moves with his cigarette toward
the right. The United Mine Workers of America (UMW),
led by John L. Lewis, was one of the most dynamic unions
of the era. Evergood's etching pays tribute to the power of
the UMW and its leader.

A more graphic depiction of the struggles of miners is
Thomas Hart Benton's lithograph *Strike (Mine Strike)*
(1933–34). It was probably based on sketches he made at a
mountainside coal mine in West Virginia during a trip
through the South in the summer of 1928. These sketches
also inspired a series of murals for the New School for
Social Research in New York City (1930–31) and the illus-
trations for Leo Huberman's *We the People*, a Marxist his-
tory of the United States published in 1932. Benton and
Huberman had a falling out soon after.[17]

Benton was the son of a populist Missouri congress-

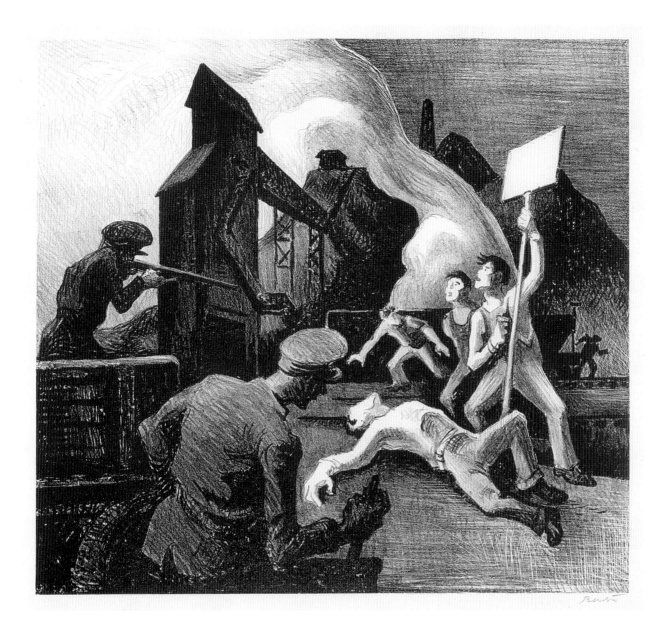

man. His great-uncle was a United States Senator who espoused the ideals of a republicanism based on independent American producers or workers. Benton inherited this belief in a worker-determined economy and a politically active community of citizens. He voted for the Socialist ticket in the early 1920s and was friendly with many members of the newly formed American Communist Party (CPUSA), but by the 1930s he was cutting his ties with organized leftist politics. Like many others, he blamed the "corrupting self-interest" of corporate capitalism for the economic crisis of 1929, but hoped that Roosevelt's New Deal would usher in a new industrial democracy where skilled labor and worker autonomy would flourish.

Benton had already produced a number of heroic images of miners and industrial workers, as well as farmers, before his 1933–34 lithograph (his New School murals

contain many such images). In *Strike* he conveys his sympathy for the striking miners by contrasting their brightly lit bodies and expressions of fear with the faceless, shadowy figures of the hired militia who fire on the strikers, a compositional strategy drawn directly from Francisco Goya's famous painting *The Third of May, 1808* (1814).

Yet, according to art historian Erika Doss, *Strike* is not an unqualified condemnation of capitalist violence against workers. Rather, it is a "complex analysis of labor conflict, revealing both the opposition of workers and militia and the damage done by their conflict: the police have murdered a striker and in the background the mine has caught fire."[18] Thus, while the foreground workers directly confront the enemy unarmed, a dark figure in the right background running away from the burning building compromises their heroism. The figure is engaged in

19

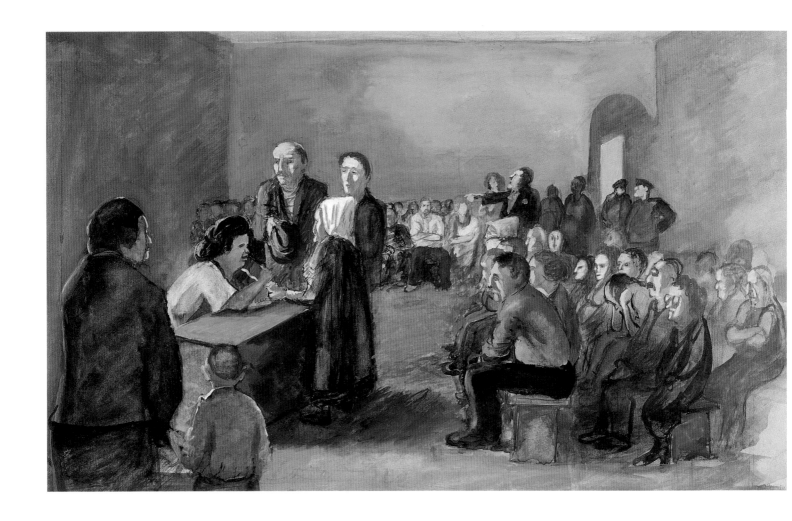

the kind of subterfuge that leads to further violence and destruction of property. Benton consistently sided with workers during strike actions, but he was suspicious of any mass action that involved violence and believed that labor or leftist organizations were as susceptible to corruption as business organizations. But the background figure in Benton's work could also represent someone hired by the mine owners to discredit the workers' actions. Benton would certainly have been familiar with such tactics.

Images of violent clashes between workers and the protectors of big business were relatively rare, however, during the 1930s, particularly among the works produced under the patronage of the federal government. More common were representations of the heroic worker on the one hand, or the defeated, unemployed or underemployed worker on the other. Harry Brodsky's *Tomato Pickers* (c. 1938) falls into the latter category. While the men are indeed employed, their solemn expressions suggest both fatigue and resignation. Brodsky says the image was derived from a truck filled with migrant workers that he drove behind on a road in Pennsylvania, yet he has carefully crafted the scene to heighten the theatricality of the event. The canvas tarp becomes a stage curtain, pulled open to reveal the

drama of exploited migrant agricultural labor.

Often the defeat or resignation of the country's unemployed was conveyed in scenes of relief stations or employment agencies. What we find emphasized in Moses Soyer's *Employment Agency* (1940)[19] and Louis Ribak's *Home Relief Station* (1935–36) is the hopelessness on the faces of those who have been forced to wait in lines for the chance of a job or of food for themselves and their families. The blank stare and empty chairs in Soyer's work suggests the fruitlessness of the man's search. He carries the telltale folded newspaper with the latest want ads in the pocket of his frayed overcoat.

Ribak's *Home Relief Station* is one of a relatively small number of images produced during the 1930s that acknowledged the presence of unemployed women, as well as men, in the United States labor force. And despite the existence of large numbers of female laborers, even fewer images of women working for wages were produced during the 1930s, particularly in the government-funded art projects. Art historian Barbara Melosh investigates the reasons for this in her book *Engendering Culture: Manhood and Womanhood in New Deal Public Art and Theater.*[20] Melosh points out that while the New Deal helped many

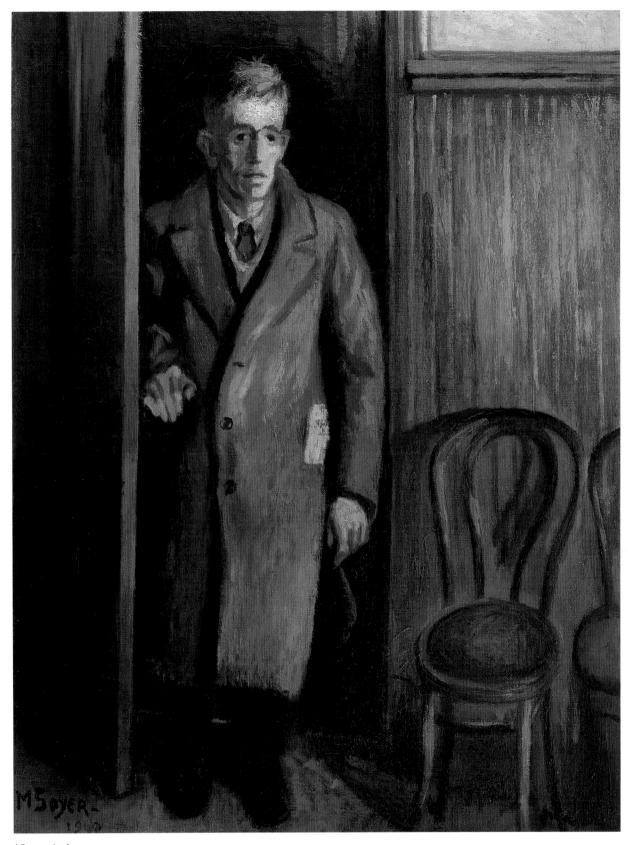

(Opposite)

Louis Ribak
HOME RELIEF STATION, 1935/36
Gouache on paper, 10 x 16 in

Moses Soyer
EMPLOYMENT AGENCY, 1940
Oil on canvas, 24 x 20 in

disadvantaged groups in the 1930s, it did not improve the lot of working women. Instead, "the New Deal stands as the single example of a liberal American reform movement not accompanied by a resurgence of feminism."[21]

The gains made by women in the 1920s were, in fact, rolled back in the 1930s. As unemployment increased, women in offices and factories were fired in order to give jobs to men. Employers, both business and government, justified their actions by citing concerns for "family stability," which in their minds meant a father engaged in paid commercial, agricultural, or industrial labor and a mother engaged in unpaid domestic labor. As a result, most government-funded public works of art depict women as wives and mothers. They are often substantial figures, but it is the work of the men in the world outside the home that is emphasized.

New Deal wives and mothers, accompanied by their heroic, hardworking husbands and sturdy children, also functioned as metaphors for citizenship and democracy. This explains why the majority of these women are of one particular race: the stable, usually rural, nuclear family as symbol of American democracy was decidedly white. Yet images did exist that challenged this ideal. One such image is Lucienne Bloch's woodcut *Land of Plenty* (c. 1935). Having been introduced to the political power of images as assistant to Mexican muralist Diego Rivera from 1932 to 1933, she joined the FAP in 1935.[22] Bloch's nuclear family—mother, father, and two children—confronts a part of rural America seldom, if ever, presented in New Deal murals. The lush fields of corn and new sources of electrical power from government projects like the Tennessee Valley Authority (TVA) were not to benefit them; they are separated from these riches by a barbed-wire fence. As the drought worsened in the 1930s and produce prices dropped, many farmers were unable to make their loan payments and lost their farms. The democratic dream of rural America was only for those who could afford it. As artist Philip Reisman commented:

> The maddening thing about the Depression was that hardships and suffering stemmed, not from a shortage of goods, as most people imagined, but from an abundance of them. Something was drastically wrong and the very framework of the republic itself appeared to be imperiled. "It remained for us to invent bread-lines knee-deep in wheat," said Socialist Norman Thomas, as tragedy began to stalk the land. "We got more wheat, more corn, more food, more money in banks, more everything in the world than any other nation that ever lived ever had," said humorist Will Rogers, "yet we are starving to death. We are the first nation in the history of the world to go to the poorhouse in an automobile. . . ."[23]

While Bloch gives her figures the physiognomy and hair characteristics of European Americans, she cuts the wood away from the outlines of their bodies, allowing the raised areas of skin and clothes to print a solid black,

The Tomato Pickers 7/15 Harry Brodsky

Harry Brodsky
TOMATO PICKERS, c. 1938
Lithograph, 19 1/2 x 13 3/4 in

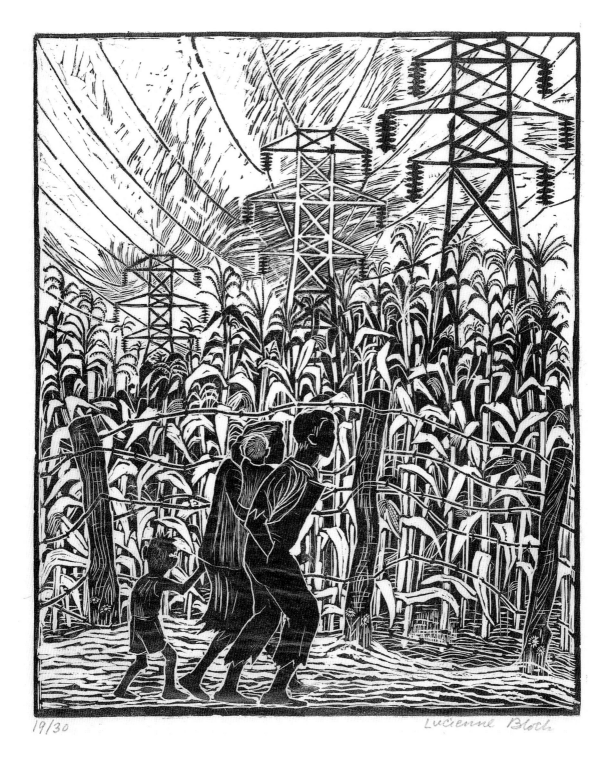

19/30 Lucienne Bloch

Lucienne Bloch
LAND OF PLENTY, c. 1935
Woodcut, 10 5/8 x 8 3/4 in

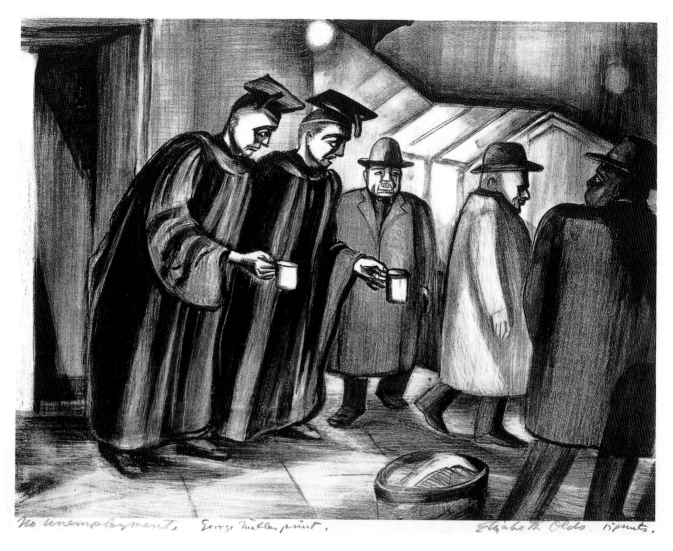

No Unemployment, George Miller print, Elizabeth Olds 15 prints

Elizabeth Olds
NO UNEMPLOYMENT, 1936
Lithograph, 9 3/4 x 12 3/4 in

(Opposite)

Peggy Bacon
RIVAL RAGMEN, 1936/38
Lithograph, 5 5/16 x 8 15/16 in

suggesting that poor African American and poor European American farmers shared the same fate.[24]

It is not surprising that this challenge to the heroic imagery of the nuclear family appears in print form. Such small works were less likely to function as government-sanctioned symbols of democracy and citizenship, even though they may have been produced in government-sponsored print workshops. In the 1930s prints were a particularly popular medium for artists depicting current political or economic conditions who wanted their art to reach a large audience. Prints—woodcuts, engravings, lithographs, etchings, serigraphs—could be produced in multiples and sold at low prices. An honorable tradition of socially conscious graphic artists was already in place, from Albrecht Dürer to Honoré Daumier. Prints also appeared in the form of handouts at demonstrations or as illustrations in left-wing journals. A number of artists who came into prominence in the 1930s cut their graphic teeth as contributors to such early twentieth-century left-wing journals as *The Masses*, *The Liberator*, and *The New Masses*.[25] They went on to help produce the hundreds of thousands of prints that came out of the workshops orga-

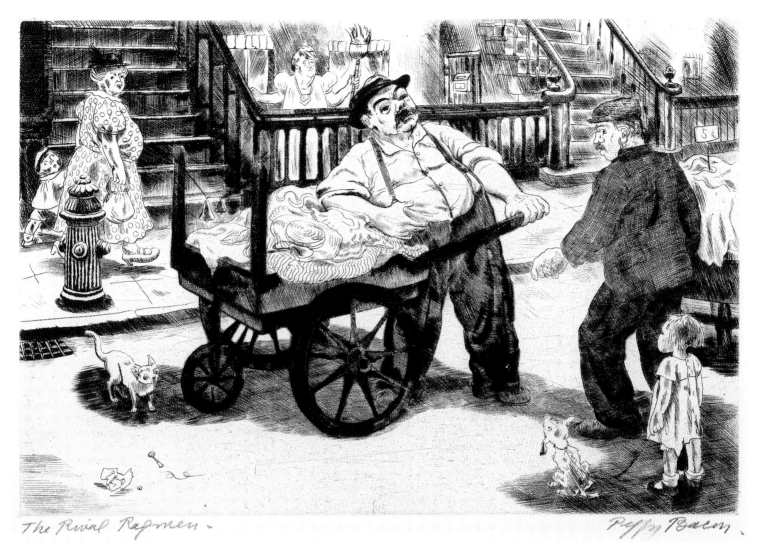

The Rival Ragmen — *Peggy Bacon*

nized by the Graphic Arts Division of the WPA.

We might expect to find more images of women working outside the home if we look at the work produced within these graphic arts workshops. Like the WPA art projects in general, the workshops contained large numbers of women artists. Yet surprisingly few images of working women were produced. According to artist and art historian Helen Langa, while "work" was an important theme in New Deal art, the work of men was seen as most appropriate for representation. Presenting women's work might displease those who administered the art projects and jeopardize one's position on the government payroll.[26] Also, women artists did not want to appear to be separating themselves from their male counterparts by championing "women's subject matter."[27] In 1935 Elizabeth Olds commented:

> American artists have lately chosen to portray our own life. We find our subject on the streets, in the factory, (in) the machines and workers of industry and on the farm. We aim to picture truly the life about us as the people we are in reference to the forces that make us. We choose all sides of life, searching for the vital and significant.[28]

Yet while she, Riva Helfond, Betty Parish, Nan Lurie, and other women produced numerous scenes of men working in factories, mines, and the fishing industry, they seldom showed women in offices, schools, or factories (except during World War II) or engaged in domestic labor. Even when depicting the effect of the Depression on higher education in her lithograph *No Unemployment* (1936), also titled *A Sacred Profession Is Open to College Graduates*, Olds' college graduates are men.

Where women do appear often in the prints of both male and female artists of the 1930s is on the streets, in the spaces between the industrial or commercial workplace and the home. Within these spaces we can also discern, if we look closely, evidence of women's labor. One example of this is Peggy Bacon's *Rival Ragmen* (1936–38). By the time Bacon produced this drypoint she was already a well-established artist, famous for her representations of city streets and caricatures of New York City dignitaries and art world figures. While the two ragmen in the center of the composition are arguing, a woman and a girl move past them in the background. A second woman and girl, this time separated by the two men, watch the altercation.

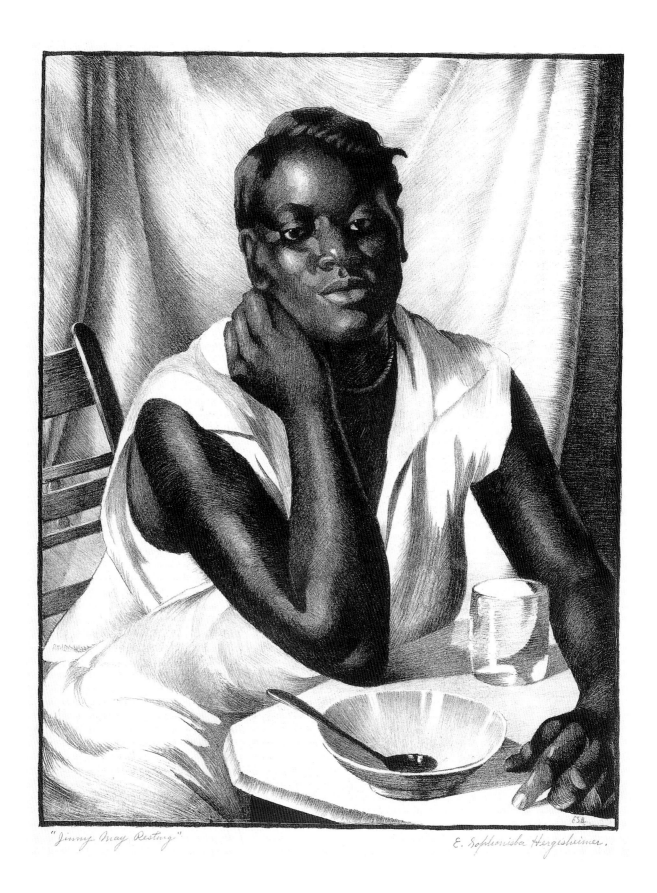

"Jinny May Resting" E. Sophonisba Hergesheimer.

Ella Sophonisba Hergesheimer
JINNY MAE RESTING, 1930s
Lithograph 17 x 13 3/8 in

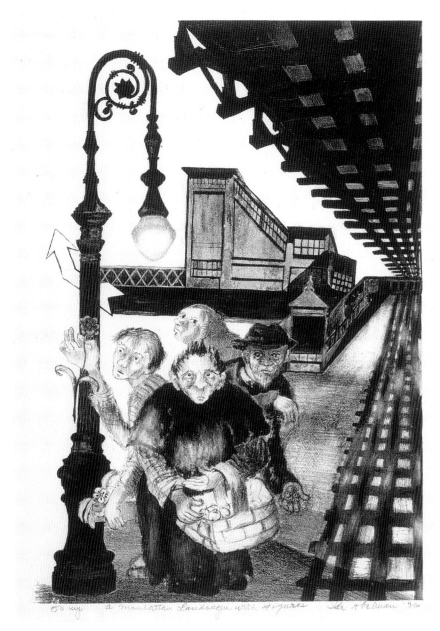

Ida Abelman
A MANHATTAN LANDSCAPE
WITH FIGURES, 1936
Lithograph, 13 7/8 x 9 5/8 in

The second woman pauses in her household chores, broom in hand. Thus, women's work is implied but not represented. Ella Sophonisba Hergesheimer presents this same in-between state in her lithograph *Jinny Mae Resting* (1930s), where the woman's labor is represented by her powerful arms and stiff neck.[29]

Ida Abelman, who assisted Lucienne Bloch on a 1935 mural for the House of Detention for Women in New York City, has also presented women in transit through or under the streets of New York City. In her lithograph *A Manhattan Landscape with Figures* (1936), a group of four figures, three women and one man, huddle under the elevated railroad, or el, next to an elaborately crafted lamppost. The woman in the foreground carries a basket of apples, some of which she appears to have just sold to the man behind her. The figure immediately to her left holds up a flower, which echoes the leaf design in the top curve

of the lamppost. Another flower rests in a box she holds in her other hand, suggesting she is selling them. While on the surface this is simply an image of women in the streets, it also shows women working. The traditional icons of domesticity—food and cut flowers—are shifted from the home to the street, a shift many women were forced to make because of financial need.

The phrase "landscape with figures" in Abelman's title ironically evokes a long artistic tradition of idyllic landscapes composed of rolling hills with figures that often occupy both the earthly and heavenly realms (the French seventeenth-century painters Claude Lorrain and Nicolas Poussin immediately come to mind). Yet this is no idyllic landscape. Nature is here reduced to commodities for sale—apples and flowers—and exists in relationship to the harsh, angular forms of industrial or commercial buildings and elevated railroads. The curvilinear, vegetal designs of

27

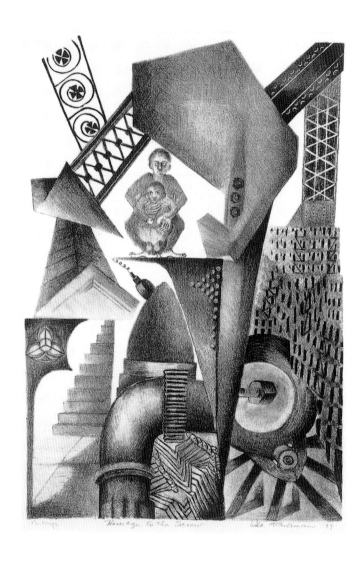

Ida Abelman
HOMAGE TO THE SCREW, 1937
Lithograph, 12 x 9 3/4 in

the lamppost show the transformation of a living nature into hard, metallic forms. The figures are overwhelmed by the surrounding architecture and appear resigned to their fate. In a related work, *Homage to the Screw* (1937), the oppressiveness of the machinery of urban life is even more starkly portrayed, as the mother and child appear about to be crushed between two slabs of metal in a world devoid of any reference to the natural world.

Abelman continues her critique of the effects of technology on the urban landscape in her lithograph *Wonder of Our Time* (1937). The expansive New York subway system was often seen as one of the wonders of public transportation, able to move tens of thousands of people from one part of New York City to another with relative ease. Yet it was already suffering from serious overcrowding during rush hours. It is this that Abelman emphasizes in her work. The leg of one woman who has managed to squeeze most of her body into the train is visible on the left side of the subway door, while at least three other women, recognizable as such by their hats, have already managed to position themselves in the car. An African American man on the far right seems to have exhausted himself either

getting to the subway or trying to get on, while three other men continue in their efforts to board the already impossibly crowded train. The combination of horror, anger, and exhaustion on the faces of the subway riders suggests that this was one "wonder" in need of further refinement. The glaring eye and downward glance of the woman with the feathered hat visible in the centrally framed window, along with the closed eyes and smiling face of the man squeezed next to her, suggest that these crowded trains were the sites of a good deal of unwanted physical contact.

Karl Schrag depicts a similar subway scene in his etching *Madonna of the Subway* (1939). Unlike Abelman, however, Schrag suggests that chivalry is, in fact, alive and well on the New York subways. No one offers the woman and child a seat, but they are at least provided with ample space to position themselves in the crowd. The crowd is much more passive than Abelman's. Men and women move in an orderly fashion through the door of the subway car, while those inside stand with downcast eyes or faces buried in newspapers. One hint of the potential chaos of the New York underground is the somewhat frantic gesture of the child in the foreground who grabs hold of his mother's

28

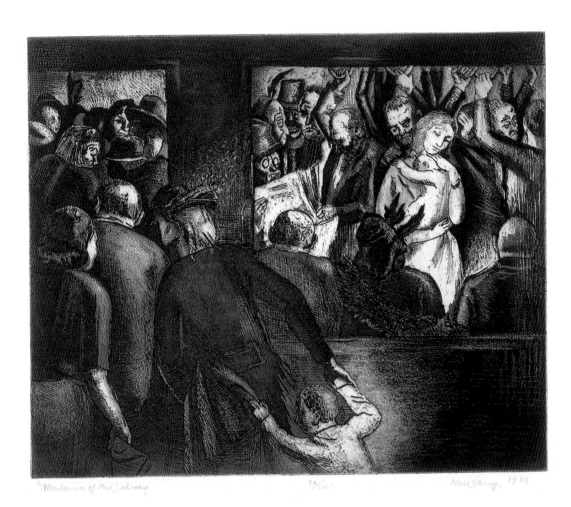

Karl Schrag
MADONNA OF
THE SUBWAY, 1939
Etching and aquatint,
9 3/4 x 11 7/8 in

"Madonna of the Subway" 20/100 Karl Schrag. 1939

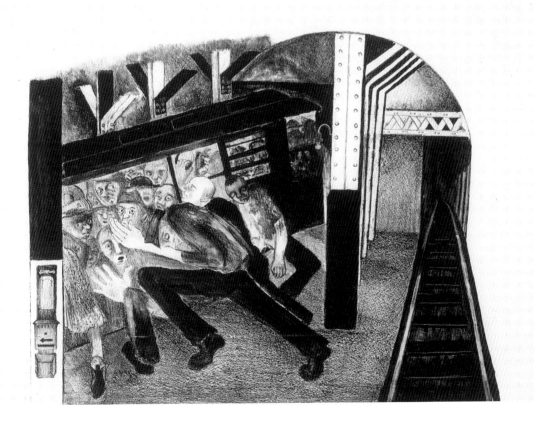

Ida Abelman
WONDER OF OUR TIME, 1937
Lithograph, 12 x 15 in

coat as they move toward the subway car door.

Other artists give us an indication of the possible destinations of the women who rode the New York subways either alone or with their children. Mabel Dwight's lithograph *Children's Clinic* (1936) shows one of the many public clinics set up to care for those unable to afford private health care. Here we can discern two female occupations, one unpaid (mother) and the other paid (health-care worker or nurse). Just as Abelman's print is a less than idealized treatment of the New York subway, Dwight removes Schrag's holy veil from the relationship between mothers and their children, a relationship both loving and stressful, particularly in times of financial crisis.

Dwight's *Children's Clinic* also records a relatively recent change in the delivery of health-care services. Ellen Wiley Todd, in her book *The "New Woman" Revised: Painting and Gender Politics on Fourteenth Street*, notes that the "experts who discussed social change, the family, and women's roles during [the 1920s and 1930s] focused on the unsettling shift from a rural, production-oriented economy to an urban, consumption-oriented economy."[30] Much of the work previously carried out within the home—food preparation, care of the sick—was now being performed in restaurants and hospitals.[31] *Children's Clinic* is only one indication of this change. In her book, Todd focuses not on health care, however, but on the purchasing of products by women for the home or for personal adornment. Advertisers had long known that women did most of the family shopping and so directed most of their advertising copy toward them. Consuming also acquired a political dimension in the 1930s. According to business and government pundits, economic recovery could only be achieved if consumption increased. Shopping, therefore, became women's patriotic duty. Of course, this patriotism was tempered by the hard facts of life. The bargain shopper, and bargain department stores, thus became a familiar sight in urban centers across the United States.

Probably the most famous locale for bargain shopping

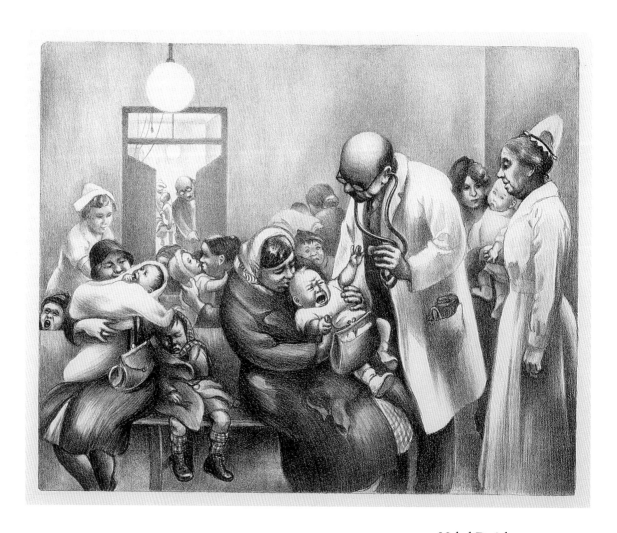

Mabel Dwight
CHILDREN'S CLINIC, 1936
Lithograph, 9 1/2 x 12 in

Kyra Markham
THE FIT YOURSELF SHOP, 1935
Lithograph, 13 x 10 in

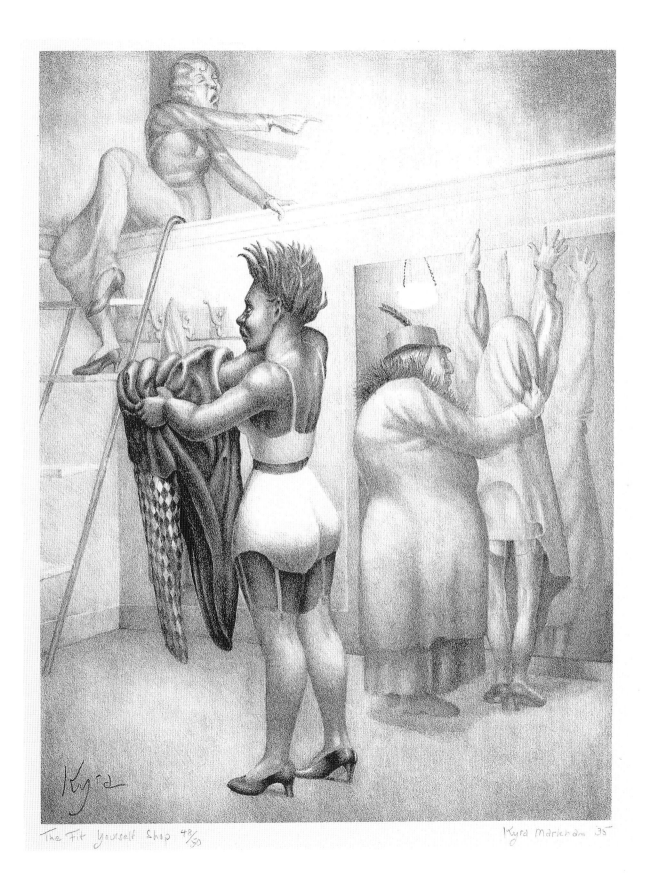

The Fit Yourself Shop 48/50 Kyra Markham 35

for women's clothing, and certainly the most fully recorded by artists, was the area around Union Square and Fourteenth Street in New York City. According to some accounts, more women's apparel was sold in Union Square on one day than in any other place in the country. As many as ten thousand dresses a day were sold at S. Klein's alone and police were sometimes called in to control the crowds.[32] The dressing rooms at Klein's and similar stores were communal, with little or no help from store clerks; these dressing rooms appear in the 1930s in works by Kenneth Hayes Miller, Raphael Soyer, and Mary Fife Laning, and in Kyra Markham's wryly humorous lithograph *The Fit Yourself Shop* (1935). Four women occupy this largely empty room. The one closest to us, who is African American, either has just pulled a dress over her head or is about to put it on; the disheveled appearance of her hair suggests the former. Another woman perches on a ledge at the top of a ladder and points in disgust at something outside of the picture to the right, perhaps a rat or mouse in the dressing room. In the right half of the print, an elderly woman, fully dressed in hat and coat, helps another, thinner woman, possibly her daughter, try on a dress. The communal dressing room contained women of all races and ethnicities, all sharing the same lower-class economic status and the same desire to improve their lot in life. One way of doing this was to dress better, to "pass" as middle or upper class. With inexpensive versions of high-fashion designs, the careful shopper could successfully carry this off. In an increasingly competitive job market where appearance counted more and more, the right outfit could make all the difference.

Sexuality—in particular, publicly displayed sexuality—is the topic of another lithograph by Markham, *Night Club* (1935). Within the darkened club two dancing figures are spotlighted, a man with drooping eyes and wrinkled brow, and a younger, heavily made up blonde woman in a provocative dress that reveals the contours of her body. The blonde woman is the epitome of the 1930s "siren" or "gold digger" who relies on her looks and fancy bargain-store dress to snag an older, well-heeled man who will take care of her.[33] According to Todd, this "figure of hyper-glamorized working-class femininity" is both "a figure of sexual danger, a threat to masculinity already compromised by unemployment," and the vehicle and victim of a consumer culture in which female bodies were for sale and looks were all that mattered.[34] A stereotyped icon of female beauty and a sexual commodity constructed for a male viewer's gaze, the siren appeared in lithographs, paintings, films, and advertisements throughout the 1930s.

As in *The Fit Yourself Shop*, Markham contrasts a scantily-clad, curvaceous young woman with a stiffer, fully dressed older woman. The latter is found in the dancing couple at the right edge of the composition and is patterned after the caricatures of feminists or suffragists from the mainstream and anti-feminist press.[35] She is much

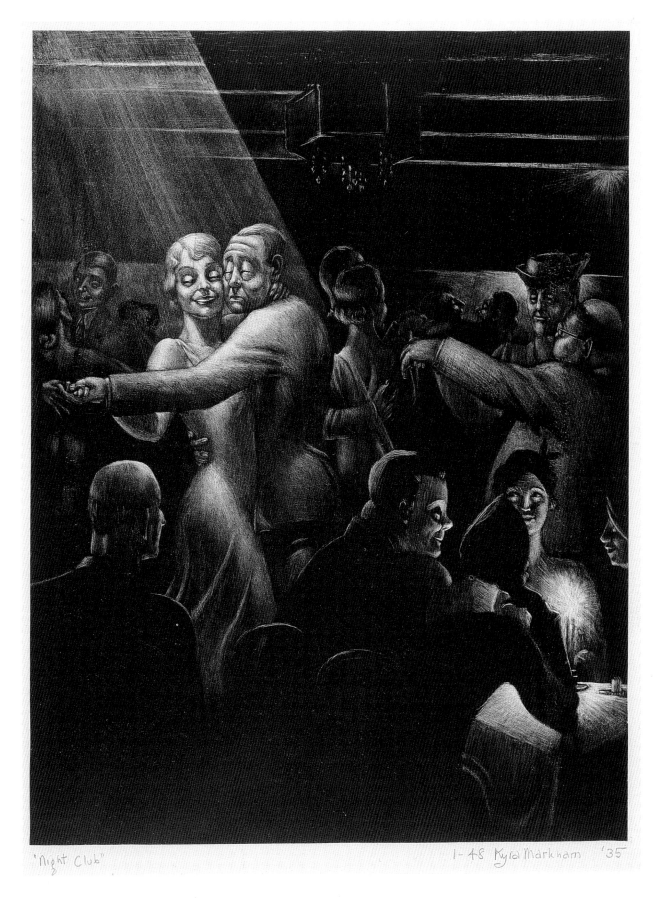

"Night Club" 1-48 Kyra Markham '35

Kyra Markham
NIGHT CLUB, 1935
Lithograph, 13 3/4 x 10 1/2 in

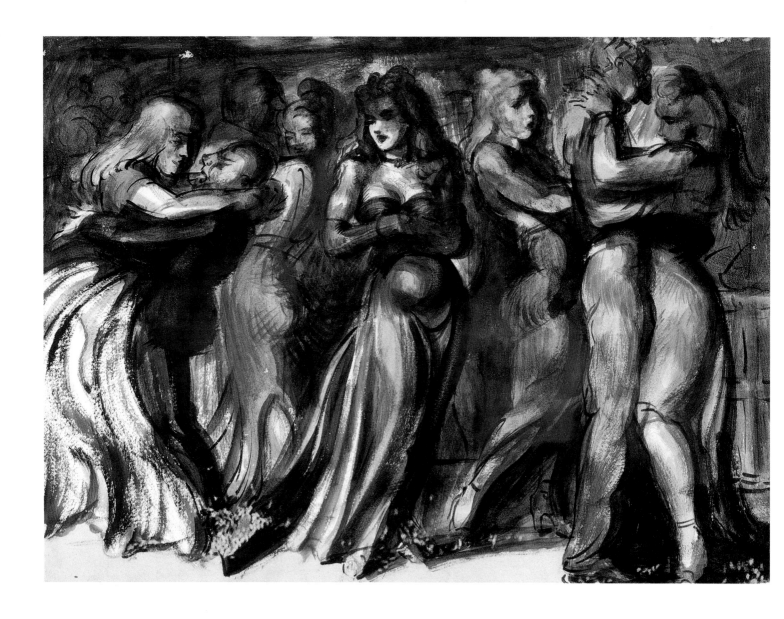

taller than her male dancing partner, has a long, unmade-up face, and wears a hat that is decidedly unfeminine. Unlike the siren, whose arms are bare, she is covered from neck to wrist. Her male companion, in addition to being shorter, is balding and overweight. He rests his hand limply in hers, giving the suggestion that she, in fact, is leading.

The siren's male partner, in contrast, holds her right hand firmly in his and pulls her close to his body with his other hand at her waist. They are all sensuality and virility, while the feminist/suffragist and her partner are masculinity (hers) and emasculation (his). Yet the siren appears to control her partner too, her smiling self-confidence contrasting with the dour expression on his face. Markham may have intended to parody both the siren's and the feminist's ultimate control over the men in their lives, but 1930s audiences would have found the siren more appealing. Even the feminist gazes at the siren, but with a smug self-satisfaction that suggests she is confident of the

superiority of her own methods of controlling men.

The artist most closely associated with the siren image is Reginald Marsh. A perfect example of the many paintings he created of this female icon during the 1930s and 1940s is his watercolor *Dance Hall Scene* (1940s). Here the siren's physical attributes are even more clearly outlined than in Markham's work and the threat to male masculinity heightened. The woman on the left looks down on her dance partner as she puts both arms around his neck, his closed eyes and open mouth suggesting ecstasy or pain (or both). The Mae West type in the center with her cleavage, rounded belly, and groin emphasized by the folds in her dress glances over at the dancing/struggling couple. The blonde to her right also stands alone, waiting for an invitation to dance, while the couple next to her are locked in an embrace, although nothing as intimate as the couple in Markham's print. Their bodies touch but their gazes are averted.

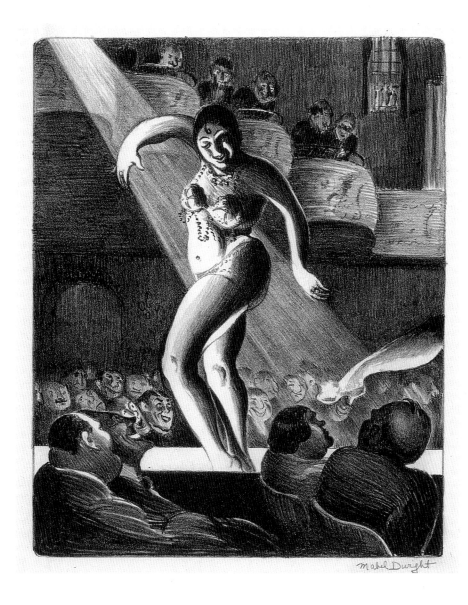

Mabel Dwight
BURLESQUE, c. 1935
Lithograph, 9 1/2 x 8 in

(Opposite)

Reginald Marsh
DANCE HALL SCENE, 1940s
Watercolor, mixed media
(with Chinese ink) on paper
22 x 30 in

The lack of intimacy in Marsh's work and the sense of isolation, and possibly alienation, suggest that this is one of a number of scenes Marsh created of taxi dancers, women who hired themselves out for dancing, a practice particularly prevalent in the 1930s. If so, then this is another scene of women working, this time on the periphery of the sex industry, for while the men paid for a dance, they often assumed they had purchased much more. Here, once again, the socializing that had once taken place within community halls or family homes had become part of a market system, where a dance and a smile were purchased as easily as a loaf of bread or a ticket to a movie.

Or as easily purchased as a drink (after the end of Prohibition in 1933) at one of the many burlesque halls that filled the Union Square/Fourteenth Street districts and other parts of New York. Here, once again, women were on display, but now the pretense of civility and respectability that could be maintained in the dance halls was dropped. The woman in Mabel Dwight's *Burlesque* (c. 1935) was hired to display her body for men. This is, therefore, another image of a woman at work. The men leer at her from below and from above, the lighting from the rampway casting macabre shadows across their faces and making them appear devilish. The performer seems at ease as she gestures gracefully with her arms. A powerful figure, she dominates both the composition and the men around her. Yet the leg emerging from the right edge of the picture frame reminds the viewer that it is not the woman herself that matters but her body parts—her legs, her breasts, her buttocks. The social commentary is clear: the burlesque dancer may well enjoy her work and experience a sense of power over her male audience, but her economic well-being is dependent upon the sexual desires of these men.

Another artist who focused a critical eye on sex workers and the night life of the 1920s and 1930s was Adolf Dehn. Dehn grew up in Waterville, Minnesota. His mother

participated in feminist and socialist politics and was inclined toward the German Lutheran Evangelical Church, while his father was an anarchist and an atheist. This early schooling in radical politics led Dehn to associate in New York with the staff of *The Masses* and to spend over a year in jail during World War I as a conscientious objector. Like many artists in this book, he studied at the Art Students League in New York and traveled to Europe. In Germany, he became friends with the leftist artist George Grosz. Many of the satirical drawings and prints Dehn produced of Berlin life were published in *The Liberator* and *The New Masses* in the 1920s.

In 1929 Dehn returned to New York and created a series of lithographs based on his Berlin drawings. *Love in Berlin* (c. 1930) is one such image. Here Dehn sets his critique of bourgeois capitalist society in the German brothel, as did many left-wing German artists at this time. The men and the prostitutes they visit stand for the political degeneration of the German bourgeoisie at large. Like Dwight in *Burlesque*, Dehn foregrounds the female body in his lithograph. Dwight, however, treats her dancer more sympathetically, giving her a dignity and presence missing from Dehn's naked, splayed figures. The distorted, crudely drawn bodies of Dehn's women make them appear even more degenerate than their male customers. They are the polar opposite of the respectable New Deal wife and mother, lost to the sanctity of the home and working at the one form of paid labor always open to women. Dehn's lithograph is thus as much a commentary on the dangers of sexually active women (particularly those who are paid for their efforts) as it is a denunciation of the German bourgeoisie.

Adolf Dehn
LOVE IN BERLIN, c. 1930
Lithograph, 11 x 15 1/8

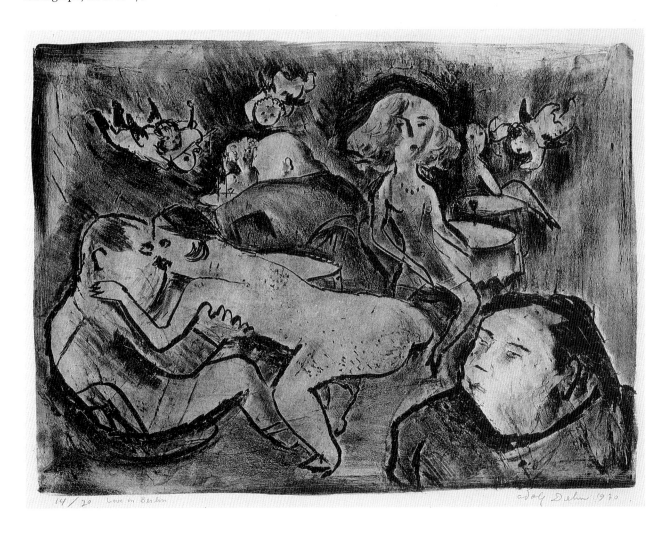

PRAYER MEETINGS AND LYNCHINGS: AFRICAN AMERICAN STRUGGLES FOR SELF-DEFINITION AND SURVIVAL

Adolf Dehn produced another work based on his Berlin drawings entitled *We Nordics* (1931). Like Mabel Dwight, Dehn presents a burlesque show, but his presentation differs in significant ways. Dwight centers on the female performer and emphasizes her sensuality; Dehn's work is divided horizontally, with almost equal emphasis given to the four black female dancers in the upper register and the five white men and women in the lower. Dehn's critique is focused more on race than on sex. The white figures look with disdain at the dancers, who are presented as far from graceful or sensual in their movements. The superiority of the Aryan or Nordic race was a central theme of the National Socialist Party, or Nazis, whose growing power in the late 1920s and early 1930s culminated in the

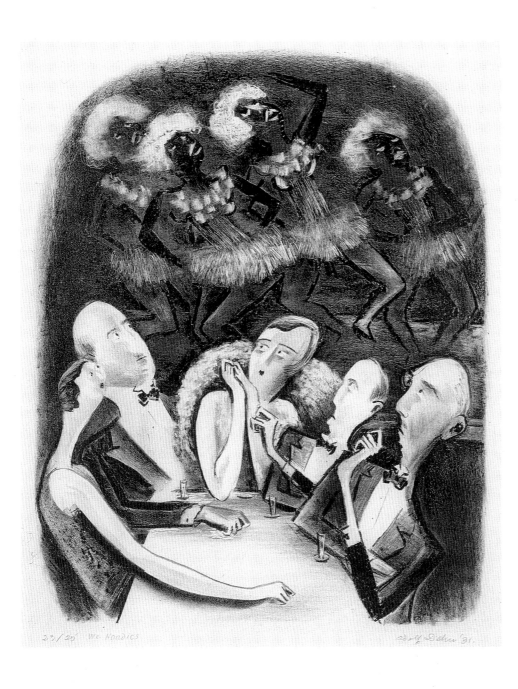

Adolf Dehn
WE NORDICS, 1931
Lithograph, 13 1/2 x 10 15/16 in

appointment of Adolf Hitler as chancellor of Germany in 1933. Dehn is caricaturing the conservative German elite, with their bald heads, weak chins, and long arms, who are both drawn to and repelled by the hedonistic atmosphere of the nightclubs of Berlin. But Dehn is caricaturing the black performers as well, giving them large eyes and lips and awkward-looking gestures, thus engaging himself in the racist stereotyping that was so prevalent in both the fine art and mass media of Europe and the United States.

While black women danced on the stages of Europe for the delectation of white viewers, African Americans in the United States were defining themselves within their own institutions. In a recent essay entitled "Nihilism in Black America," the African American theologian and scholar Cornel West writes:

> The genius of our black foremothers and forefathers was to create powerful buffers to ward off the nihilistic threat, to equip black folks with cultural armor to beat back the demons of hopelessness, meaninglessness, and lovelessness. These buffers consisted of cultural structures of meaning and feeling that created and sustained communities; this armor constituted ways of life and struggle that embodied values of service and sacrifice, love and care, discipline and excellence. . . . These traditions consist primarily of black religious and civic institutions that sustained familial and communal networks of support.[36]

Joseph Delaney
REVIVAL, 1940
Oil on canvas, 34 x 23 3/4 in

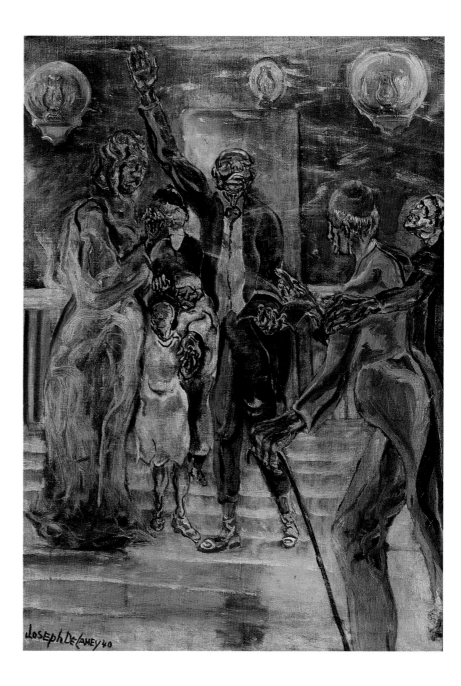

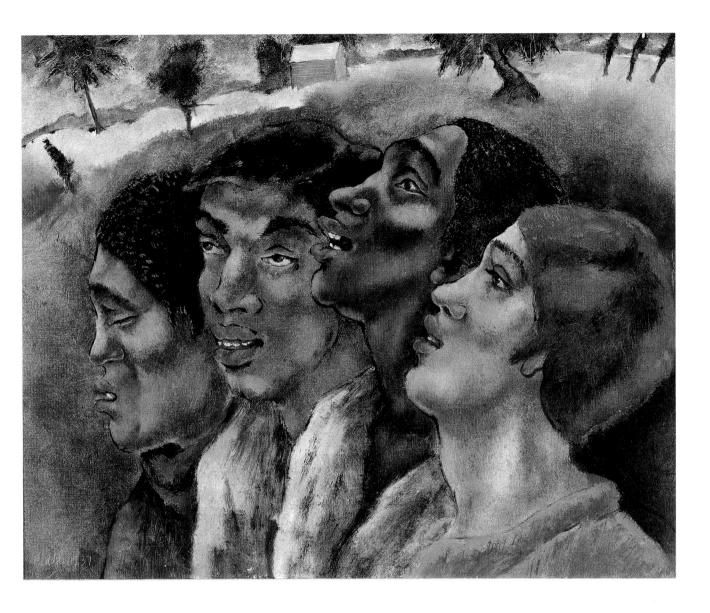

George Biddle
SPIRITUALS, 1937
Oil on canvas, 16 $1/8$ x 20 $1/8$ in

African American artist Joseph Delaney draws from his own childhood as the son of a Methodist minister in Knoxville, Tennessee, in his painting *Revival* (1940). Using a fluid and exaggerated style formed during his studies with Thomas Hart Benton in New York City, Delaney captures the emotional power of religion for the family in the center of the composition. The gas lamps appear to float above the heads of the figures, a literalization of the "light of Christ." There is also a tension between the central male figure's upturned face and expressive gesture encompassing the woman and children to his right, and the downturned gaze and self-contained pose of the woman. The figure on the far right also encloses the man next to him with his left arm. There is thus expressed in these gestures a sense of both enclosure and release, of support and enlightenment.

This same sense of community and shared purpose can be felt in George Biddle's painting *Spirituals* (1937). A member of a white, wealthy Philadelphia family, Biddle

attended Harvard in the early part of the century, where one of his classmates was Franklin D. Roosevelt. This early friendship prompted Biddle to approach Roosevelt in 1933 and add his voice to the many others calling for federal support for the arts. Biddle had visited Paris in the 1920s to study contemporary art, but found a 1928 sketching trip in Mexico with Mexican muralist Diego Rivera more aesthetically meaningful. Biddle was impressed by the simplicity and directness of the Mexican murals he saw, as well as their reliance on both Italian Renaissance and pre-Columbian mural painting. These murals also combined historical narratives with social and political concerns (indeed, the former were constructed through the lens of the latter).[37] Biddle soon abandoned the decorative nudes and picturesque scenes that had marked his work up to that time and took up the recording of contemporary American life.[38]

Biddle recorded American life as a New Deal social reformer. Many progressive artists participated in the campaign for civil rights by creating images that spoke to the dignity and strength of African Americans. Such was the case with *Spirituals.* In this painting one can see the same mix of Italian Renaissance art and contemporary social concerns that marked the Mexican murals Biddle so admired. The strong profiles and muscled necks of the two right-hand figures call to mind the sibyls in Michelangelo's Sistine Chapel in Rome. The gentle arc of the singers' heads suggests the rise and fall of the gospel music coming from their throats. The range of expressions and skin color gives each figure an individuality that counters the racial stereotyping often present in representations of African Americans. At the same time, their compositional unity evokes a sense of cohesion. The figures are placed not inside a church, but in a rural landscape rising and falling in harmony with the figures' heads.[39]

Another view of African American religious life is found in Palmer Schoppe's lithograph *'Speriences Meeting* (1935). Here the gestures do not offset each other to create a balance of emotions between contemplation and jubilation as in Delaney's painting. Instead, they combine to emphasize the participants' emotional and physical involvement in the revival meeting. Like Delaney's figures, Schoppe's are elongated and exaggerated, a similarity that

Palmer Schoppe
'SPERIENCES MEETING, 1935
Lithograph, 13 x 8 3/4 in

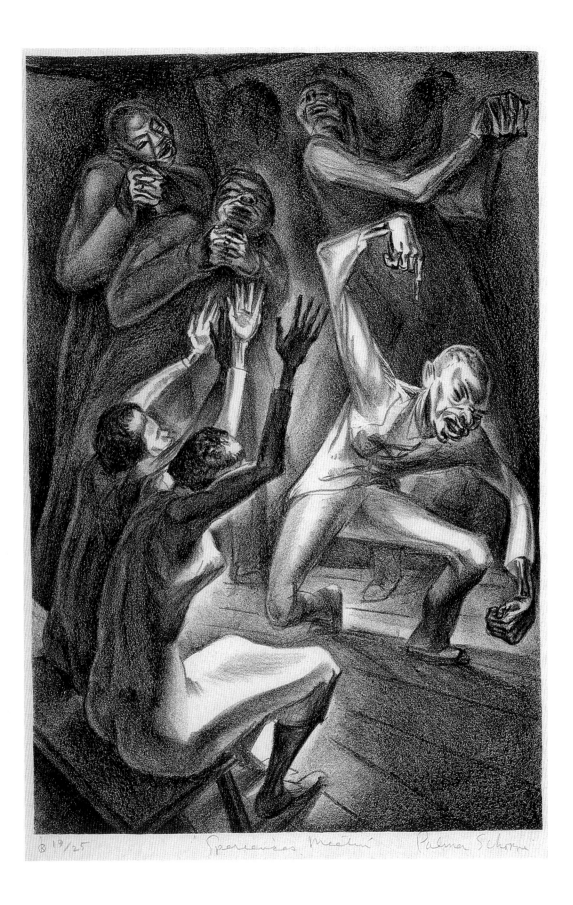

13/25 Sperecevicas Mcetini Palmer Schoppe

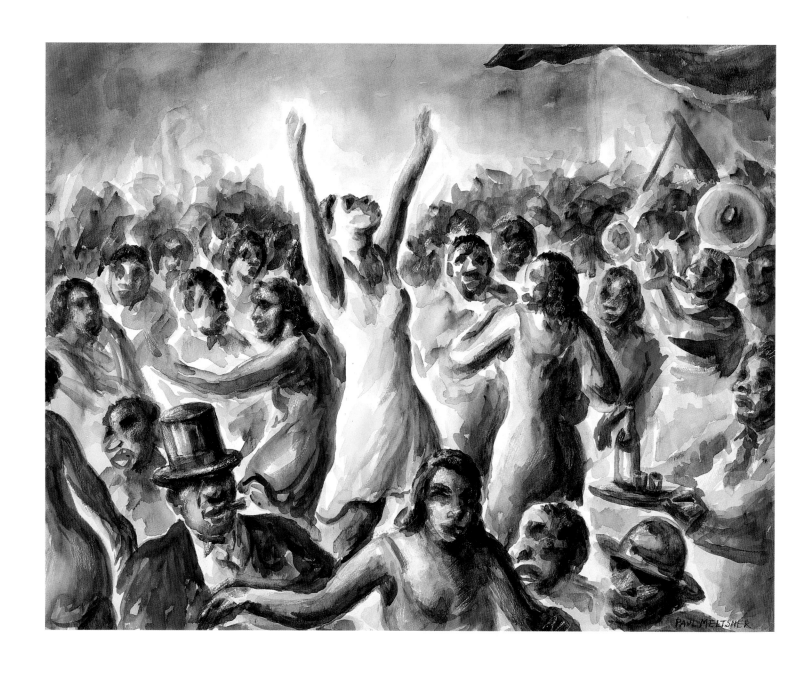

Paul Meltsner
NIGHTCLUB SCENE, c. 1935
Watercolor on paper, 19 x 24 in

can be traced to their common teacher, Thomas Hart Benton. Schoppe also plays with light and dark as Delaney does, incorporating artificial light sources to emphasize the drama of the moment, although Schoppe's light sources are hidden from view. Indeed, the light appears to emanate from the bodies of the central male figure and the two seated women to his left, adding to the intensity of the scene.

Schoppe visited Harlem during a trip to New York, as did many white Americans. He found there the jazz and blues music that was so much a part of the African American cultural flowering of the 1920s and early 1930s known as the Harlem Renaissance. Art historian David Driskell notes that, as in Europe, white scholars, artists, and socialites were drawn to the clubs of Harlem thinking that they would encounter a world of sensuality, of exotic "others" free from the Puritan confines of white Protestant culture. As a result, white artists often "portrayed black America as uncivilized, indulgent, passionate, mysterious, sexy, and savage."[40] There is certainly some of this in Schoppe's lithograph, where the wild abandon of the figures and the contorted features of the central figure dominate the composition. This "passion and sexiness" also appear in Paul Meltsner's *Nightclub Scene* (c. 1935), with its crowd of writhing bodies in close physical contact. Delaney's dignified *Revival* can be seen as an effort to counter this type of "savage" imagery.

Like Driskell, Cornel West examines white America's obsession with black sexuality, and its fear of it, in his essay "Black Sexuality: The Taboo Subject." West argues that along with this obsession and fear is a refusal by both blacks and whites to speak candidly about black sexuality, particularly when discussing race relations. To do so would be to acknowledge the crucial link between black sexuality and the power black people are perceived to have over whites. While some black people might see advantages in maintaining this perception, many see the disadvantages. "If black sexuality is a form of black power in which black agency and white passivity are interlinked," writes West, "then are not black people simply acting out the very roles to which the racist myths of black sexuality confine them?"[41]

In examining the history of such a refusal within black communities to address black sexuality, West notes that

> most black churches shunned the streets, clubs, and dance halls in part because these black spaces seemed to confirm the very racist myths of black sexuality to be rejected. Only by being "respectable" black folk, they reasoned, would white America see their good works and shed its racist skin.[42]

One African American artist who did not refuse to address black sexuality was Jacob Lawrence. In two works from the late 1930s, *Street Scene—Restaurant* (1936–38) and *Interior Scene* (1937), Lawrence looks at the sexualized relations between black Americans and white Americans not only on the streets of New York City but also in a much more sexually charged space—the brothel.

Lawrence moved to Harlem from Philadelphia with his mother, sister, and brother in 1930. Harlem was the largest black urban community in the United States at the time, the destination point for many African Americans escaping the rural South.[43] His first encounter with art-making took place at Utopia House, a local settlement house that offered hot lunches for children and a chance to gain some training in arts and crafts. African American artist Charles Alston, who was teaching there at the time, encouraged Lawrence in his art-making endeavors and later allowed Lawrence to rent a corner of his studio. There the young artist was privy to the heated debates of artists and intellectuals who gathered there: Claude McKay, Langston Hughes, Richard Wright, Aaron Douglas, and many others. Lawrence also won the attention and support of African American sculptor Augusta Savage and gained further artistic training from 1932 to 1934 in the WPA Harlem Art Workshop, signing on with the FAP/WPA in 1938 as an easel artist.

Early on, Lawrence identified the subject matter that would absorb his time and energies as a painter: the life of Harlem and the history of African Americans. Art historian Patricia Hills describes Lawrence as "the pictorial griot—the professional . . . praise singer and teller of accounts—of his own African-American community."[44] He fulfilled this role not only with the stories he had to tell but also with the way he spun them out in sequences or series of images. Lawrence also determined early on the style he would use to convey these stories. At Utopia House he was already painting brightly colored street scenes inside corrugated boxes with a sense of patterning derived from the rugs and other decorative furnishings of his own home.

Street Scene—Restaurant is one of Lawrence's earliest professional works, painted when he was nineteen years old. This is not just any street scene, but one that contains the propositioning of a white man by a black woman. She can be identified through her posture, clothes, and the company she keeps (the other two women) as a prostitute. The nervous expression on the man's face, his glance over his shoulder, and his hand in his pants pocket suggest not only that he has come to pay for the services of these women, but also that he knows he has ventured into potentially hostile territory (both as a white man in an African American neighborhood and as someone engaged in an illegal activity). The women are there to serve his sexual needs, but Lawrence, in a seemingly casual and

humorous way, invests them with an air of self-confidence and power that suggests they are the ones with the upper hand in this situation.

Lawrence's *Interior Scene* is a companion to *Street Scene*. Not only are both exactly the same size, but *Interior Scene* continues the narrative begun in *Street Scene*; the white customer has entered the brothel and done his business. Lawrence's treatment of prostitution in this painting is surprisingly matter-of-fact and lacking in prurient detail. *Interior Scene* is the opposite of Dehn's *Love in Berlin* (just as Dehn's later *The Residential Section of Key West* [1942], in its depiction of the placid street life of a southern town, is strikingly different from Lawrence's urban *Street Scene*). Rather than foregrounding, like Dehn, the splayed, naked body of one of the female sex workers, Lawrence focuses on the business and paraphernalia of the sex industry. He notes the condoms on the bed and in the pocket of one of the johns; the rats, both dead and alive (and both white and black); the flies buzzing around the lamp and the basin containing a red cloth or liquid; the fumigator on the table to deal with the flies; the painting of the Caucasian lactating Madonna, an ironic commentary on the role of women as nurturers and on the virgin/ whore dichotomy so often used to separate white and black women; the money the woman on the bed slips into the top of her nylon; the black heads peeking through the window. The painting is both humorous and matter-of-fact. It counters both the romantic fantasies and the brutal satires that were the more common modes of representing female sexuality, white and black.

Lawrence's simple, flat shapes and rejection of mimetic detail equalize the characters in the scene. They are types rather than portraits, actors in a social drama where there is no lead role. The overall perspective from which we view the scene—as if we are hanging like the light bulb from the ceiling—also works against highlighting any one character. Hills, in describing Lawrence's *Harriet Tubman* series, comments that his style, "with its flat shapes, controlled outlines, and limited range of color, kept the emotion restrained [and] the conceptual goals clear."[45] This is certainly true of *Interior Scene* as well. It is about the business, rather than the passions, of sex. One final passage, this time from Lawrence's own writing, is equally descriptive of the formal power of *Interior Scene*, although Lawrence had African art in mind when he wrote it:

> For here was an art both simple and complex—an art that possessed all of the qualities of the sophisticated community. It had strength without being brutal, sentiment without being sentimental, magic but not camouflage, and precision but not tightness.[46]

As Cornel West points out, however, sexual relations between blacks and whites have been, and still are, more often marked by obsession and fear than by the businesslike exchange of cash for services rendered. This obsession and

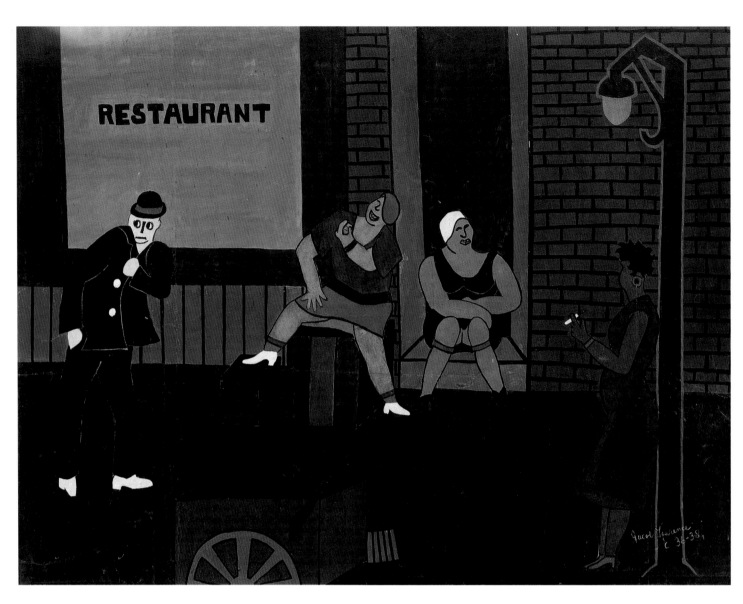

Jacob Lawrence
STREET SCENE—RESTAURANT, 1936/38
Tempera on paper, 26 1/2 x 35 in

Jacob Lawrence
INTERIOR SCENE, 1937
Tempera on paper, 28 x 33 1/2 in

(Opposite)

Adolf Dehn
THE RESIDENTIAL SECTION OF KEY WEST, 1942
Watercolor and gouache on paper, 19 x 27 1/2 in

George Biddle
ALABAMA CODE, 1933
(OUR GIRLS DON'T SLEEP WITH NIGGERS)
Lithograph, 13 3/8 x 9 7/16 in

fear was caught up in one particularly horrific practice—lynching. According to art historian Marlene Park, in her detailed article on images of lynching in the 1930s, "[t]hough there were mob murders in colonial America, lynching became a major form of deliberate, lawless violence after the Civil War."[47] While lynching victims included women and children, most were men. And while Native Americans and Italian, Mexican, and Chinese nationals were among those lynched, the majority of lynching victims were African American (of the nearly five thousand recorded lynching victims, 72.7 percent were African American). Many victims were tortured and burned before being hung and some lynchings were announced in advance by newspapers and, later, radio.[48] In his 1905 book *Lynch-Law*, James Elbert Cutler noted

that "the commonest justification for lynching negroes in recent years, the plausibility of which rests very largely on race prejudice, is the crime of rape directed against white women."[49]

In 1935 two exhibitions opened in New York that focused on lynching. One was sponsored by the National Association for the Advancement of Colored People (NAACP), the other by the CPUSA's New York City John Reed Club. Many works in these two exhibits were read as commentaries on the 1931 trial of the Scottsboro Nine, in which nine African American boys hitching a ride on a train were falsely accused of raping two white girls.[50] While no one was lynched or executed, the nature of the Scottsboro case was all too familiar. The mere presence of black men and white women in the same physical space

Louis Lozowick
LYNCHING, 1936
Lithograph, 10 x 7 1/4 in

aroused deep-seated suspicions and anger in many white men.

George Biddle's lithograph *Alabama Code (Our Girls Don't Sleep With Niggers)* (1933) speaks directly to—and calls into question—this charge of rape.[51] The girl perched seductively in the lap of a lecherous old man, who fondles her breast with his left hand, represents one of the Alabama girls who accused the Scottsboro Nine of raping her. Using a defense tactic common in rape trials until very recently—although certainly not used in the Scottsboro trial—Biddle suggests that the girl is sexually promiscuous, that rather than being sexually assaulted, she more probably seduced the young men. In fact, in February 1933, a month before the second Scottsboro trial, one of the girls repudiated the rape charge, but the all-white jury still found the defendants guilty. Biddle, while impugning the moral character of the white Alabama girl, also suggests that she herself was being manipulated and used (both politically and sexually) by the white men who controlled the South.[52]

A year after the two New York anti-lynching exhibitions, Louis Lozowick, whose image of a black worker holding off a baton-wielding policeman had been included in the CPUSA show, created another anti-lynching work, the lithograph *Lynching* (1936). The contorted face of a lynched African American man, lit from below, fills the lower right-hand corner of the composition. Behind, barely visible in the shadows, is a hooded Klan figure. The anonymity of the Klansman looming in the background is contrasted with the powerful presence of the highly individualized face in the foreground. This face is, in fact, a

self-portrait. Lozowick later wrote of this work:

> It represents a lynching but it is a self-portrait just the same. I cannot recall the special event or the immediate reason that may have prompted me to do the scene. The time was certainly turbulent. . . . The news from the South was disturbing. I was still under the impression of news paper [sic] reports about a flood in Alabama where while white[s] were being rescued, blacks were callously left to drown. Whether that was the reason I could not tell. It could have been.[53]

While Lozowick does not explain why he presented himself as a lynched black man, he may have been making a connection between the racial persecution he experienced as a Jew and that experienced by African Americans.[54]

In his painting *American Justice* (also titled *White Justice*) (1933), Joe Jones presents another kind of lynching, where an African American woman, rather than man, is the victim. This painting is a stark contrast to Jacob Lawrence's presentation of self-confident African American prostitutes. It graphically portrays what is absent (yet understood) in Lawrence's treatment of sexual relations between white men and black women—the rape and murder of black women by white slave owners and, after the end of slavery, by members of white vigilante organizations like the Ku Klux Klan. That the woman in Jones's painting has been raped as well as murdered is suggested by her half-naked body, the draped phallic forms of the Klansmen and the Klan member's torch at the right edge of the crowd, held as if an extension of his penis. Here sexuality is clearly implicated in the relations between whites and blacks. Jones also integrates the theme of white/black relations into his work in formal terms. Stark white highlights draw the viewer's gaze from the Klansmen's robes, to the woman's upturned eyes, to the sheet that covers the lower half of her body, the noose hanging from the tree, the chest of the dog, the tree itself, and back around to the burning house and the trees behind the Klansmen. These white highlights are everywhere countered by rich browns—the torso and legs of the woman's body, the back of the dog, the bottom of the lynching tree, and the earth in the center of the canvas. Most strikingly, the white central tree in the group of trees behind the Klansmen is flanked—one might even say overpowered—by two brown trees. While the foreground figure may comment ironically on Western artistic traditions—the reclining nude in the landscape, the partially draped classical figure that often symbolizes abstract notions like peace and justice—the woman is, above all, dead, a victim of white vigilante mob violence. Her crime (besides being black) may only have been to have achieved some degree of financial success—we assume it is her home that is burning in the background—in a racist South.[55]

A final example of the numerous images of lynchings that appeared in the 1930s is Boris Gorelick's *Strange Fruit* (1939). Gorelick chose to present his condemnation of

Joe Jones
AMERICAN JUSTICE, 1933
(WHITE JUSTICE)
Oil on canvas, 30 x 36 in

lynching in a surreal, dreamlike—or, one could say, nightmarish—manner. The title of Gorelick's work comes from a poem written by Abel Meeropol (a k a Lewis Allen) in 1936, which was turned into a song first performed by Billie Holiday. The first verse reads:

> Southern trees bear a strange fruit, blood on the leaves and blood at the root, Black body swinging in the Southern breeze, Strange fruit hanging from the poplar trees.[56]

The origin of the print was not, however, the text of this song. It was, instead, a newspaper story of a lynching Gorelick came across in the 1930s. In a letter he says:

> I tried to incorporate and juxtapose all of the known facts of the event as reported. However, I meant it to be more than "Graphic Reportage." It was a personal statement of outrage and protest. The story shown is of a young Negro, in the dark of night in Mississippi, snatched from his bed and family by the local sheriff and his posse, and dragged to the jail-house where the keys are thrown to a waiting mob of klansmen who lynch him by hanging him from the nearest tree. His body is later found by his wife and buried by his family and friends. It is a cry from the grave.[57]

Through distortions of scale, macabre shadows, and exaggerated gestures, Gorelick achieves his "personal statement of outrage and protest." The body of the lynched man in the center of the composition is both present and absent: it dissolves into dust before our eyes, the dust falling into a waiting coffin; it casts two shadows, one to the left and one below on the ground. The right side of the composition is filled with grotesque hooded figures and threatening trees. On the left the lynched man's family and friends lay him to rest. In the center of the image are the keys, symbolic of the betrayal of justice that lynching embodies.[58] The print is a compendium of the iconography of lynching that appeared with such frequency in the works of artists, African American and white, during the 1930s.

Strange Fruit Boris Gorelick — 39

THE AESTHETICIZATION OF POLITICS: ART AGAINST FASCISM

The attention of politically active artists also turned to the international arena as hostilities in Europe escalated after Hitler rose to power in 1933. The Spanish Civil War and, later, World War II were recorded by artists of all political persuasions, yet those on the left carried their condemnations of fascism further, implicating capitalism in their critiques and claiming that fascist forces in Europe were aided by political, racial, and religious intolerance in the United States.

Many artists in the United States who devoted their talents to the fight against fascism looked for inspiration to the work of the leftist German artist George Grosz. Grosz was best known for his biting political caricatures of plutocrats, militarists, and industrialists of the newly established Weimar Republic in the years immediately following World War I. In the mid-1920s, however, Grosz's revolutionary zeal was dampened by the failure of the German Communist Party to seize power and its increasing bureaucratization (Grosz is assumed to have quit the Communist Party in 1923).[59] According to historian Beth Irwin Lewis, the tone of his drawings shifted from political polemic to a more generalized social criticism. "Delineations of the new, prosperous, and sedate businessman supplanted the earlier caricatures of profiteer and capitalist."[60]

One of these prosperous businessmen appears in Grosz's *The Butcher Shop* (1928). The butcher offers the female shopper prime cuts of human bodies. The female torso hanging between the butcher and the shopper is reminiscent of Grosz's earlier "lustmord" or "sex murder" scenes, an example of which is *The Woman Slayer* (1918). The horrific nature of murder and bodily mutilation is downplayed, however, in *The Butcher Shop*. In place of the grimacing, bloodstained, knife-wielding murderer of the 1918 painting is the attentive knife-wielding butcher awaiting the directions of his female customer. Murder becomes not the deranged act of a depraved individual in a violent society but a calculated act of commerce. Now evil and suffering are not simply the result of a corrupt ruling class but of a whole society concerned solely with material gain. Here it is not the German elite alone who are the culprits, but also small businessmen and the servants of this elite who come under the spell of a National Socialist Party claiming to represent the interests of German workers.

The regional electoral victories of the National Socialist Party in the late 1920s did not bode well for revolutionary and avant garde art. Persecution of leftist and modernist art and artists, Grosz among them, escalated as the Nazis came to power in 1933, and culminated in the government-organized exhibition "Entartete Kunst" ("Degenerate Art") of 1937. Hitler and his cultural ministers denounced modernist art as repugnant, barbarous, uncontrolled, and degenerate. In other words, it was the very opposite of the ordered, classicizing, and easily readable art of the National Socialist Third Reich.[61] On

Boris Gorelick
STRANGE FRUIT, 1939
Lithograph, 10 3/8 x 13 7/8 in

George Grosz
THE BUTCHER SHOP, 1928
(FLEISCHLADEN/ DER MENSCHLADEN)
Pen and ink, brush and watercolor on paper, 23 x 18 in

January 12, 1933, eighteen days before Hitler became chancellor, Grosz left Germany with his wife for the United States. After they arrived, he largely abandoned the biting political works of his earlier German years.[62] These works, however, continued to inspire political artists in the United States throughout the 1930s and 1940s.

One such artist, Stuyvesant Van Veen, echoes Grosz's graphic depictions of the carnage of war and of the hypocrisy of the ruling political and military elites in *Peace Conference* (1932), a reference to the post World War I conference at Versailles in 1919. Rising from the arc formed by the assembly of politicians at the bottom of the composition are ranks of soldiers, some grotesque in their expressions, others with skull-like heads, still others torn apart on the battlefield. Rivers of blood flow downward into the political assembly hall. In the upper left hangs the sign "My Hero;" in the lower left the words "War to End War" emerge out of the cartridge belt feeding the machine gun operated by the grimacing soldier. This gun directs our

Stuyvesant Van Veen
PEACE CONFERENCE, 1932
Ink and watercolor on paper, 19 x 29 in

Werner Drewes
DISTORTED SWASTIKA, 1934
Linocut, 6 x 10 1/4 in

attention to the large cannon in the center of the composition, upon which a Christ-like figure has been crucified (the gun to the left carries a similar figure).[63]

Another artist who left Germany and emigrated to the United States was Werner Drewes. Drewes studied at the Bauhaus in the 1920s and developed an interest in abstract design. Troubled by the political climate, Drewes left Germany in 1930 with his wife and two sons for the United States.[64] He settled in New York City and became one of the early members of the American Abstract Artists group. A printmaker by profession, he created a portfolio of woodcuts in 1934 entitled *It Can't Happen Here*. One of the woodcuts, which also appeared on the cover of the portfolio, was *Distorted Swastika* (1934). With this portfolio Drewes wanted, in his own words, "to convey my feeling of the joy of being free to express myself as I wanted, in contrast to my fellow artists left behind in Germany. That it couldn't happen here that we have a dictatorship. At that time at least we felt free."[65] Certainly Drewes would not have been able to produce this twisted, toppled version of the Nazi Party symbol in Germany without suffering dire consequences.

Walter Quirt, also interested in abstract images, was not as convinced as Drewes that the United States was

56

immune to the threat of dictatorship. An active member of the CPUSA and its New York City John Reed Club, Quirt took part in many discussions about how artists could serve the interests of the working class. In keeping with Soviet cultural policy of the early 1930s, most club members favored easily recognizable narrative imagery dealing with the lives and struggles of workers over more abstract or modernist works.[66] Yet Quirt did not adopt such imagery and chose, instead, to paint in a style best described as "social surrealism."[67] While as dreamlike or seemingly irrational as surrealist work, social surrealist paintings included specific references to current political struggles. Despite these references, Quirt's 1933 *The Future Belongs to the Workers* met with resistance from many John Reed Club members as being too ambiguous to function effectively as political propaganda or to be appreciated by workers. His friend and fellow social surrealist James Guy, also a John Reed Club member, met with similar criticisms.

Political developments in the Soviet Union soon altered the cultural policies of the CPUSA. Worried about Adolf Hitler, who had come to power promising to rid the country of communists as well as Jews, Joseph Stalin toned down his anticapitalist rhetoric and, in 1935, called upon Western democracies to band together in a "popular front" to resist the spread of fascism. The John Reed Clubs were replaced by a new cultural organization, the American Artists' Congress (Quirt was one of four hundred artists and critics who signed the call for the founding of the Congress). While its political interests were well-defined—opposition to fascism and support for artists' economic rights—the Congress did not dictate any particular style of art. Professional artists of all styles and media were welcomed into the group and aesthetic differences were downplayed in the interests of political solidarity.[68]

In 1936, the year of the first meeting of the American Artists Congress, Quirt began the painting *Obeisance to Poverty* (1936–38). Within a barren surrealist landscape are located a number of two-dimensional cutout figures whose meanings are, for the most part, unclear. The group of figures on the left, which includes a Jewish man in a yarmulke and prayer shawl (possibly a rabbi), and a bishop or archbishop, pay obeisance to a woman and child in the center of the painting who are seated on a platform projecting from a structure on the right. Behind the woman and child, on the right, are three additional figures, two on the ground who appear to be attendants and one on a high platform who gestures toward the woman and child, as if presenting them to the group. We can assume that the woman and child represent poverty. They are also an undeniable reference to the Christian Madonna and child. Quirt was one of many 1930s artists who chose to use this imagery, which most often symbolized the destitution of American families and their ultimate perseverance (Schrag's *Madonna of the Subway* is one example of this). The stoic mother

Walter Quirt
OBEISANCE TO POVERTY, 1936/38
Oil on gessoed panel, 11 3/4 x 15 1/2 in

and child is particularly prevalent in the photographs taken for the Farm Security Administration.[69]

Yet Quirt does not simply repeat this celebratory portrayal of the staying power of women and their ability to maintain the family through suffering and hard times; he critiques it. The Virgin Mary appears in Western Christian art in many guises, one of which is the Madonna of Humility, who is often seated on the ground to emphasis her allegiance to the humble and the poor. This was the Madonna most often used in New Deal imagery. Yet Quirt does not place his Virgin of poverty on the ground, but has her floating above the crowd, more like an Enthroned Madonna or Queen of Heaven, the Madonna of Humility's opposite. He points out the hypocrisy of elevating the notion of poverty as character-building or a mark of the faithful rather than confronting the effects of poverty on the everyday lives of

Mervin Jules
MODERN MEDICINE MEN, c. 1938
Oil on masonite, 16 $1/2$ x 23 $1/2$ in

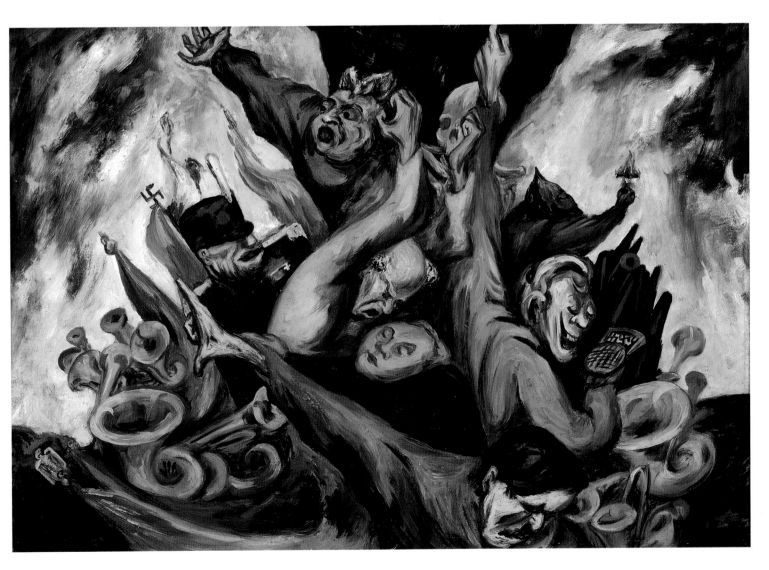

men and women.

Mervin Jules also includes a reference to the misuse of religious figures or principles in his *Modern Medicine Men* (1930s). In the central group of figures appear not only Hitler and Mussolini, but also Father Charles Coughlin and a shrouded Ku Klux Klan member carrying a burning cross. Coughlin is recognizable by the radio microphone he grasps in his left hand. He gained his fame, nationally and internationally, through his weekly radio broadcasts from the Shrine of the Little Flower in Detroit, Michigan, in which he regularly attacked the New Deal, organized labor, communism, and Jews. For Jules, the "medicine" offered by these political and religious leaders was far from life-enhancing; on the contrary, they were writing prescriptions for chaos and death.

Hugo Gellert also connected religion and capitalism through the figure of Father Coughlin. Gellert's lithograph *Pieces of Silver* (1930s) first appeared in his illustrated book *Aesop Said So* (1936) under the title *Father Coughlin and His Flock*. In this book Gellert combined satirical images and text to expose the connections between corrupt politicians, unscrupulous businessmen and hypocritical religious leaders.[70] *Pieces of Silver* shows Coughlin preaching into the microphone. One half of his body is covered with the garments of a priest while the other is clothed in a business suit. The hand of the priest is raised in a gesture of blessing; the hand of the businessman grasps a bag of money. To reinforce this obvious connection between Judas and Coughlin, who both betray Christ for money, Gellert places the crucified Christ on the face of the radio microphone in the center of the composition.

Two additional images of Coughlin can be found in Lynd Ward's wood engraving *Spring Idyll* (1935) and Ben Shahn's watercolor *Father Coughlin* (1939). Ward situates Coughlin in the heavens, pompously gesturing in front of an American flag, while the angel in the center of the composition drops bombs from her right hand and coins from her left. The recipients of the former are the soldiers on the battlefield, of the latter the capitalist industrialists. Ben Shahn's *Father Coughlin*, on the other hand, focuses not on the politics of Coughlin but on his fanaticism, which is conveyed through the distorted facial expression and raised fist (the similarity to Hitler is surely intentional).

Another artist who joined in the debates over the political ramifications of stylistic choices, or even of continuing

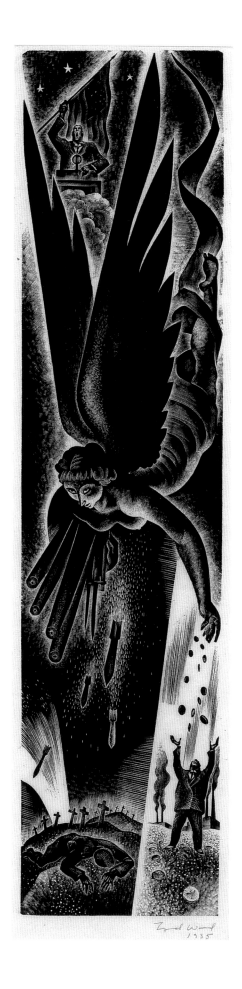

Lynd Ward
SPRING IDYLL, 1935
Wood engraving, 10 3/4 x 2 1/2 in

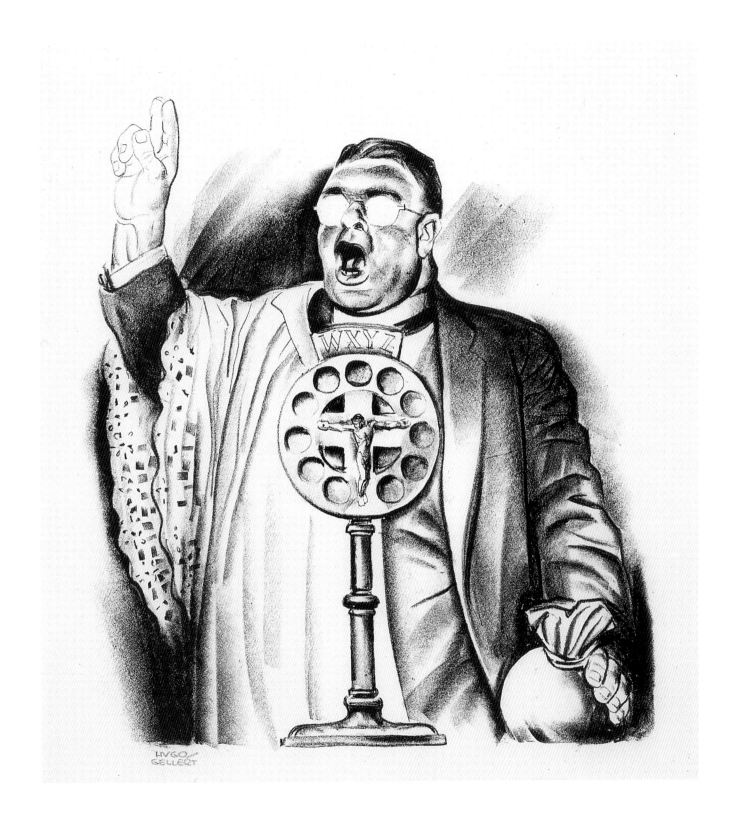

Hugo Gellert
PIECES OF SILVER, 1930s
Lithograph, 12 5/8 x 11 5/8 in

Ben Shahn
FATHER COUGHLIN, 1939
Ink and wash on paper, 15 $\frac{1}{2}$ x 12 in

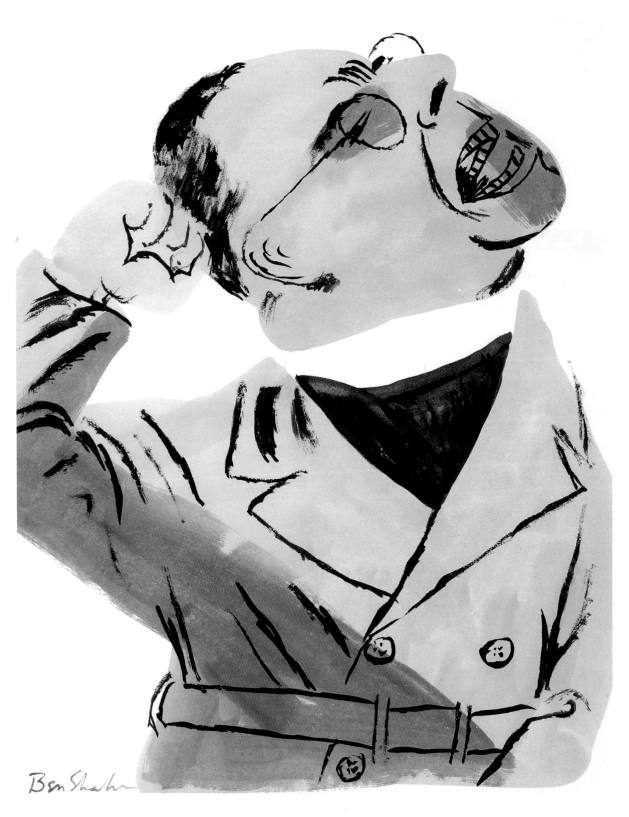

to paint in the midst of political or economic crises, was Joseph LeBoit. LeBoit's etching *Tranquility* (1936) contains a particularly pointed commentary on the situation of the artist during times of war. At an easel sits an artist whose face is completely obliterated by a large gas mask. Two dogs rest calmly close by. Through the window warplanes fly over a devastated landscape. The canvas on the artist's easel contains an abstract image of curvilinear and angular lines radiating out from a dark circle. LeBoit suggests that such abstract images are not enough, that to stay locked in one's studio producing art leads to an artificial and self-deceiving sense of "tranquility," one easily shattered by the approaching conflict outside.

While World War II would not officially start until 1939, another military conflict began the same year LeBoit

Joseph LeBoit
TRANQUILITY, 1936
Etching and aquatint, 14 x 11 in

Bull's eye

(Opposite)

Edward Hagedorn
BULL'S EYE, 1938
Etching, 19 3/4 x 16 in

William Gropper
AIR RAID IN SPAIN, c. 1937
Wash and watercolor on paper, 14 x 20 1/2 in

created his etching—the Spanish Civil War. From 1936 to 1939 the elected Republican government battled the troops of General Francisco Franco, leader of the Nationalist rebels and, from 1937 on, head of the fascist Falange Party. Franco had the military support of both Hitler and Mussolini, while the Republicans received official government support only from the Soviet Union. Other Western European nations and the United States chose to remain neutral. Leftists throughout Europe and the United States, however, organized unofficial support in the form of both supplies and troops, the Abraham Lincoln Brigade being the American contribution in the latter realm.

The American Artists' Congress made support of Republican Spain one of its top priorities and encouraged artists to address this military conflict in their work.

Edward Hagedorn responded with the simple but powerful etching *Bull's Eye* (1938). The single, outstretched figure is an embodiment of the many thousands of lives lost in this struggle. The barbed-wire enclosures in the background replicate graveyard crosses. Hagedorn has created an image of war as an encounter between individuals, not armies, thus emphasizing the personal responsibility of each and every soldier for the deaths by his hand. Another powerful image is William Gropper's watercolor *Air Raid in Spain* (c. 1937), in which Gropper emphasizes the vulnerability of the woman and child, exposed in the middle of an open, barren field to the guns and bombs of the planes above. In their hurry to escape, the woman and child trip as the woman gazes up in anguish at the approaching planes. The Spanish Civil War was the first time military aircraft

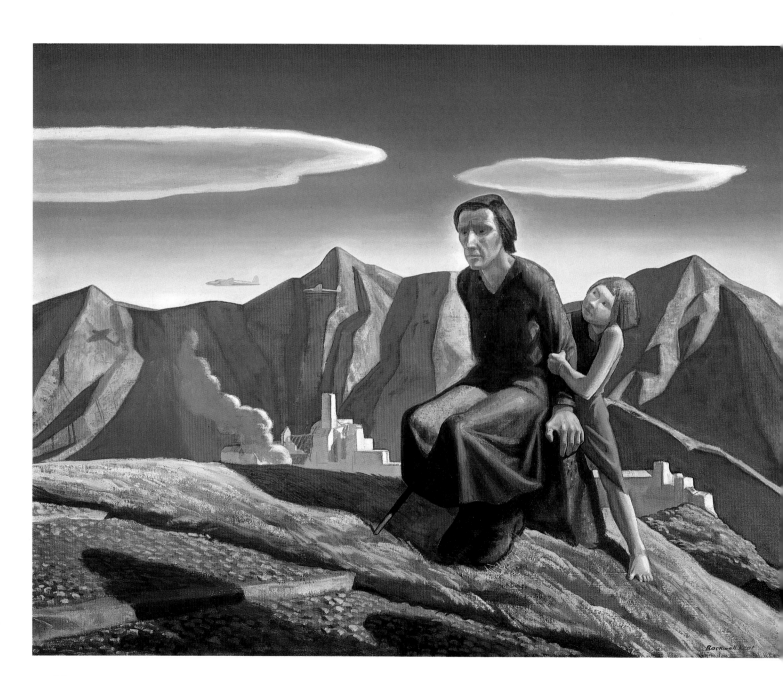

Federico Castellon
SPANISH LANDSCAPE, 1938
Lithograph, 9 1/4 x 14 1/2 in

engaged in massive bombing attacks on civilian targets.

Rockwell Kent employed a setting and figural grouping similar to Gropper's in his painting *Bombs Away* (1942). While painted in 1942, the barren, mountainous landscape and planes flying low over a bombed-out town is a clear reference to Guernica, the northern Spanish town attacked by German warplanes in 1937 and memorialized that same year in Pablo Picasso's powerful painting *Guernica*. The clear, harsh light and sharply defined shadows create a static, almost surreal, atmosphere—one reinforced by the statuesque form of the seated female figure. Kent conveys the extent of the woman's loss not by the display of dead or maimed bodies, but in her dazed expression and immobility. That the danger has not yet passed is clear in the concerned expression on the child's face as she grabs the woman's arm and attempts to rouse her from her state of shock. The shadows on the road could signal the approach of either friends or enemies. An ardent socialist and mem-

ber of the American Artists' Congress, Kent was particularly committed to the Spanish Republican cause, executing poster designs, donating money, and giving speeches in support of the Republic.[71]

Federico Castellon also draws on surrealist iconography to convey his response to the destruction and human suffering that took place during the Spanish Civil War in his lithograph *Spanish Landscape* (1938). Castellon was born in Altamira, Spain, and came to the United States in 1921. Largely a self-taught artist, he was awarded a traveling fellowship by the new Republican government of Spain in 1934, which allowed him to travel throughout Europe from 1934 to 1936. In *Spanish Landscape*, it is the land rather than the people or houses that conveys the devastation of war. The cracked, broken rocks and soil, and gnarled, barren tree contrast sharply with the clean, geometric forms of the buildings. The two female figures do not run from danger; one moves slowly down a worn

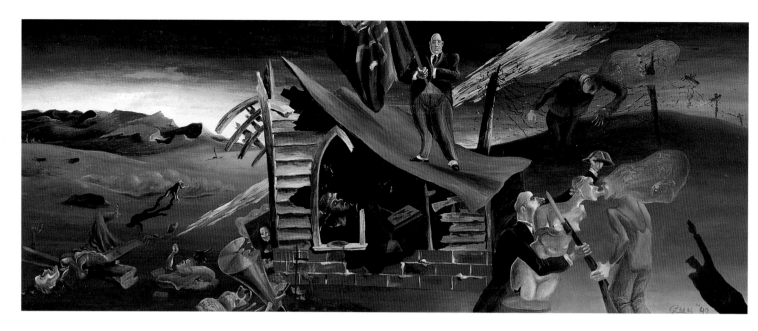

James Guy
BLACK FLAG, c. 1940
Oil on masonite, 10 x 26 in

path while the other leans against a rough wall. The land symbolizes the nation itself, shattered by a civil war whose effects would live on long after the fighting ended.[72]

With the outbreak of World War II, many other artists joined Hagedorn, Kent, and Castellon in condemning the military aggression of Hitler, Mussolini, and Hirohito. James Guy, like fellow social surrealist Walter Quirt, believed that "only surrealism, with its unsettling and often bizarre imagery, was forceful enough to shock the complacent viewer into a greater awareness of the need for change."[73] Having created biting indictments of unfair labor practices and the oppressive working and living conditions suffered by exploited workers, Guy turned his attention in the late 1930s and early 1940s to the wars raging overseas. In *The Black Flag* (c. 1940), he created a nightmarish landscape presided over by a diplomat holding aloft a black flag on which is painted a death's head and a Nazi swastika. Below him to the right another member of the German ruling elite offers a soldier a neoclassical statue of a woman, legs and arms missing, which the soldier kisses. According to Ilene Fort, Guy used this kissing motif a number of times—Hitler kissing a blonde woman in *Carnivorous Landscape* (c. 1938), Mussolini embracing a woman who represents Spain in *Harvest of Fascism* (1937)— and always with negative connotations. In *The Black Flag*, "the kiss is a political ploy to hide the true intent of the diplomat, who speaks of peace and friendship but actually intends destruction."[74] In this instance, the soldier's head literally explodes as a result of his amorous action.

Yet the particular iconography of this kiss scene is also suggestive of the carefully crafted cultural policy of the National Socialists. From the very beginning of his politi-

cal reign, Hitler was aware of the power of art in all of its manifestations—architecture, painting, photography, film, music, and pageantry. An aspiring artist himself, he used every aesthetic means at his disposal to project his own image of the Third Reich, of the greatness and superiority of German culture. All of his major military and civil projects were justified in terms of their aesthetic or cultural significance. In 1936 at a rally in Nuremburg, Hitler stated: "Art is the only truly enduring investment of human labor." Architects built, painters painted, workers labored, and soldiers fought in the name of German culture.[75]

Hitler's aestheticization of politics helps explain why he was so set on destroying modernist art in Germany. The art of the Third Reich was to be based on the classical past, on Greek and Roman architecture and sculpture. It was to be solemn, narrative, and idealistic. It was to celebrate the "Aryan race" in all its perfection. Modernist art—and Guy's painting was certainly a good example of such art—was anathema to the Nazi aesthetic. Guy's legless and armless neoclassical statue with the blonde hair of the Aryan woman thus literally embodies Hitler's spurious aesthetic program. She is not a real woman but an image of a woman, manipulated by men. Framed between the Nazi flag and the shadow of a soldier engaged in a Nazi salute, she is the German cultural greatness for which the soldier is about to fight, a greatness attained through the destruction of the cultures and knowledge of both the present and the past. As Fort writes, "the bombed church supports the diplomat of peace who waves a flag of death, while the remains of civilization—books, masterpiece paintings—lie in rubble nearby. . . . All of tradition, culture, and refinement are destroyed as the real world takes on the surreal dimension of a battlefield."[76]

The group of people who suffered most from Hitler's domestic persecutions were German and eastern European Jews. Even before he enacted his "final solution" after the outbreak of World War II—the extermination of Jews in all countries conquered by his armies—Hitler had systematically stripped German Jews of their property and civil and political rights. Those who could, fled to other countries. The tragic, gaunt figure in William Gropper's *De Profundis* (1942) symbolizes these displaced Jews, who prayed for deliverance from pain and suffering. The Hebrew inscription in the lower left corner reads: "Out of the depths above, I called thee O Lord (Psalm 130:1)." But those who managed to escape were not always guaranteed safe haven. In 1938, a conference of thirty-two nations was held in France to deal with what was termed "the refugee crisis." While President Roosevelt was instrumental in organizing this conference, his position was that "no country would be expected or asked to receive a greater number of emigrants than is permitted by existing legislation."[77] When Nazi assaults on Jews escalated at the end of 1938, United States immigration laws, and those of most other coun-

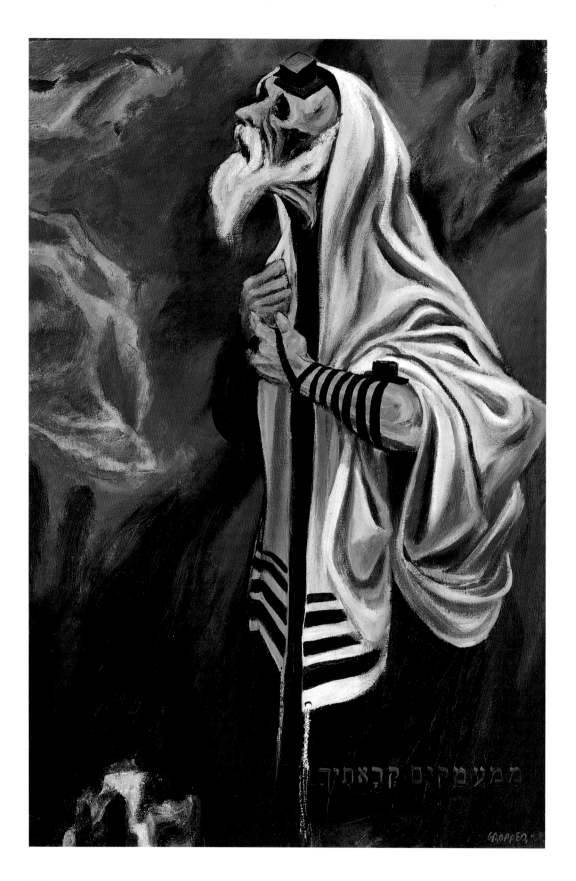

מִמַּעֲמַקִּים קְרָאתִיךָ

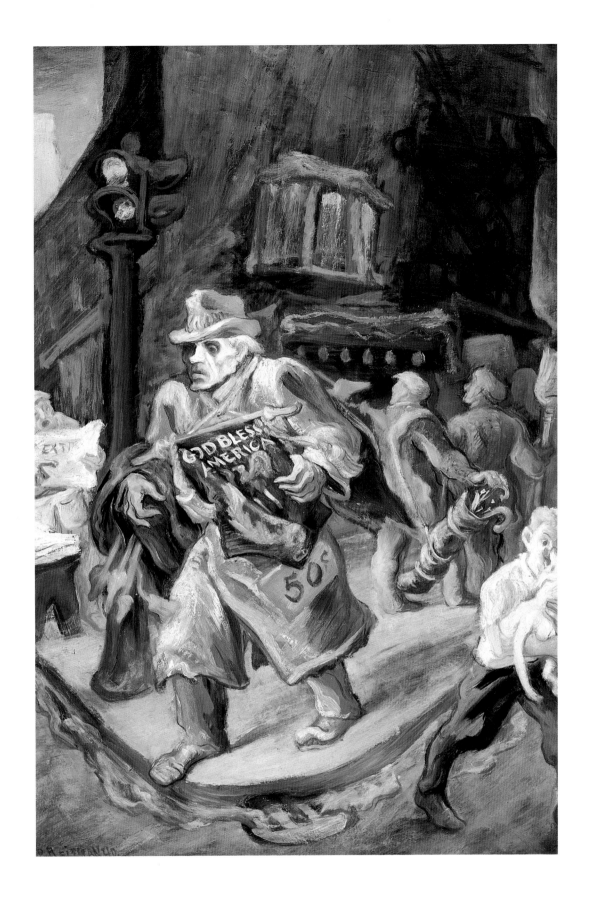

Philip Reisman
GOD BLESS AMERICA, 1940
Oil on masonite, 25 1/$_2$ x 17 1/$_2$ in

tries, remained tightly enforced.

Philip Reisman would have been particularly alert to the plight of Jewish refugees. He and his family had immigrated to the United States from Poland in the first decade of the century to escape the increasingly violent persecution of Jews in eastern Europe. In his painting *God Bless America* (1940), a gnarled, ghostlike figure traverses the streets of a city peddling the trappings of patriotism at a discount: a banner declaring "God Bless America" and emblazoned with the American eagle sells for only fifty cents. In his zeal to carry out his mission, he is about to ignore the red traffic light. Patriotism, bolstered by religious faith, is blind to the everyday laws of social order.

Osvaldo Luigi Guglielmi, known as O. Louis Guglielmi, provides another image of the streets of America at the onset of World War II in his painting *Morning on the East Side* (1939). Guglielmi was particularly concerned with the plight of impoverished city dwellers, a concern related to his own upbringing in a poor Italian section of New York City. In 1944 Guglielmi wrote:

> I like to evoke the feel of a street, the unseen life hidden by blank walls, its bustle, and noise, the mystery of a deserted alley. My people may be occasional figures in a landscape or at times they are symbols of beings struggling in a flight of freedom from a world they helplessly had a part in creating.[78]

Like Quirt and Guy, Guglielmi was a social surrealist. Yet his social commentary is much more understated. In *Morning on the East Side*, every element in the painting is clearly recognizable and carefully recorded; it is simply the quality of the light, the isolation of the figures, that suggests the "unreal" or "surreal." While this painting is less explicit in its political commentary than some of Guglielmi's earlier work—e.g., *The Hungry* (1938) and *One Third of a Nation (Tenement)* (1938)—it conveys a distinct mood of unease; the figures of the old man and woman, while in motion, seem static, almost frozen in time. The light is bright, yet the figures cast no shadows. There is a sense of impending doom, that something is about to descend upon them, engulfing them in "a world they helplessly had a part in creating."

The entry of the United States into World War II after Japan's bombing of Pearl Harbor resulted in the transformation of existing federal art programs and the founding of new artists' organizations. The military began commissioning some artists to prepare camouflage, design recruiting posters, and document what the war looked like. Artists not employed by the government formed the National Art Council for Defense, and Artists Societies for Defense. In January 1942, when the federal government urged that there be only one organization to coordinate the war efforts of artists, the two groups merged to form Artists for Victory.[79] Its main function was "to act as a liaison between individuals and the federal, state, and local government agencies (as well as private industries and businesses) need-

O. Louis Guglielmi
MORNING ON THE EAST SIDE, 1939
Oil on canvas, 20 x 16 in

ing artistic jobs done for war purposes."[80] It also organized art exhibitions, one of its most ambitious being the 1943 print exhibition "America in the War." Artists selected for the exhibition provided 26 copies of their work, and on October 20, 1943, "America in the War," an exhibition comprising 100 prints, opened simultaneously in 26 museums across the nation.[81]

One of the prints in "America in the War" was Harry Sternberg's *Fascism* (1942). Sternberg was an active member of the American Artists' Congress and the son of poor Jewish immigrant parents, so it is no surprise that his print contains such a biting indictment of fascism. A three-headed figure (Mussolini, Hitler, and Hirohito) wreaks havoc across the land, trampling on the symbols of Judaism and Christianity, as well as on the instruments of science and the arts. Rats scurry about the figure's feet and corpses litter the landscape. The colors work to heighten the horror of the scene: the sky is blood red, the skin of the monster sickly green, and the corpses a decaying yellow or cold blue. The power of Sternberg's print was recognized by the judges for "America in the War," who awarded it an honorable mention in the serigraphy division. Members of Artists for Victory continued to create such testaments to the horrors of military conflicts until Germany and Japan finally surrendered in 1945. Soon, however, they were faced with a different kind of war to document.

Harry Sternberg
FASCISM, 1942
Screenprint, 15 1/4 x 20 1/2 in

NO MORE MONEY FOR MODERN ART: ART IN A COLD WAR ERA

Not until the end of World War II did the full extent of the material devastation and physical suffering of this global conflict become known to the American public. Many artists had personally experienced this devastation during the war as soldiers or war correspondents. Joseph Hirsch was one such artist, having served as a wartime artist-correspondent from 1943 to 1944. During his travels in the South Pacific, Italy, and North Africa, Hirsch recorded the appearance of war, yet in his paintings he moved away from detailed reportage toward more symbolic statements. In *The Survivor* (1945), Hirsch divides the small canvas into two parts: on the right is the head of a figure almost completely covered by a shawl or blanket; on the left are two pairs of joined hands, one belonging to the figure, the other to a person whose body is cut off by the left edge of the canvas. Hirsch refuses to identify the survivor or the

Joseph Hirsch
THE SURVIVOR, 1945
Oil on canvas, 10 x 16 in

rescuer. The paint is roughly applied, the background an indeterminate and mottled grey-green. This could be the South Pacific, Italy, or North Africa. At first glance the figure appears to be clasping the other pair of hands in gratitude. Upon closer examination it seems that the event taking place is the lighting of a cigarette. Though a seemingly mundane action, the sharing of cigarettes during war-time came to symbolize a particular form of camaraderie that developed among soldiers and between soldiers and civilians. Hirsch has also made the left pair of hands a dark brown. He may have intended this as a reference to African Americans in the United States armed forces during World War II (although still in segregated units), or a more general reference to the crossing of racial boundaries that occurred in the fight against fascism.

Another artist who turned his attention to recording the aftermath of World War II was Henry Koerner. Koerner grew up in Vienna during the 1920s and 1930s, fled after Hitler invaded Austria in 1938, and reached New York in 1939. He became an American citizen in 1943 and in 1944 was sent by the Office of Strategic Services (OSS) first to England and then, at the end of the war, to Germany, where he executed pen and ink drawings of war criminals at the 1945 Nuremberg Trials. Koerner later commented that this was "the phenomenon of a preordained situation— that I should meet the murderers of millions of Jews and my parents."[82] He had not heard from his parents since 1940 and finally confirmed their fate during a 1946 trip to Vienna: they had died in one of Hitler's concentration camps.

While in Europe, Koerner painted works in a meticulous, surreal style reminiscent of Hieronymus Bosch and Pieter Bruegel the Elder, a style also similar to the social surrealism of Guglielmi, Quirt, and Guy. Of his two years in Germany from 1945 to 1947 Koerner wrote: "Reality had turned into surreality . . . 'normal life' into existentialism."[83] A group of his paintings were exhibited first in 1947 in Berlin and then, the following year, at Midtown Galleries in New York. *Life* magazine described the latter exhibition as the "best paintings to date that have come out of the aftermath of the war."[84]

Women Crossing Bridge (1946) is one of Koerner's postwar paintings. It describes the seemingly insurmountable task of rebuilding the heavily bombed cities of Europe. As the men sift through piles of bricks in an underground passage, two women work together to pull a cart, most certainly containing scavenged goods, across the bridge. That the street is almost totally devoid of rubble is testimony to the progress that has already been made. When shown in Berlin, this painting undoubtedly aroused thoughts of the city's own complicated postwar reconstruction. After the Potsdam Conference in the fall of 1945 (Potsdam was a Berlin suburb), Berlin was divided into four zones governed by French, English, U.S., and Soviet

Henry Koerner
WOMEN CROSSING BRIDGE, 1946
Gouache on wood panel, 17 x 20 in

Anton Refregier
POLITICIANS AT WORK, c. 1946
Oil on canvas, 26 x 32 in

Rockwell Kent
HEAVY HEAVY HANGS OVER THY HEAD, 1946
Lithograph, 9 x 12 in

armies of occupation. The wartime cooperation of the Allied governments soon dissolved, however, and in 1948–49 the Soviets blockaded the French, English, and U.S. sectors of the city, known collectively as West Berlin (Berlin itself was located in the Soviet zone). The Western powers kept West Berlin alive through a massive airlift of essential goods.[85]

Such postwar Allied negotiations are the subject of Anton Refregier's painting *Politicians at Work* (c. 1946). Four figures in black suits sit or stand before a table covered with papers. Behind them rise the barbed wire, corpse-filled gas ovens, and gallows of the Nazi concentration camps. This scene is probably a commentary on the United Nations Conference on International Organization (UNCIO) held on April 25, 1945, in San Francisco, where the official U.N. charter was drawn up.[86] Hopes ran high that the U.N., unlike its predecessor the League of Nations, would succeed in its peacekeeping endeavors. Yet these hopes were dampened by the increasing hostilities between the Soviet Bloc countries on the one hand and the United States and its European allies on the other, hostilities that erupted into a full-scale Cold War. Now the battle was not between fascism and democracy, but between communism and democracy. The fact that the barbed wire in Refregier's

Politicians at Work cuts across the face of the standing figure suggests that these politicians are unable (or unwilling) to untangle themselves from the economic and political legacies of global military conflicts.[87]

Artists in the United States soon felt the effects of the Cold War. In April 1947, Secretary of State George C. Marshall announced the cancellation of "Advancing American Art," a travelling exhibition of contemporary art put together the previous year by the State Department. Conservative politicians and artist organizations had attacked the exhibition as "communistic" for its inclusion of "modern" art and politically suspect artists. Modern art—a term that would apply to most of the images in this book—was "incomprehensible, ugly and absurd," and thus a threat to the moral and aesthetic integrity of American culture. The administration of President Harry S Truman, extremely sensitive to accusations of communist infiltration within its ranks, was quick to react. On May 6, 1947, Secretary of State Marshall announced that there would be "no more taxpayers' money for modern art."[88]

Rockwell Kent's lithograph *Heavy Heavy Hangs Over Thy Head* (1946) is an apt commentary on the growing tensions of the Cold War era. The threat of another world war loomed large in the minds of many. The rat is about to

HEAVY HEAVY HANGS OVER THY HEAD

"APOCALIPTIC REVELATION" MARINKO 47

disrupt the peaceful sleep of the innocent child by gnaw-
ing through the strap of the gun hanging over the bed. In
the distance is a rocky landscape and a small village similar
to those found in the background of Kent's 1942 painting
Bombs Away. Kent based this print, in fact, on an earlier
painting of the same name produced during World War II.
That Kent considered an image conceived in wartime
appropriate for peacetime suggests the tenuous nature of
this peace.[89]

The art world of the late 1940s and early 1950s was
filled with many other images that referred, often obliquely,
to the political turmoil and sense of dread that had taken
over the nation. In George Marinko's drawing *Apocalyptic
Revelation* (1947), gesturing figures rise up out of (or sink
down into) dark holes in a stage; above hang large, fore-
boding masks, which peer down at the faceless figures
trapped below. One of the figures wears a halo, yet seems

as unable to extricate himself from his dark hole as the
others. The theme of entrapment also appears in Eugene
Savage's painting *The Fisherman* (1948). A group of mus-
cular fishermen have succeeded in trapping in their net a
beautiful woman. As they strain to pull the boat on shore,
two children watch with glee, while a black man, eyes
wide open, peers at the woman over the back edge of the
boat. Does the female figure represent Europe, caught in
the clutches of fascist dictators? This subject would cer-
tainly have been on Savage's mind in 1948, as he prepared
to execute a mosaic mural at the American Military
Cemetery in Epinal, France. Or does this woman represent
culture or truth or beauty, sacrificed to the material and
political interests of politicians during the Cold War? Both
readings would have been possible in 1948.

Another artist who both painted the injustices being
perpetrated by Cold Warriors and expressed his concerns

(Opposite)

George Marinko
APOCALYPTIC REVELATION, 1947
Graphite on paper, 7 3/4 x 9 3/8 in

Eugene Savage
THE FISHERMAN, 1948
Oil on canvas, 26 1/4 x 30 3/4 in

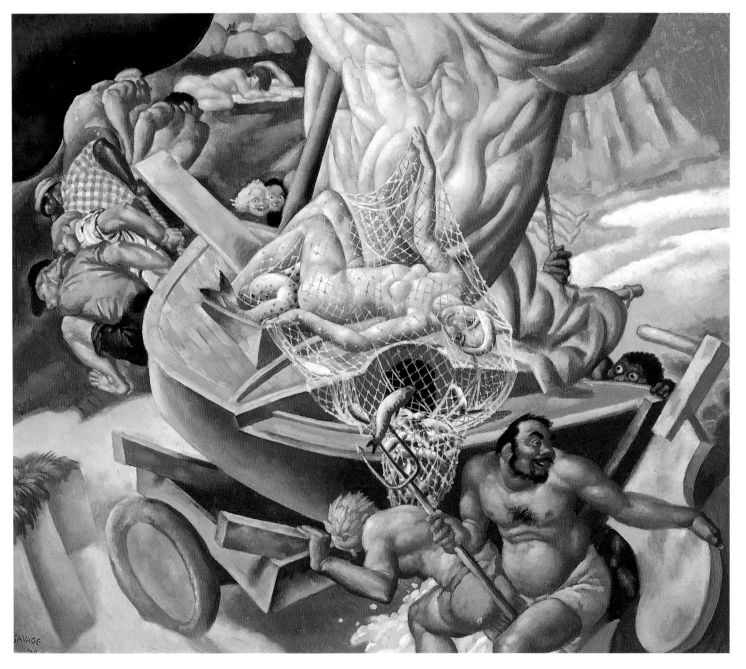

in lectures and articles was Ben Shahn. Shahn had established a reputation for himself during the 1930s and 1940s as a painter, muralist, and photographer—a reputation solidified in 1947 when a retrospective of his work opened at the Museum of Modern Art in New York City. At the same time as Shahn rose to prominence in the New York art world, however, so did abstract expressionism, or—as he preferred to call it—"nonobjective art." As indicated in the introduction to this essay, Shahn felt that nonobjective art's popularity was the result of the oppressive political climate of the late 1940s. As works of art condemning political injustices were criticized as subversive and un-American, more and more artists retreated from political activity into their studios and an art of complete abstraction. Shahn, throughout the late 1940s and 1950s, pointedly condemned this move and called on artists to maintain their political involvement and their commitment to an art "greatly concerned with the implications of man's way of life."[90]

Anticommunism during the Cold War reached a hysterical pitch after Senator Joseph McCarthy was firmly ensconced in 1953 as chair of the Senate Committee on Government Operations and its Permanent Subcommittee on Investigations. The titles of three of Shahn's works painted in that fateful year attest to his perception of the state of the nation: *Age of Anxiety* (1953), *Anger* (1953), and *Discord* (1953). In *Discord*, two men are engaged in hand-to-hand combat; the figure in the foreground, dressed in red, appears to be losing. The image was derived from a drawing Shahn had executed the year before for an article in *Harper's* magazine on corruption on the New York waterfront, but here his placement of the figures in an indeterminate setting allows the viewer to read the work as a commentary on discord in general in 1953. The red clothing, however, marks this painting as a direct commentary on the Red Scare, for Shahn had been publicly accused in 1948 of communist sympathies for using so much red in his painting *Allegory* (1948). The figure in red may also allude to the Korean War, which began in June 1950 and ended in July 1953. This was the first major military engagement of the Cold War era in which the Soviet Union and the United States were openly involved. Both sides possessed atomic weapons, but neither used them.

In 1956 Shahn created a work that contains an explicit commentary on this re-emergence of military actions. Shahn described his watercolor *Goyescas* (1956) as follows:

> I painted a creature that may be interpreted as military or militantly religious, or conservative because of the

Ben Shahn
DISCORD, 1953
Watercolor on paper, 38 3/8 x 25 3/8 in

old-fashioned hat he's wearing of a century ago, the admiral's hat. His costume is noncommittal, it could be of any country, of any religion. Curiously enough, he has four hands, a kind of symbolism I don't often engage in. His hands are clasped in an agony of distress over a group of heads that might be dead or dying, in great, overwhelming pity for them—and then another set of hands that rise out of those hands, which seem not to care at all what the other set of hands are doing, engaged in playing this child's game of cat's cradle, a game that is as far removed from reality as one can imagine.[91]

Thus Shahn, like Goya, reveals the hypocrisy of politicians, military leaders, and clerics who make public gestures of concern and solicitude while privately ignoring the human casualties of their callous and inhumane actions. Shahn may also be saying that no matter how hard they may try to remain disengaged, such public figures will ultimately be affected by, and called to account for, their pronouncements and actions. One part of them, one set of hands, will always remain immersed in the blood and tears of the dying and dead.

Jack Levine's *Oak Street* (1959) also contains a commentary on the casualties of war, although a much

Ben Shahn
STUDY FOR GOYESCAS, 1956
Brush, ink, and watercolor on paper, 25 $^1/_2$ x 30 in

Jack Levine
OAK STREET, 1959
Oil on canvas, 40 x 35 in

more indirect one. Levine wrote of this painting:

> In *Oak Street*, there's a lanky, raw-boned figure of a derelict next to the window of a pawnshop. I hadn't used this sort of elongation for some time. I was inspired to paint this figure by a character in [Bertold] Brecht's *Threepenny Novel*, Fewkoombey, who is a veteran of the Boer War and is now a tattered beggar practically incapable of speech. I called it *Oak Street* perhaps because Old Oak Street was the location of Peachum's headquarters in the novel.[92]

The gaunt figure gazing at the accordion displayed in the pawnshop window thus represents the fate of so many war veterans who, when they found that there were no jobs for them upon their return from the front, sunk into a life of poverty. Levine's limited palette of browns and greens and his loose application of paint imbue the figure with an earthy, yet transient, quality. He is of the same texture and color as his surrounding architectural environment, and appears almost invisible, as if about to dissolve into the storefront.

Alton Pickens also generates a sense of transience and disquietude in his painting *The Puppeteers* (1954). Two giant figures, who appear to be female, hover over two small naked male figures who are at the bottom of a large cylinder-like container. One is down on all fours while the other rides on his back. The torso of the figure on his knees has been stretched to an unnatural length. The giant figures hold crucifix-shaped objects in their left hands, while their right hands grasp short, thin rectangular objects. While the title suggests these are devices to which puppet strings are attached, no strings are visible. The crosses appear brightly lit and illuminate the upturned, smiling face of the seated figure. The face of the figure on his hands and knees, however, is in shadow and is marked by a wide-mouthed grimace of fear or anger, which may be because the seated figure has one hand clenched around his neck.

The crucifix shapes suggest that Pickens is commenting on how religion manipulates people's lives, creating peace for some and terror for others. Yet Pickens' painting seems to be a broader commentary on a general sense of disquietude felt by so many individuals in the middle of

Alton Pickens
THE PUPPETEERS, 1954
Oil on canvas, 46 x 34 in

the twentieth century. In a 1947 essay entitled "There Are No Artists in Hiroshima," Pickens wrote:

> My painting concerns itself with man and the traumata of his life. . . . I cannot paint reality for what it pretends to be or for what I think it should be. I attempt to capture the warping of truth and fiction into one schismatic reality. The limitations of my skill and perception compel me to select the minutest aspect of this phantasmagoria, often constituting only a strange ritual of manners, real but senseless. Underlying all this is the consciousness that each new hour verifies another intangible—the feeling of imminence and threat that follows our lives and pursues the life of any sentient man.[93]

Pickens' words echo those of contemporary European existentialist writers Jean Paul Sartre and Albert Camus, who focused on the individual's relationship to the universe or to God. For Sartre, there was no God or fixed human nature. Humans were entirely free and thus entirely responsible for their actions, a responsibility that created feelings of dread and anguish. To people confronted with the weight of such a responsibility, of having to make concrete ethical choices every day of one's life, even a wrathful, all-powerful God—or a political demagogue like Joseph McCarthy—might seem to be a welcome alternative.

Jared French's tempera painting *Business* (1959–61) also contains a confrontation between male and female, although in this instance the confrontation takes place in the decidedly material, rather than spiritual, realm. Four precisely rendered figures appear on a balcony, a vast expanse of sea visible behind them. The seated female figure on the left glances up at the standing male figure, dressed in a costume suggestive of the East. Between them, behind a table, sits a naked man. To the far right stands a waiter holding a wine bottle on a tray. While the exacting detail suggests this scene could actually have taken place, the incongruity of the clothing (or lack of it), the blank expressions of the figures, and their stiff poses create a disturbing sense of the unreal or surreal.

The seaside setting of *Business* links it to a particular moment in French's life, the late 1930s and early 1940s, when French, Margaret Hoening (French's wife), and painter Paul Cadmus summered together on Fire Island. The three artists formed a photographic collaborative called PaJaMa, after the first two letters in each of their names. Photographer George Platt Lynes and painter George Tooker also took part in this informal collective. The group took several photographs of figures, naked and draped, positioned in highly artificial poses on the beach. Many of French's subsequent paintings were based on these photographs.[94]

Two additional events occurred in 1939–40 that affected the look and subject matter of French's paintings: the publication of the first English-language edition of C.G. Jung's *Archetypes of the Collective Unconscious* (1939) and

French's shift from oil to tempera. According to painter and writer Nancy Grimes, "the slow, finicky process of tempera painting liberated French's imagination." He turned away from his earlier commitment to a realist vernacular and toward "themes drawn from the art of the past, from myth and from his own life."[95] The writings of Jung certainly played a central role in this turn to myth. French, like his contemporary Jackson Pollock, was drawn to Jung's claim that in each and every human mind there is a collective unconscious, a set of predispositions and understandings of the world inherited through the combined experiences of the entire human race. This collective unconscious was filled with archetypes or archaic symbols. Jung's theory helped explain the recurrence of certain myths and symbols across time and cultures. Throughout the 1940s and 1950s French's figures increasingly assumed the look of archetypes, ideal or symbolic representations of human form rather than specific human individuals. Many were patterned after archaic Greek statues—the kouros and kore figures of the seventh and sixth centuries B.C.—with their distinctive "archaic" smile.

In *Business*, the archetypal is present in the seated naked male figure. The other figures are more individualized, both in facial features and in costume, taking the scene out of the archetypal and setting it much more firmly in the world of the particular. In addition, the naked seated male figure and the exposed posture of the female figure, whose arms seem to be shackled to the back of the chair by her gold bracelets, imbue the scene with a strong sexual undercurrent. This same combination of the archetypal and the particular, as well as an undercurrent of sexuality, is present in an earlier painting of French's that also contains a similar arrangement of figures. In *The Double* (1940), a naked male figure, this time standing in a shallow grave, his hands covering his genitals, is flanked by a woman on the left and two men on the right, all fully clothed.

Before marrying Margaret, French had been lovers with Paul Cadmus. His continued close friendship with Cadmus and other gay artists, as well as his overwhelming focus on the male body in his paintings, suggest that French still had sexual relations with men after his marriage.[96] French certainly could not have been open about such sexual relations, for homosexuals were persecuted at the time and homosexuality was often linked with communism as a subversive, immoral, and un-American activity. Art historian Jonathan Katz has argued that such persecution in the 1950s resulted in the development of coded references to homosexuality in the art of two other gay artists, Robert Rauschenberg and Jasper Johns.[97] French's paintings may also contain such a coded language. The tension and anxiety that mark so many of them may be due as much to French's life as a bisexual man in a Cold War era, as to the archetypal battles between good and evil waged in the collective unconscious.[98]

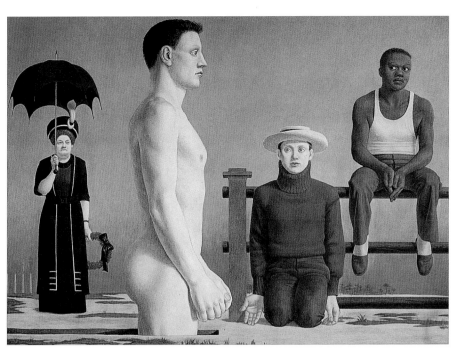

Jared French
THE DOUBLE, c. 1950
Egg tempera on gesso panel, 21³/4 x 30 in
Private collection, Photograph courtesy of
Midtown Payson Gallery

Jared French
BUSINESS, 1959/61
Egg tempera on panel, 30 x 43 in

IMAGES OF THE OTHER: PROSPERITY, POVERTY, AND THE VIETNAM WAR

The title of French's painting suggests that some sort of business transaction is taking place. Perhaps it is an exchange of goods between the turbaned figure, who holds a chain attached to an elaborately painted or carved box, and the woman. Indeed, one cannot help but focus on the richness of the turbaned figure's costume, which lends an air of prosperity to the scene. The 1950s and 1960s have been presented as decades of prosperity, as a time when the dream of owning a home and one if not two cars was becoming a reality for more and more working-class Americans. This prosperity was, in large part, due to the fact that after World War II, European nations relied heavily upon the United States for help in rebuilding their war-torn economies. In turn, there was increasing consumer demand at home, fueled by both real needs and by the enticements of a burgeoning advertising industry.[99]

This prosperity was called into question, however, as early as 1962—the year Michael Harrington published *The Other America: Poverty in the United States.*[100] Harrington pointed out another American reality—40 million individuals living below the poverty level. Government statistics attested to their existence, but the poor had become invisible in a country whose image-makers were maintaining the illusion of prosperity and whose employed were moving into the suburbs, away from the urban centers of poverty. Unlike earlier in the century, when political machines operated out of immigrant or working-class neighborhoods, the poor now had no political clout. Harrington's book helped make these invisible poor visible. President John F. Kennedy was inspired in part by the book to initiate an "unconditional war" on poverty, a war enacted by President Lyndon B. Johnson after the assassination of Kennedy in November 1963.

One artist well aware of the invisibility of the poor in the 1960s was Robert Gwathmey. In an interview with Studs Terkel at the end of the decade, he commented:

> During the Depression, we were all more or less engulfed. Today when people say poverty, they turn their head. They don't want to admit poverty exists. They're living too high, so on-the-fat, right? If you're living on-the-fat and see poverty, you simply say: They're no good. In the Depression, there was a little more Godlike acceptance of the unemployed guy, because you could be he.[101]

Gwathmey was born in Richmond, Virginia, in 1903 and grew up a member of a comfortable, white middle-class family (his mother was a teacher) in a South marked by rigid class and racial segregation. "As a youth I was conscious of harsh inequalities in my community," he recalled, a consciousness heightened by a trip to Baltimore in 1925.

"It was my first trip North. . . When I got back home, I was shocked by the poverty. The most shocking thing was the Negroes, the oppressed segment. If I had never gone back home, perhaps I would never have painted the Negro."[102]

Gwathmey did not begin to paint southern life, particularly the rural communities where African Americans lived and worked, until the late 1930s. His involvement in the Philadelphia Artists Union and the leftist politics of the art world prompted him to make his art more of a commentary on life around him. Though he continued to live in the North (Philadelphia and New York City), he made frequent trips to Virginia. He also met African American artists in New York City in the late 1930s and 1940s, including Jacob Lawrence, William H. Johnson, and Charles White. Impressed by the influence of southern folk art in the work of Lawrence and Johnson, he later adopted a similar use of strongly outlined figures and flat areas of rich color.

According to Charles Piehl, Gwathmey's paintings of the early 1940s were much stronger political commentaries on racism in the South (e.g., attacks on lynching and poll taxes) than the work he produced from the mid-1940s to the early 1960s. Gwathmey was subject to the same pressures as Shahn and Kent and other politically active artists who worked during the Cold War (the FBI kept Gwathmey under surveillance). At a time when the art market was shifting from narrative realism toward complete abstraction, Gwathmey's work became more reflective and less aggressive. "Absent are the gaunt figures of plantation patriarchs juxtaposed to their industrious field laborers," writes Piehl. "If Gwathmey intended a social statement in this art, he manifested it only in a very general, muted manner."[103]

By the early 1960s, however, the political edge returned to many of Gwathmey's paintings. He was deeply affected by the increasingly violent encounters between civil rights workers and southern whites, and by the growing United States involvement in Vietnam. As someone familiar with the long history of racism in the South, he was well-situated to produce visual commentaries on the oppressed conditions and growing resistance of African Americans throughout the United States to racist practices and institutions. Gwathmey engages in such commentary in his painting *Custodian* (1963). Almost two-thirds of the painting is taken up by an intense, oppressive yellow sky. In the center of the lower third of the composition sits an old African American man, his large, gnarled hands suggesting a lifetime of hard physical labor. Now, however, he sits quietly, a rifle propped against one leg. Behind him is a life-size painting of the body of a dancing African American man holding a large slice of watermelon, the kind of painting one might find at a fairground, where one could step up and become, at least for as long as it took to take a photograph, the racist stereotype of the high-stepping, water-

Robert Gwathmey
CUSTODIAN, 1963
Oil on canvas, 46 x 38 in

Joseph Hirsch
SUPPER, 1963/65
Oil on canvas, 66 x 85 in

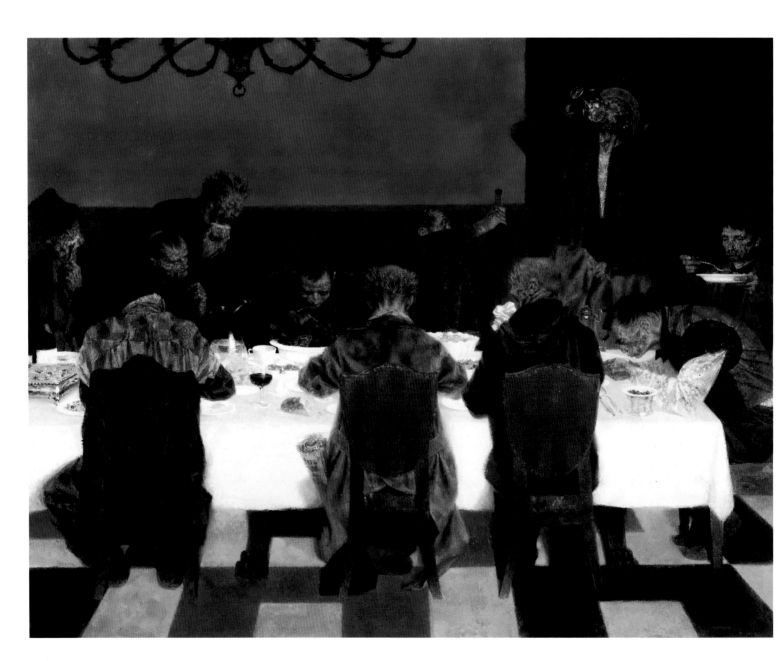

melon-eating "darkie." Yet in place of the head in Gwathmey's painting are a pitchfork and hoe, symbols of southern agricultural life. To the left of this central grouping, in the distance, sits an African American woman in a red and purple print dress; to the right are pieces of abandoned automobiles. The man and woman are going nowhere.

According to Harrington, in spite of technological innovations, farm subsidies, and bigger profits for large corporate farms, the harshest and most bitter poverty in the United States was still to be found in the fields, where many remained to eke out an existence on small family farms. The hardest hit of these areas were located in the South, a part of the country Gwathmey knew well.[104] Harrington also noted that "the Negro poor farmer is not simply impoverished; he is terrorized as well."[105] On isolated farms outside of towns or cities, African American farm families were particularly vulnerable to violence or intimidation by the Ku Klux Klan or other white vigilante groups. Gwathmey's "custodian" confronts this terrorization. He sits under the oppressive southern sky and waits, rifle in hand, custodian of a life of hard labor, poverty, and racist stereotypes. Gwathmey suggests these circumstances have even created divisions among African Americans themselves (the painting separates the man and the woman). The seated man is not, however, the racist stereotype; he acknowledges but does not accept his own humiliation. The solidity of the seated figure counters the one-dimensional weightlessness of the painted stereotype. Here Gwathmey is commenting on his own profession, on the complicity of the visual arts in maintaining racist stereotypes and on their potential to break down these stereotypes with works such as *Custodian*.

While the rural poor starved in fields of plenty, the urban poor went hungry in the concrete jungles of America's inner cities. Many of these urban poor were elderly. Joseph Hirsch provides us with a poignant commentary on the state of the elderly poor in the United States in his painting *Supper* (1963/65), produced at the same time President Johnson officially inaugurated his war on poverty. The allusions to the biblical Last Supper are clear. Twelve old men in tattered clothing sit at a long table covered with a white cloth and laden with food the men seem unaccustomed to: casseroles, dishes of fruit, goblets of wine. Most are busy eating, while one holds an open book, possibly a Bible, and another offers a bottle of wine to the standing man on the right, who is in the process of draining his glass of the last drop. The stark white table cloth throws into sharp relief the dark clothing and wrinkled faces of the men.

Soup kitchens were a common occurrence in cities across the country, providing some of the only nutritional meals available to the elderly. Yet no soup kitchen would have prepared such a meal for its customers. The incongruity of the setting highlights the plight of these men.

The intensity with which they eat their food and the quiet pleasure they seem to take in each other's company suggest how little effort it would take to improve the lives of the elderly poor. Yet the lavish setting also highlights the limits of individual instances of Christian charity. These men need more than an occasional Christmas dinner. They need a society as a whole that operates on the model of true Christian charity, that always cares about the health and dignity of its aged.

Hirsch's painting may also include a reference to another social movement that ran parallel to, and was inextricably bound up with, the war on poverty: the civil rights movement of the 1960s. The dark brown coloring of the faces of a number of the men may be due to the accumulation of dirt and grime from days and nights spent on city streets. Yet it may also indicate that the men at this table are both white and African American. In 1963, the year Hirsch began his painting, the Justice Department reported that 300 cities had desegregated their lunch counters. After the first sit-in by African American students at a Woolworth's lunch counter in 1961, hundreds of whites and African Americans descended on southern cities, risking physical violence and arrest to sit side by side in public restaurants, just as Hirsch's old men are doing in *Supper*.

George Tooker's *Lunch* (1964) is an even more direct reference to these lunch counter sit-ins. In the midst of a crowd of fair-haired customers sits an African American man. His eyes are downcast as he consumes a slice of the same white bread being eaten by his lunch counter companions. Unlike Hirsch's old men, the figures in Tooker's painting do not engage in a quiet camaraderie, despite the fact that they are closely packed together. Instead, they are lost in their own worlds. This sense of isolation is not particular to this painting alone: it is a quality that marks much of Tooker's earlier work. In paintings like *Subway* (1950), *Government Bureau* (1956), and *The Waiting Room* (1959), Tooker captured what many saw as the alienation of the individual in a modern, bureaucratic, technological society. Hirsch's oil painting, though a critique of the treatment of the elderly poor, contains a richness of color and texture that lends it a human warmth. Tooker, on the other hand, floods his tempera painting with the greenish hue of the fluorescent lights found so often in institutional settings, emphasizing the sameness of the figures in the painting and draining them of vitality and life.

Like his close friends Cadmus and French, Tooker created works that were enigmatic, yet grounded in the world around him. "I am after painting reality impressed on the mind so hard that it returns as a dream," stated Tooker, "but I am not after painting dreams as such, or fantasy."[106] Taking a hard look at racial segregation in the early 1960s would have revealed that one could desegregate lunch counters, but one could never force those who ate together to enjoy each other's company. Tooker's *Lunch* plainly

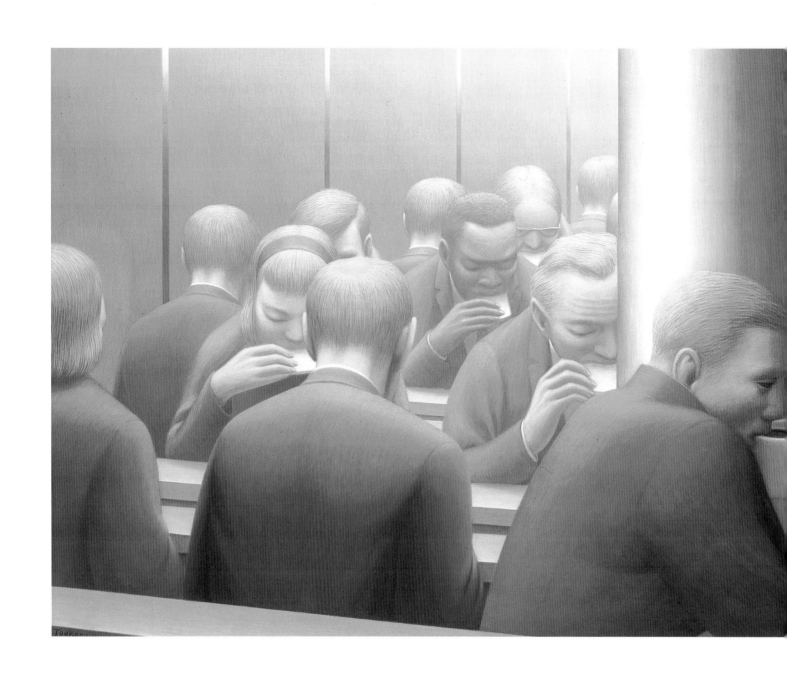

George Tooker
LUNCH, 1964
Egg tempera on gessoed panel, 20 x 26 in

confronts this harsh reality.

One African American artist whose work was affected by the turmoil of the early 1960s was Romare Bearden. In 1963, the year of Martin Luther King, Jr.'s March on Washington, a number of African American artists, including Charles Alston, Emma Amos, and Norman Lewis, met at Bearden's New York studio. The meeting led to the founding of The Spiral Group, which concerned itself not only with civil rights campaigning but also with African American identity in relation to both Africa and the United States. Bearden proposed that the group produce a collaborative collage that would express some kind of consensus or unity. He had already begun working with a series of "black-and-white photomontaged images clipped from commercial sources: snippets of human anatomy— eyes, arms, bodies, feet—assembled with seemingly no regard for the usual concepts of scale and proportional relationships."[107] According to a later account:

> Everyone lost interest [in the collaborative project] but Bearden, and he went ahead on his own. He enlarged his small photomontages photostatically from their original dimensions, about the size of a piece of typewriting paper, to 3 by 4 feet, or 6 by 8 feet. . . . They seemed a radical departure from Bearden's abstract paintings of the 1950s and early 1960s because of their photographic and documentary quality. While they spanned the entire range of Bearden's memories of the South, Pittsburgh, and Harlem, a number of them represented urban street scenes filled with faces set against brick walls, stairways, lamp posts, tenement windows, latticed fire escapes, and bridges.[108]

These works, the larger of which were called *Projections*, were shown at Cordier and Ekstrom Gallery in New York in October 1964 and a year later at the Corcoran Gallery in Washington, D.C.

One of the smaller 1964 collages (about 13 by 16 inches) is *Watching the Good Trains Go By* (1964). As in his other photomontages, Bearden builds up both figures and background from pieces of photographs taken out of their original spatial configurations. The result is an image that contains disturbing contrasts in scale, with the faces of the figures, in particular, larger than life. The faces range in age from a young child to an old woman, representing the different generations within African American communities. "I build my faces . . . from parts of African masks, animal eyes, marbles, mossy vegetation," stated Bearden.[109] The bright patterns of the figures' clothes call to mind the pieced and appliquéd quilts that existed in so many African American homes, while the sharp-edged, shifting compositional rhythms echo the syncopated rhythms of jazz. Thus, Bearden draws his style, as well as his subject matter, from African American culture. "I work out of a response and need," stated Bearden, "to redefine the image of man in the terms of the Negro experience I know best."[110]

Bearden also includes two motifs in *Watching the*

Good Trains Go By that appear in many of his other photomontages, the train and the guitar. In writing of Bearden's work in 1984, Myron Schwartzman commented:

> Guitar players sound their folk blues in dozens of Bearden's collages. These musicians, together with the recurrent motifs of railroad trains, conjur women, women at the bath, and the roosters that watch them bathe, not only suggest the idiomatic particularity of the landscape Bearden remembers, but act also as metaphors and icons in the terrain of Bearden's painterly vision.[111]

According to the African American author John Williams, Bearden repeatedly used the guitar not just because he was interested in music and song writing, but to depict a sense of timelessness. Stringed instruments exist throughout the world; they were among the earliest musical instruments in ancient cultures and are still vital today in African American music.[112]

The train also resonated with multiple meanings. It signaled the ride north to freedom, yet its tracks, often laid by African American chain gangs, marked the dividing line between white and black neighborhoods. When he was small, Bearden and his grandfather would visit the railroad station to "watch the good trains go by":

> I use the train as a symbol of the other civilization—the white civilization and its encroachment upon the lives of blacks. The train was always something that could take you away and could also bring you where you were. And in the little towns it's the black people who live near the trains.[113]

The train also figured in many of the songs of blues and jazz musicians, representing a sense of possibility, of movement through time and space; at the same time, the sound of its whistle seemed to capture the despair of ever being able to achieve that freedom of which Martin Luther King, Jr., so eloquently spoke.

La Primavera (1967) is another of Bearden's photomontages. It is much larger than *Watching the Good Trains Go By* (just under 4 by 6 feet) and differs in composition, containing only a few figures and large areas of pure color. The subject of *La Primavera* is also different. Rather than focusing on contemporary African American life or memories from his own childhood, Bearden makes reference to a 1478 painting of the same name by the Italian artist Sandro Botticelli. Allusion to European masterpieces of the past was not unusual for Bearden, who spent a number of years in the 1950s copying such paintings. In 1964 he remarked:

> I am a man . . . who shares a dual culture that is unwilling to deny the Harlem where I grew up or the Haarlem of the Dutch masters that contributed its element to my understanding of art.[114]

Botticelli's *Primavera* contains the central figure of Venus, accompanied on her right by the Three Graces and Mercury on her left by Chloris, Flora, and the west wind

Zephyrus. In the myth, Zephyrus rapes Chloris and then "rewards " her by transforming her into Flora, the goddess of spring. While the right-hand figure in Bearden's painting is obviously female, the gender of the figure facing her, who offers her sprigs of leaves, is not clear. The figure is taller and has a face made up, in large part, of a carved African mask. Thus, Bearden could be referring either to the transformation of Chloris into Flora, or to the earlier encounter between Zephyrus and Chloe that led to it. The suggestion that good can result from violence would certainly not have fallen on deaf ears in 1967. The presence of the child reinforces the theme of transformation or cultural synthesis: whatever the nature of the encounter between the two adult characters, the result is a new beginning. In that sense Bearden's work is, like Evergood's

Romare Bearden
WATCHING THE GOOD TRAINS GO BY, 1964
Photomontage and mixed media on paper, 13 3/4 x 16 7/8 in

Romare Bearden
LA PRIMAVERA, 1967
Collage and mixed media on board, 44 x 56 in

Spring of over thirty years earlier, a hopeful painting. Yet by 1968 these hopes would be dashed as events both at home and abroad left even the most radical activists wondering whether good could ever come out of violence.

Ivan Le Lorraine Albright's *The Cliffs Revolve But Slowly* (1965) is not about any particular event or social movement of the 1960s. It is a representation, from three different viewpoints, of the landscape outside his Wyoming studio. In his notes for this painting, Albright writes: "For a complete static state neither the sun, the view, or you move. Result, a frozen position in time and space—akin to looking at a corpse—the life has flown. There are few things more disagreeable to look at than frozen stillness—barren of life."[115] By the 1960s Albright was well known for his painfully detailed depictions of

flesh, objects, or landscapes that, despite their "frozen stillness," seem to rot or decompose before the viewer's very eyes. Yet works like *The Cliffs Revolve But Slowly* seem prophetic in their intimations of a time when landscapes would, once again, be covered with rotting or charred flesh and whitened bones.

In the early 1960s the United States began sending military advisors to South Vietnam to aid that country's government in its war with North Vietnam. In August 1964, two United States spy ships exchanged fire with North Vietnamese boats in the Gulf of Tonkin. President Johnson took this incident as an act of open aggression by North Vietnam and ordered a series of retaliatory air raids. Congress, responding to a request by the president, passed the Gulf of Tonkin Resolution, giving Johnson the power to "take all necessary measures to repel any armed attack against the forces of the United States and to prevent further aggression." Now, instead of military advisors, the United States began sending its own troops to join the South Vietnamese army in its fight against the North

Ivan Albright
THE CLIFFS REVOLVE BUT SLOWLY, 1965
Gouache on paper, 16 1/4 x 24 1/8 in

Peter Saul
FEEL IT (CHINA GOD), 1966
Colored crayon, felt-tip marker and
ballpoint pen on paper, 41 x 58 in

Vietnamese. By the end of 1966 almost 400,000 United States soldiers were stationed in Vietnam (these figures would peak at 543,000 in 1968).

Johnson's decision to send soldiers to Vietnam divided the country. Demonstrations broke out on campuses. Television coverage of the war filled living rooms with images of napalm-scarred bodies, defoliated landscapes, and wounded soldiers. Senator J. William Fulbright remarked that the Vietnamese carnage was "poisoning and brutalizing our domestic life. . . . The 'Great Society' has become the sick society."[116] Peter Saul, in *Feel It (China God)* (1966), creates a vivid image of this "sick" society in a style that combines the drawings of teenage boys, *Mad* magazine/Disneyland cartoons, surrealism, and pop art. Large-breasted women with elastic bodies float above the exposed living room of a suburban home as a male figure

with elongated thumbs and neck reaches out with his tongue toward a yellow square head with popped-out eyes marked "China." A swastika carries the message "Feel It," while the word "God" appears in a red cloud below. The colors are garish and the figures two-dimensional. Sex and war are intertwined in a mass of phallic and bulbous forms.

Saul was one of a number of artists who, by the late 1960s, were rejecting the then-prevailing notion that art should be devoid of political commentary. In describing how he came to use Vietnam in his work, he wrote:

> I was thumbing through *Time* magazine . . . in a motel room in Ohio when suddenly I remembered one of the rules of modern art is you're not supposed to have any political content (for no good reason; some nonsense about a lot of artists doing it in the '30s, therefore no one is supposed to do it again). How could I resist break-

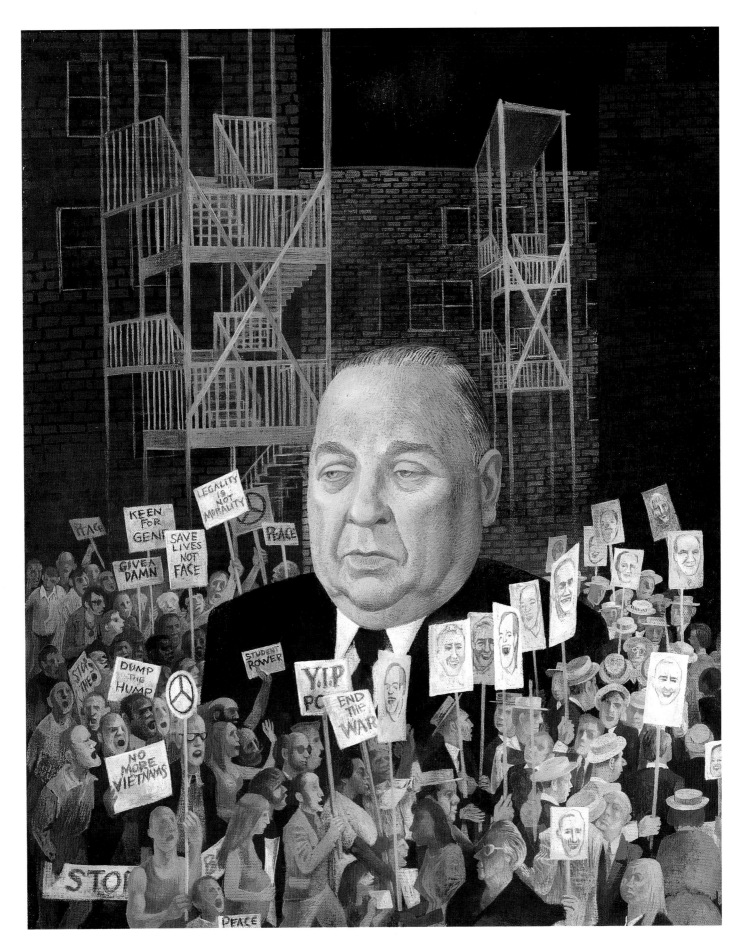

100

ing such a stupid rule. I began immediately with pencil and paper. But, I didn't care whether or not the American government was right or wrong, or about anyone getting killed. That only occurred to me after months of work when I suddenly thought about it. The more I thought about it, the more I protested the war.[117]

By 1968 it was difficult not to care, not only about the war in Vietnam but also about the failure of the war on poverty and of the nonviolent resistance championed by Martin Luther King, Jr. In February 1968 Senator Robert F. Kennedy wrote: "We seem to fulfill the vision of Yeats: 'Things fall apart, the center cannot hold; / mere anarchy is loosed upon the world.' "[118] Little hope was left for a peaceful or legislative end to racism, militarism, and poverty after the assassinations of King on April 4, 1968, and, less than three months later, of Senator Robert Kennedy.

The violence that surrounded the antiwar and civil rights movements of the 1960s spilled over into the Democratic National Convention held in Chicago in August 1968. Antiwar demonstrations outside of the heavily fortified convention center were met by Chicago police wielding billy clubs. The Walker Report, outlining the results of an investigation into the police officers' behavior, concluded there had been "unrestrained and indiscriminate police violence." It went on:

> That violence was made all the more shocking by the fact that it was inflicted upon persons who had broken no law, disobeyed no order, made no threat. These included peaceful demonstrators, onlookers, and a large number of residents who were simply passing through, or happened to live in, the areas where confrontations were occurring.[119]

Antiwar demonstrators were further dismayed by the defeat of their presidential candidate, Senator Eugene McCarthy, at the convention.

Bernard Perlin commemorates the Chicago convention in his painting *Mayor Daley* (1968). Chicago's Mayor Daley is surrounded by two groups. On the left are antiwar demonstrators sporting signs calling for support for McCarthy and an end to the war in Vietnam; on the right are convention delegates holding up placards bearing the image of McCarthy. The two groups merge in front of Daley, suggesting that the demonstrations outside of the convention hall were part of the same legitimate political process that was taking place within the convention hall. The demon-

strators are African American and white, young and old, male and female (the delegates, however, are primarily white and male). Daley is immobilized by their numbers, caught between the crowds and the carefully-delineated tenement buildings in the background. Perlin provides us with a catalogue of the faces and locale of the grass roots movements that were attempting to bring about an end to the suffering both at home and in Vietnam. The latter would be achieved five years later, but at a cost of countless lives. The fight against domestic poverty and racism is still being waged today.

CONCLUSION

Despite its varied critical reception during this century, politically engaged art remains an important part of an increasingly diverse art world, just as the reforms enacted by the Roosevelt and Johnson administrations have weathered the past sixty years, although not entirely unscathed. The artists in this book remind us of what life was like before such social welfare and civil rights legislation was passed. In powerful visual statements, they call upon us to acknowledge injustice when we see it and join in the efforts to preserve a democratic society. They also remind us of a crucial aspect of any democracy—freedom of speech, the right to dissent in public without fear of reprisals. Their paintings and prints encourage us to expand, rather than limit, our efforts to ensure that this country lives up to its democratic ideals, that the rights of all citizens to "life, liberty and the pursuit of happiness" are protected, but not at the expense of citizens of other countries. Ben Shahn closed a 1951 lecture with words that still ring true today:

> . . . if either art or society is to survive the coming half-century, it will be necessary for us to re-assess our values. The time is past due for us to decide whether we are a moral people, or merely a comfortable people, whether we place our own convenience above the life-struggle of backward nations, whether we place the sanctity of enterprise above the debasement of our public. If it falls to the lot of artists and poets to ask these questions, then the more honorable their role. It is not the survival of art alone that is at issue, but the survival of the free individual and a civilized society.[120]

Bernard Perlin
MAYOR DALEY, 1968
Oil on canvas, 20 x 16 in

NOTES

1. While most of the works in this book are included in the exhibition of the same name, I will also discuss several works from the collection of Philip and Suzanne Schiller that are not included in this exhibition.

2. Louis Lozowick, "Towards a Revolutionary Art," *Art Front* (July/August 1936), quoted in Patricia Hills, "Philip Evergood's 'American Tragedy': The Poetics of Ugliness, The Politics of Anger," *Artsmagazine* 54 (February 1980): 142.

3. Quoted in Studs Terkel, *Hard Times, An Oral History of the Great Depression* (New York: Pantheon Books, 1970), p. 375.

4. The extent to which these artists understood or studied Marxism varies. David Shapiro writes of the political art of the 1930s: "The Marxism of most artists, whether it included membership in one of the Marxist parties or not, tended to be uncomplicated by knowledge of Marxist theory, in spite of what Marxist scholars may have been writing and thinking during the thirties. With rare exceptions, the painters and sculptors were not intellectuals. They saw American economic life as having failed because of the 'inherent contradictions of capitalism.' Therefore, capitalism was bad, a way of exploiting one class for the benefit of another, and it was doomed." (*Social Realism: Art as a Weapon*, ed. and introduction [New York: Frederick Ungar Publishing Co., 1973], p. 13).

5. See David Caute, *The Great Fear: The Anti-Communist Purge Under Truman and Eisenhower* (New York: Simon and Schuster, 1978), and Victor Navasky, *Naming Names* (Harmondsworth, England: Penguin Books, 1980).

6. Clement Greenberg's essay "Modernist Painting" (in *The New Art*, ed. Gregory Battcock [New York: E.P. Dutton, 1966], pp. 100–110) provides the most succinct summary of this argument.

7. Ben Shahn, "American Painting for the Past Twenty-Five Years: An Unorthodox View," presented at Harvard University, April 12, 1951, typescript, p. 9. Ben Shahn papers, unmicrofilmed papers, Archives of American Art, Smithsonian Institution, Washington, D.C.

8. Ben Shahn, "The Future of the Creative Arts," *University of Buffalo Studies* 19 (February 1952): 127. This talk was presented at a symposium of the same name that took place from December 7 to December 9, 1951 at the University of Buffalo. Abstract art was also attacked as "communistic" in the late 1940s and early 1950s because it destroyed all that was "true" and "beautiful" in art and thus threatened the moral fiber of the nation.

9. Lozowick, "Towards a Revolutionary Art."

10. For more on Holger Cahill's attitude toward art, see Holger Cahill, "American Resources in the Arts," in Francis V. O'Connor, ed., *Art For the Millions: Essays from the 1930s by Artists and Administrators of the WPA Federal Art Project* (Greenwich, Connecticut: New York Graphic Society, 1973).

11. From 1934 to 1943 the Farm Security Administration (FSA), formerly the Resettlement Administration (RA), also hired artists to provide works of art for the new planned communities being built by the FSA and to take photographs of the conditions of urban and rural workers throughout the country. For further information on the federal art projects see Francis V. O'Connor, *Federal Support for the Visual Arts: The New Deal and Now* (Greenwich, Connecticut: New York Graphic Society, 1969); William F. McDonald, *Federal Relief Administration and the Arts* (Columbus: Ohio State University Press, 1969); Marlene Park and Gerald Markowitz, *New Deal For Art: The Government Art Projects of the 1930s* (Hamilton, New York: Gallery Association of New York State, Inc., 1977); Marlene Park and

Gerald E. Markowitz, *Democratic Vistas: Post Offices and Public Art in the New Deal* (Philadelphia: Temple University Press, 1984); and Barbara Melosh, *Engendering Culture: Manhood and Womanhood in New Deal Public Art and Theater* (Washington and London: Smithsonian Institution Press, 1991).

12. Quoted in Gerald M. Monroe, "Artists as Militant Trade Union Workers During the Great Depression," *Archives of American Art Journal* 14, no. 1 (1974): 7.

13. The original group of artists included, among others, Max Spivak, Boris Gorelick, James Guy, Louis Ribak, Michael Loew, and Bernarda Bryson. For a detailed history of the Artists Union, see Gerald Monroe, "The Artists Union of New York," Ph.D. dissertation, New York University, 1971.

14. Quoted in John I. H. Baur, *Philip Evergood* (New York: Whitney Museum of American Art, 1960), pp. 47–48.

15. Ibid., p. 52.

16. Evergood may have chosen to include both African American and white men in his painting because of his memory of the encounter on the cold winter night. Yet the campaign for civil rights for African Americans was a central part of both Evergood's own politics and progressive politics in general in the 1930s. Evergood's own experience with anti-Semitism may also have strengthened his identification with the struggles of African Americans. Evergood's father had changed the family's last name from Blashki to Evergood after the young Philip had his admission to the Royal Naval Training College of Osborne held in abeyance because of his Jewish last name. According to Evergood, Winston Churchill himself, then First Lord of the Admiralty, advised his father to take this action (ibid., pp. 19–20). "Evergood" was Philip's father's middle name, which was a literal translation of his father's mother's name, Immergut.

17. For a discussion of Benton's visit to West Virginia, see Henry Adams, *Thomas Hart Benton: An American Original* (New York: Alfred A. Knopf, 1989), pp. 140–141. Samples of the illustrations Benton produced for Huberman's text can be found in the same book, pp. 170–173. One of the images produced on page 170 of a strike scene at an industrial site includes an armed guard reminiscent of the guard with the rifle in *Strike*.

18. Erika Doss, *Benton, Pollock, and the Politics of Modernism: From Regionalism to Abstract Expressionism* (Chicago: University of Chicago Press, 1991), p. 51. For an additional discussion of Benton's politics, see Elizabeth Broun, "Thomas Hart Benton, A Politician in Art," *Smithsonian Studies in American Art* 1 (Spring 1987): 59–77.

19. The male figure in this painting appeared in an almost identical form in a doorway in a circa 1935 work of the same name (Neuberger Museum, State University of New York at Purchase). To the right of the figure, however, is not a single empty chair but three chairs, the first occupied by a woman, the next empty, and the third occupied by a man.

20. Melosh, *Engendering Culture*.

21. Ibid., p. 1.

22. Bloch is best known for her work as a muralist. For more on her life and work see Michele Vishny, "Lucienne Bloch, The New York City Murals," *Woman's Art Journal* 13 (Spring/Summer 1992): 23–28.

23 Quoted in Martin H. Bush, *Philip Reisman: People Are His Passion* (Wichita: Edwin A. Ulrich Museum of Art, Wichita State University, 1986), p. 31.

24. That Bloch was able to be more critical in her prints than in her mural work is evident if we compare *Land of Plenty* to her mural of the same year (1935) for the House of Detention for Women in New York City. The mural, located in the recreation room for black prisoners, focuses on an interracial

group of women and children in an outdoor playground with factory buildings and the New York City skyline in the background. Bloch's inclusion of both black and white women appears to be a critique of the racial segregation practiced by the prison.

25. For more on the artists who worked on these periodicals, see Rebecca Zurrier, *Art for the Masses: A Radical Magazine and Its Graphics, 1911–1917* (Philadelphia: Temple University Press, 1988), and Virginia Hagelstein Marquardt, "Art on the Political Front in America: From *The Liberator* to *Art Front*," *Art Journal* 52 (Spring 1993): 72–81.

26. Helen Langa, "Egalitarian Vision, Gendered Experience: Women Printmakers and the WPA/FAP Graphic Arts Project," in *The Expanding Discourse: Feminism and Art History*, ed. Norma Broude and Mary D. Garrard (New York: Icon Editions/Harper-Collins, 1992), pp. 412–413.

27. Even Frances Perkins, Roosevelt's secretary of labor, refused to make a special case for working women because she felt that reform legislation that singled out women, qua women, for preferential legislation ultimately would work against women (see Karal Ann Marling, "American Art and the American Woman," in Karal Ann Marling and Helen Harrison, *Seven American Women: The Depression Decade* [Poughkeepsie, New York: Vassar College Art Gallery, 1976], p. 12).

28. Elizabeth Olds, in a 1935 interview with the *Omaha World-Tribune*, quoted in Langa, "Egalitarian Vision," p. 411.

29. The theme of the female office worker at rest on her lunch hour or in transit between office and home is found in the work of Isabel Bishop. See Ellen Wiley Todd, "The Question of Difference," *Smithsonian Studies in American Art* 3 (Fall 1989): 24–41.

30. Ellen Wiley Todd, *The "New Woman" Revised: Painting and Gender Politics on Fourteenth Street* (Berkeley: University of California Press, 1993), p. 152.

31. For a detailed discussion of the effects of this shift on the organization of work, see Harry Braverman, *Labor and Monopoly Capital: The Degradation of Work in the Twentieth Century* (New York: Monthly Review Press, 1974).

32. My discussion of the Union Square-Fourteenth Street district is drawn from chapter three of Todd, *The "New Woman" Revised*.

33. See ibid., chapter five.

34. Ibid., p. 180.

35. For an example of such caricatures, see ibid., p. 28–29.

36. Cornel West, "Nihilism in Black America," in *Race Matters* (New York: Vintage Books/Random House, 1993), pp. 23–24.

37. See Shifra Goldman, "Mexican Muralism: Its Social-Educative Roles in Latin America and the United States," *Aztlan* 13 (Spring/Fall 1982): 11–133.

38. See Martha Pennigar, *The Graphic Work of George Biddle With Catalogue Raisonne* (Washington, D.C.: Corcoran Gallery of Art, 1979).

39. I would like to note my debt to art historian Kenon Breazeale, whose comments on Biddle's painting inform my discussion of the work.

40. David C. Driskell, *Two Centuries of Black American Art* (New York/Los Angeles: Los Angeles Museum of Art/Alfred Knopf, 1976), pp. 59, 61.

41. Cornel West, "Black Sexuality: The Taboo Subject," in *Race Matters*, p. 126.

42. Ibid.

43. See Ellen Harkins Wheat, "Jacob Lawrence and the Legacy of Harlem," *Archives of American Art Journal* 26, no. 1 (1986): 18–25.

44. Patricia Hills, "Jacob Lawrence as Pictorial Griot: The Harriet Tubman Series," *American Art* 7 (Winter 1993): 42.

45. Ibid., p. 46. Hills calls Lawrence's style "expressive cubism."

46. Quoted in ibid., p. 47.

47. Marlene Park, "Lynching and Antilynching: Art and Politics in the 1930s," *Prospects* 18 (1993): 312.

48. Ibid., pp. 311–312.

49. James Elbert Cutler, *Lynch-Law: An Investigation into the History of Lynching in the United States* (1905; reprint ed., Montclair, New Jersey: Negro Universities Press, 1969), p. 207, quoted in Park, "Lynching and Antilynching," p. 313.

50. See Mari Jo Buhle et al., eds., *Encyclopedia of the American Left* (Urbana and Chicago: University of Illinois Press, 1992), pp. 684–686.

51. Walter White, the organizer of the NAACP show, found Biddle's print too ambiguous. He wrote to Biddle: "I have your lithograph and I think it is superb. I haven't the authority to pass upon this alone but I am wondering if it is definitely enough connected with the subject of lynching to be intelligible to a great number of people of mixed knowledge about the Scottsboro case who will see the show?" (Walter White to George Biddle, January 18, 1935, NAACP papers, quoted in Park, "Lynching and Antilynching," p. 336).

52. Park notes that in 1931 a number of church groups and women's clubs joined together to form the Association of Southern Women for the Prevention of Lynching, which attempted to combat the misconception that rape was the cause of lynching ("Lynching and Antilynching," p. 313).

53. Louis Lozowick to Dr. Francis V. O'Connor, June 9, 1972, Lozowick Papers, 1334, Archives of American Art, Smithsonian Institution, Washington, D.C., quoted in Park, "Lynching and Antilynching," p. 344.

54. Another Jewish artist who made this connection at approximately the same time was Ben Shahn. In his initial studies for his 1937–1938 mural in the Jewish community of Jersey Homesteads, Shahn included two black men in coffins in the top left-hand corner as an indication of the racial prejudice that greeted Jewish immigrants upon their arrival in the United States. He later changed these figures to Nicola Sacco and Bartolomeo Vanzetti, the two Italian-American immigrants who were tried and executed for robbery and murder in the 1920s and whose case, like that of the Scottsboro Nine, became an international cause. See Frances K. Pohl, "Constructing History: A Mural by Ben Shahn," *Artsmagazine* 62 (September 1987): 36–40.

55. The historian Victor Silverman suggested this interpretation to me, noting that lynching victims, particularly in the South, were often African American men and women who had been successful in gaining a certain degree of financial stability.

56. For the text of the rest of the song, see Park, "Lynching and Antilynching," p. 351.

57. Boris Gorelick to Marlene Park and Gerald E. Markowitz, August 30, 1976, quoted in Park, "Lynching and Antilynching," pp. 349–50.

58. One cannot help but wonder if Gorelick had seen Pablo Picasso's *Guernica* (1937), which was on view in New York in 1939. Certainly the two works exhibit many differences, but both contain a similar sense of chaos, desperation, and despair, achieved in large part through distorted bodies, facial expressions, and exaggerated gestures.

59. Uwe M. Schneede, *George Grosz: His Life and Work,* with contributions by Georg Bussmann and Marina Schneede-Sczesny, translated by Susanne Flatauer (New York: Universe Books, 1979 [1975]), p. 112.

60. Beth Irwin Lewis, *George Grosz: Art and Politics in the Weimar Republic* (Princeton, New Jersey: Princeton University Press), p. 176.

61. For further information on the persecution of modernist artists during Hitler's reign see Berthold

Hinz, *Art in the Third Reich,* trans. by Robert and Rita Kimber (New York: Pantheon Books, 1979 [1974]). Five oil paintings, two watercolors, and thirteen drawings by Grosz were included in the "Degenerate Art" exhibition (Lewis, *George Grosz,* p. 227).

62. Schneede, *George Grosz,* p. 120.

63. According to art historian Gail Stavitsky, this watercolor and ink drawing is a study for a never-realized mural for the central wall of the entrance area of the RCA building of Rockefeller Center ("American Artists' Congress," *Artsmagazine* 60 [April 1986]: 109).

64. In the mid-1920s, Drewes bought an abstract painting by the German artist William Wauer. He left it with his parents when he went to the United States. When Hitler came to power, they took the painting off the stretcher, rolled it up, and hid it under their bed because they feared it would be taken away or destroyed (Martina Roudabush Norelli, *Werner Drewes: Sixty-Five Years of Printmaking* [Washington, D.C.: Smithsonian Institution/National Museum of American Art, 1984], p. 13).

65. Ibid., p. 21.

66. The Soviet government had not always mandated such a socialist realist art. During the years immediately following the Bolshevik Revolution of 1917, the art schools were run by artists committed to an art far more abstract than anything that existed in the 1930s. Two of the main proponents of this abstract art were Kazimir Malevich, the founder of Suprematism, and Liubov Popova, a member of the Cubo-Futurists.

67. Ilene Susan Fort, "American Social Surrealism," *Archives of American Art Journal* 22, no. 3 (1982): 8–20.

68. For more on the American Artists' Congress see Matthew Baigell and Julia Williams eds., *Artists Against War and Fascism: Papers of the First American Artists' Congress* (New Brunswick, New Jersey: Rutgers University Press,1986), and Garnett McCoy, "The Rise and Fall of the American Artists' Congress," *Prospects* 13 (1988): 325–340.

69. See Wendy Kozol, "Madonnas of the Fields: Photography, Gender, and 1930s Farm Relief," *Genders* 2 (July 1988): 1–23. One of the most powerful representations of this stoic mother motif in literature of the period can be found in John Steinbeck's novel *The Grapes of Wrath* (1939).

70. For a further discussion of Gellert and his production of illustrated texts containing "revolutionary symbology" see Richard N. Masteller, *"We, the People!": Satiric Prints of the 1930s* (Walla Walla, Washington: Donald H. Sheehan Gallery, Whitman College, 1989), pp. 32–42.

71. David Traxel, *An American Saga: The Life and Times of Rockwell Kent* (New York: Harper and Row, 1980), p. 184.

72. In 1947, Franco declared Spain a kingdom, with himself as regent. He retained power until his death in 1975.

73. Ilene Susan Fort, "James Guy: A Surreal Commentator," *Prospects* 12 (1987): 126. Fort notes that *The Black Flag* was exhibited in 1939.

74. Ibid., p. 143

75. For more on Hitler and the art of the Third Reich, see Hinz, *Art in the Third Reich.*

76. Fort, "James Guy," p. 143.

77. Robert Dallek, *Franklin D. Roosevelt and American Foreign Policy* (Oxford: Oxford University Press, 1979), p. 167.

78. Louis Guglielmi, "I Hope to Sing Again," *Magazine of Art* 37 (May 1944): 175, quoted in Fort, "American Social Surrealism," p. 12.

79. Ellen Landau, "'A Certain Rightness': Artists For Victory's 'America in the War' Exhibition of 1943," *Artsmagazine* 60 (February 1986): 44.

80. Artists for Victory charter, quoted in ibid.

81. After the initial showing, ten more museums requested smaller versions of the exhibition and two complete sets were circulated by the USO and the Armed Services (ibid., p. 46). For more information on Artists for Victory, see Ellen Landau, *Artists for Victory: An Exhibition Catalog* (Washington, D.C.: Library of Congress, 1983).

82. Quoted in Gail Stavitsky, "'Of Two Worlds': The Painting of Henry Koerner," *Artsmagazine* 60 (May 1986): 76.

83. Quoted in ibid.

84. "Henry Koerner: His Own Tragedy Spurs Artist to Paint Moving Postwar Pictures," *Life* (May 10, 1948): 7.

85. In 1949, East Berlin was made the capital of Soviet-controlled East Germany, while in 1950, West Berlin was established as a state within, and the *de jure* capital of the Federal Republic of Germany (West Germany), with Bonn as the *de facto* capital. The division of Berlin was further demarcated in 1961 when the Soviets constructed the 29-mile long Berlin Wall—an edifice that stood as a stark reminder of the postwar Cold War for 28 years.

86. Art historian Andrea Swanson Honoré has identified the three central figures as, from left to right, Lord Halifax, Arthur Vandenburg, and United States Senator Tom Connelly (conversation with author, January 3, 1994).

87. Refregier's *Politicians at Work* is similar to a painting of the same name included in the 1946 Pepsi Cola "Portrait of America" exhibition (the background of this painting contains Venetian blinds instead of gas chambers, gallows, and barbed wire). Both works were connected thematically to another project Refregier began in 1946—the design and execution of 27 murals on the history of California for the Rincon Annex Post Office in San Francisco. The murals included scenes of San Francisco as a cultural center, the United Nations, and the building of the Golden Gate Bridge.

88. For further information on the cancellation of this exhibition, see Frances K. Pohl, *Ben Shahn: New Deal Artist in a Cold War Climate, 1947–1954* (Austin: University of Texas Press, 1989), pp. 33–37.

89. Kent's *Heavy Heavy Hangs Over Thy Head* appeared the following year in Howard Fast's 1947 pamphlet *May Day, 1947.*

90. Shahn, "The Future of the Creative Arts," p. 127. For further discussion of the debates concerning the "humanistic" value of abstract and realist art, see Serge Guilbaut (Arthur Goldhammer trans.), *How New York Stole the Idea of Modern Art: Abstract Expressionism, Freedom, and the Cold War* (Chicago and London: University of Chicago Press, 1983), and Pohl, *Ben Shahn.*

91. Quoted in "Nightmare: Goya Gets a Guggenheim, A Conversation with Ben Shahn," in Henry Brandon, *As We Are: 17 Conversations Between the Americans and the Man From London* (New York: Doubleday, 1961), pp. 81–82.

92. Jack Levine, *Jack Levine,* with introduction by Milton Brown, compiled and edited by Stephen Robert Frankel (New York: Rizzoli, 1989), p. 91.

93. Quoted in Greta Berman and Jeffrey Wechsler, *Realities and Realism: The Other Side of American Painting, 1940–1960* (New Brunswick, New Jersey: Rutgers University, 1981), p. 104.

94. See Nancy Grimes, "French's Symbolic Figuration," *Art in America* 80 (November 1992): 110–115; Nancy Grimes, *Jared French's Myths* (San Francisco: Pomegranate Artbooks, 1993); Berman and Wechsler, *Realism and Realities,* pp. 93–99; and Peter Morrin, "PAJAMA Game: The Photographic Collection of Paul Cadmus," *Artsmagazine* 53 (December 1978): 118–119.

95. Grimes, "French's Symbolic Figuration," p. 112.

96. Grimes, in *Jared French's Myths*, states that French was bisexual (p. VII).

97. Jonathan Katz, "The Art of Code: Jasper Johns and Robert Rauschenberg," in Whitney Chadwick and Isabelle de Courtivon, eds, *Significant Others: Creativity and Intimate Partnership* (London and New York: Thames and Hudson, 1993), pp. 189–207.

98. See Grimes, *Jared French's Myths*, pp. XIII-XIV, for a discussion of *The Double* in relation to Jung.

99. For a discussion of the connection between consumerism and pop art of the 1960s, see Christin J. Mamiya, *Pop Art and Consumer Culture: American Super Market* (Austin: University of Texas Press, 1992).

100. Michael Harrington, *The Other America: Poverty in the United States* (New York: Penguin Books, 1962).

101. Quoted in Terkel, *Hard Times: An Oral History of the Great Depression*, pp. 375–76.

102. Elizabeth McCausland, "Robert Gwathmey," *Magazine of Art* (April 1946): 149, quoted in Charles K. Piehl, "The Southern Social Art of Robert Gwathmey," *Wisconsin Academy of Sciences, Arts, and Letters* 73 (1985): 55.

103. Charles K. Piehl, "A Southern Artist at Home in the North: Robert Gwathmey's Acceptance of His Identity," *The Southern Quarterly* 26 (1987–88): 9. See also Charles K. Piehl, "Robert Gwathmey: The Social and Historical Context of a Southerner's Art in the Mid Twentieth Century," *Arts in Virginia* 29, no. 1 (1989): 2–15.

104. Harrington, *The Other America*, p. 47. In 1954, 12 percent of farm operators controlled more than 40 percent of the land and grossed almost 60 percent of the farm sales. The bottom 40 percent of commercial farms accounted for only 7 per cent of total farm sales.

105. Ibid., p. 48.

106. Selden Rodman, *Conversations with Artists* (New York: Devin-Adair, 1957), p. 209, quoted in Thomas H. Garver, *George Tooker* (San Francisco: Pomegranate Artbooks, 1992), p. 10.

107. Lowery S. Sims, "The Unknown Romare Bearden," *Art News* 85 (October 1986): 120.

108. Myron Schwartzman, "Romare Bearden Sees in a Memory," *Artforum* 22 (May 1984): 68.

109. Romare Bearden to Michael Gibson, June 15, 1975, quoted in Ibid.

110. Quoted in John Williams, "Introduction," in M. Bunch Washington, *The Art of Romare Bearden: The Prevalence of Ritual* (New York: Harry N. Abrams, 1972), p. 9.

111. Schwartzman, "Romare Bearden Sees in a Memory," p. 65.

112. Williams, "Introduction," p. 15.

113. Quoted in Kinshasha Holman Conwill, Mary Schmidt Campbell, and Sharon Patton, *Memory and Metaphor: The Art of Romare Bearden, 1940–1987* (New York: Studio Museum of Harlem, and Oxford: Oxford University Press, 1991), p. 39.

114. Charles Childs, "Bearden: Identification and Identity," *Art News* 63 (October 1964): 25.

115. Ivan Le Lorraine Albright, *Notebook*, n.p., Collection of Philip and Suzanne Schiller.

116. Quoted in William E. Leuchtenberg, *A Troubled Feast: American Society Since 1945*, revised ed. (Boston/ Toronto: Little, Brown and Co., 1979), p. 174. The recent publication of Robert S. McNamara's memoirs, *In Retrospect: The Tragedy and Lessons of Vietnam* (New York: Times Books, 1995), has shed new light on the Vietnam war, although many still find his recollections incomplete and his apologies long overdue. In reviewing McNamara's book, Vietnam specialist David Eliott, who served in Vietnam in the early 1960s, writes: "Prior to the Gulf of Tonkin incident, I was assigned to a military-CIA operation that was part of "Plan 34A," a series of raids on coastal areas of North Vietnam conducted during the first half of 1964. These operations later became an important footnote to history, because they shed light on one of the key questions of the war: did the U.S. provoke a North Vietnamese retaliation against the destroyer *Maddox* in the Gulf of Tonkin, despite the government's claim that Hanoi had aggressively attacked a U.S. ship without cause? Wayne Morse, one of two Senate dissenters from the Gulf of Tonkin Resolution . . . charged that the attacks had been prompted by a pattern of offensive actions (the Plan 34A operations). When linked to the *Maddox* patrol, these operations amounted to a hostile attack on North Vietnam and undermined Johnson's claim that the U.S. was a victim of aggression." ["War and Remembrance," *Pomona College Magazine* (Summer 1995): 27.

117. Peter Saul, "Saul on Saul," in *Peter Saul* (DeKalb, Illinois: Swen Parson Gallery, 1980), p. 17.

118. Quoted in Leuchtenberg, *A Troubled Feast*, p. 200.

119. Ibid.

120. Shahn, "The Future of the Creative Arts," pp. 127–28.

ARTISTS' BIOGRAPHIES

by Andrea Swanson Honoré

IDA ABELMAN was born in New York City in 1910. She studied at Grand Central Art School, the National Academy School of Fine Arts, the City College of the City of New York, Hunter College, and the Art Students League. Abelman was employed by the Civil Works Administration from 1934 to 1935, made prints in the New York City Federal Art Project from 1936 to 1938, and worked as a lithography instructor at the Community Federal Art Center (later the Sioux City Art Center) in Sioux City, Iowa, beginning in 1938. Abelman was also a member of the WPA-sponsored Design Laboratory School in New York, a program modeled on the philosophy of the German Bauhaus school. Her total print production on the project was twenty-three works, several of which were color lithographs. Abelman also painted two post office murals under government sponsorship, both in tempera and both in 1941: *Lewiston Milestones* in the Lewiston, Illinois, post office and *Boonville Beginnings* in Boonville, Indiana.
SOURCES: *Who's Who in American Art*, 1940–41; Archives of American Art: Holger Cahill papers, roll 1106; Francis O'Connor papers, roll 1087; Park and Markowitz, *Democratic Vistas*, pp. 27, 208, 209; University of Michigan, *The Federal Art Project*, pp. 18–19; Francey, *American Women at Work*, pp. 12–13.

IVAN LE LORRAINE ALBRIGHT (1897–1980) was born in North Harvey, Illinois. His father was the artist Adam Emory Albright, and Ivan began drawing under his supervision at an early age. After two years of college, first at Northwestern University and next at the University of Illinois, Urbana, he did his military service in France, where he was chief draftsman with the American Expeditionary Force Medical Corps from 1918 through 1919. After his return to the States, he enrolled at the School of the Art Institute of Chicago in 1920. Albright continued his studies at the Pennsylvania Academy in 1923, briefly attended the National Academy in New York, then began a series of travels that brought him to California, Arizona, New Mexico, Pennsylvania, and back to Warrenville, Illinois, by 1928. He had been exhibiting his paintings and watercolors since 1918, and in 1931, was accorded an exhibition at the Art Institute of Chicago. Albright was employed by the Public Works of Art Project in Illinois between 1933 and 1934. During the rest of the 1930s, he was actively painting and teaching. In 1942, he won both the Temple Gold Medal of the Pennsylvania Academy and the First Medal in the "Artists for Victory" exhibition for his painting *That Which I Should Have Done I Did Not Do (The Door)*. In 1943, he painted the portrait featured in the MGM production *The Picture of Dorian Gray*. After his marriage to Josephine Medill Patterson Reeve in 1946, Albright moved to Chicago. He enjoyed several exhibitions and honors throughout the 1940s and 1950s, and in 1963, moved to Vermont. His retrospective exhibition was held at the Art Institute in 1964, and traveled to the Whitney in 1965.
SOURCES: Ryerson and Burnham Libraries, Art Institute of Chicago, notebooks and scrapbooks of Ivan Albright;

Whitney Museum of American Art, vertical file material on Ivan Albright, 1946–(ongoing); Miller and Barr (eds.), *American Realists and Magic Realists*, pp. 24–25; Harriet and Sidney Janis, "The Painting of Ivan Albright," *Art in America* (January 1946): 43–49; Katharine Kuh, *The Artist's Voice—Talks with Seventeen Artists*, New York: Harper and Row, 1962; The Art Institute of Chicago, *Ivan Albright, A Retrospective Exhibition*, Chicago: Art Institute of Chicago, 1964; Margarita Walker Dulac, "Ivan Albright: Mystic—Realist," *American Artist* (January 1966): 32–37, 73–74, 76; Michael Croydon, *Ivan Albright*, New York: Abbeville Press, 1978; Phylis Floyd, *The Ivan Albright Collection (Ivan Albright as Draftsman and Painter)*, Hanover, New Hampshire: Hood Museum of Art, Dartmouth College, 1987.

PEGGY BACON (1895–1987) was born in Ridgefield, Connecticut. Before 1920, she studied at the School of Applied Arts for Women, the New York School of Fine and Applied Arts, and the Art Students League with Kenneth Hayes Miller, George Bellows, and John Sloan among others. Bacon made her first drypoints as early as 1917, and drew her subject matter from the working women and street idlers of her Fourteenth Street neighborhood. She married artist Alexander Brook in 1920, and was party to the circle of artists, including Yasuo Kuniyoshi, Reginald Marsh, Kenneth Hayes Miller, and Brook, who formed the Fourteenth Street School. Along with etching, Bacon was an active lithographer, painter, and caricaturist. During the 1930s, she also contributed drawings to the *New Republic*, illustrated books, and taught at the Fieldston Ethical Cultural School, the Art Students League, and the Tyler School of Art, among others. In 1934, she was awarded a Guggenheim Fellowship and in 1956, she was elected to the National Institute of Arts and Letters.
SOURCES: Harold Ward (intro.), *Younger Artist Series: Peggy Bacon*, Woodstock, New York: 1922–23; Roberta K. Tarbell (essay) and Janet Flint (checklist), *Peggy Bacon: Personalities and Places*, Washington, D.C.: Smithsonian Institution Press, 1987; Roberta K. Tarbell, "Peggy Bacon's Pastel and Charcoal Caricature Portraits," *Women's Art Journal 9* (Fall/Winter 1988–89): 32–37; *Master Prints of Five Centuries: The Alan and Marianne Schwartz Collection*, p. 44.

ROMARE BEARDEN (1914–1988) was born in Charlotte, North Carolina, but grew up in Harlem and Pittsburgh. Bearden first studied at Lincoln College in Pennsylvania and Boston University, before earning a degree in mathematics from New York University in 1935. He then shifted his interest to art and for the next three years, studied with George Grosz at the Art Students League. Bearden later wrote, "What Grosz had done with post-World War I Germany, made me realize the artistic possibilities of American Negro subject matter." Bearden was an active member of the Harlem Artists Guild, and in the mid-1930s was part of a social scene (called the "306 Group") that included the leading black poets, authors, and musicians of the day. He served in the Army during World War II, and in 1945, began exhibiting independently in Washington and New York. His paintings of this period show a strong Cubist influence and revolve around biblical and

classical subjects. In 1950, Bearden traveled to Paris to study at the Sorbonne on a GI Bill stipend. Upon his return, he attempted a career in songwriting but returned to art following his 1954 marriage to Nanette Rohan. It was at this time that Bearden began experimenting with collage-like surfaces of layered and torn painted paper. In 1963, Bearden and others formed the Spiral Group of artists concerned with the problems of the black artist and the manifestation of black pride through cultural projects. With "Spiral" as his touchpoint, Bearden synthesized the African-American subjects that characterized his work of the thirties with his matured collage style in works combining photographic images, painted paper, and canvas. In 1966, he was elected to the American Academy of Arts and Letters. Bearden was also engaged in exhibitions, publications, posters, murals, mosaics, and book and magazine illustrations—most concerning African American causes and themes. During the 1970s and 1980s, he received several honorary degrees and was the subject of three major retrospective exhibitions.

SOURCES: Archives of American Art, Romare Bearden papers and oral history collection; Charles Childs, "Bearden: Identification and Identity," *Art News* 63, 6 (October 1964): 24–25, 54, 61–62; M. Bunch Washington, *The Art of Romare Bearden: The Prevalence of Ritual*, New York: Abrams, 1977; Lynn Igoe, *Artis, Bearden and Burke: A Bibliography and Illustrations List*, Jefferson, North Carolina: Museum of Art, North Carolina Central University, 1977, pp. 1, 7–41; Doré Ashton and Albert Murray, *Romare Bearden, 1970–1980*, Charlotte, North Carolina: The Mint Museum, 1980; Myron Schwartzman, *Romare Bearden, His Life & Art*, New York: Harry N. Abrams, Inc., 1990; Kinshasha Holman Conwill, Mary Schmidt Campbell, and Sharon F. Patton, *Memory and Metaphor: The Art of Romare Bearden, 1940–1987*, New York: The Studio Museum in Harlem; New York and Oxford: Oxford University Press, 1991; Lowery Stokes Sims, *Bearden*, New York: Rizzoli International Publications, 1993; Lee Stephens Glazer, "Signifying Identity: Art and Race in Romare Bearden's Projections," *Art Bulletin* LXXVI, no. 3 (September 1994): 411–426.

SELECTED WRITINGS BY BEARDEN: "The Negro Artist's Dilemma," *Critique* (November 1946): 16–22; "Rectangular Structure in My Montage Paintings," *Leonardo* (January 1969): 11–19; with Harry Henderson, *Six Black Masters of American Art*, Garden City, New Jersey: Zenith Books, Doubleday, 1972; with Carl Holty, *The Painter's Mind: A Study of the Relations of Structure and Space in Painting*, New York: Crown Publishers, 1969.

FRED BECKER was born in Oakland, California, in 1913, and was raised in Hollywood. He began his art education in 1931 at the Otis Art Institute and continued his studies at the Beaux-Arts Institute of Design in New York, beginning in 1934. Becker joined the graphic division of the Federal Art Project in 1935. His series of wood engravings, *The Life of John Henry*, (1936–38), is one of his notable achievements under federal sponsorship. Becker joined the faculty of the New School for Social Research in 1941 and became a member of Stanley William Hayter's experimental Atelier 17 in the

same year. With Hayter, Becker's graphic work moved in the direction of surrealism, carried out in multi-plate and color intaglio methods. Becker taught at a number of institutions following the war, including Temple University, Washington University, the Yale-Norfolk summer school, and Brandeis University. He received a Guggenheim Fellowship in 1957, with which he traveled to Paris to again work at Atelier 17. Becker taught at the University of Massachusetts at Amherst from 1968 to 1986, and has remained active as a printmaker.

SOURCES: Jane M. Farmer, *American Prints from Wood*, Washington, D.C.: Smithsonian Institute Traveling Exhibition Service, 1975; Joanne Moser, *Atelier 17: A 50th Anniversary Retrospective Exhibition*, Madison, Wisconsin: Elvehjem Art Center, 1977; Acton, *Color in American Printmaking*, pp. 170, 250–51; *Graphic Excursions*, p. 139.

THOMAS HART BENTON (1889–1975) was born in Neosho, Missouri, to a prominent political family. He was named after his great uncle, the eloquent Missouri senator and friend of Andrew Jackson, and his father, "Colonel" Benton, was the U.S. attorney in Missouri under President Cleveland and four-term congressman to the state. Benton's early schooling was in Washington, D.C., and he studied at the Art Institute of Chicago from 1906 to 1907. The following year, he went to France and attended the Académie Julian. Benton returned to the States in 1912 and lived in Fort Lee, New Jersey, while painting and working for the film industry. In 1918, he enlisted in the Navy and worked as a draftsman at Norfolk Naval Base. Benton's drawings of daily life in the navy and a new interest in American history mark the first turn in his art away from a modernist technique developed in Paris, and toward the narrative and realistic "American scene" artwork with which he is identified. Throughout the 1920s, he exhibited mural-sized works depicting American historical subjects, traveled the "back country," and published a few theoretical articles. In 1925, he obtained a teaching position at the Art Students League in New York. He executed his first major mural, *Modern America*, at the New School of Social Research in 1930–31, the same year that he began his lifelong friendship with artist John Steuart Curry. In 1932, he painted a series of murals for the library of the Whitney Museum of American Art and in 1933, a mural series for the State of Indiana exhibit at the Century of Progress exhibition. Benton had his first show with friends Curry and Grant Wood in 1934, and the three were designated the "Regionalist School" in a corresponding *Time* magazine article. In the same year, he began a fifteen-year association with Associated American Artists (AAA) to publish his lithographs. Benton had come to be identified with a very chauvinistic and conservative view of the American scene, so his work was at once widely popular and hotly debated among socially concerned artists. He moved to Kansas City in 1935 to begin work on murals for the Missouri State Capitol and to teach at the Kansas City Art Institute. Benton published a book of his life and travels, *An Artist in America*, in 1937. He also illustrated several books, pamphlets, and magazine articles throughout this period. Benton's first retrospective exhibition was held at the Nelson Gallery in Kansas City in 1939, and the show traveled

successfully to the AAA Gallery in New York. From 1940 to 1942, Benton illustrated John Steinbeck's *Grapes of Wrath* for the Limited Editions Club and after Pearl Harbor, painted a series of war paintings that was purchased and widely distributed in book and poster form by Abbott Laboratories of Chicago. In the years that followed, Benton continued with his painting, illustration, travel, and mural work, although public focus on his work waned considerably. He received three other retrospective exhibitions in his lifetime, was engaged in a few other Hollywood-related projects, and was awarded several awards and honorary doctorates, including election to the American Academy of Arts and Letters in 1962.

SOURCES: Thomas Hart Benton, *An Artist in America*, 4th ed. Columbia, Missouri: University of Missouri Press, 1983; Creekmore Fath, (comp. and ed.), *The Lithographs of Thomas Hart Benton*, Austin: University of Texas Press, 1979; Mary Scholz Guedon, *Regionalist Art: Thomas Hart Benton, John Steuart Curry, and Grant Wood: A Guide to the Literature*, Metuchen, New Jersey: Scarecrow Press, 1982; Karal Ann Marling, *Tom Benton and His Drawings: A Biographical Essay and a Collection of His Sketches, Studies and Mural Cartoons*, Columbia: University of Missouri Press, 1985; Henry Adams, *Thomas Hart Benton: An American Original*, New York: Knopf (distributed by Random House), 1989; Erika Doss, *Benton, Pollock, and the Politics of Modernism: From Regionalism to Abstract Expressionism*, Chicago: University of Chicago Press, 1991.

GEORGE BIDDLE (1885–1973) was born in Philadelphia and schooled at Groton, Harvard, and Harvard Law. Although he passed the Pennsylvania bar exam, he decided in 1908 to study art. He first enrolled in the Pennsylvania Academy of Fine Arts, which he followed with years of art-related study and travel in Munich and in Paris at the Académie Julian. Biddle served as a cavalryman in France during World War I— a disheartening experience that was followed by a trip to the South Seas, where his artwork turned to pottery and sculpture. His other travels included some time in Mexico, where he came into contact with Diego Rivera and the publicly sponsored murals of the 1920s. In 1933, his experience of Mexican art prompted a well-known letter to his former classmate Franklin Roosevelt about the importance of state-sponsored art. Biddle's letter is often linked to the formation of the Treasury Section of Painting and Sculpture and began the artist's engagement in official negotiations over the Federal Art Project. Biddle was the president of the Society of Mural Painters and also painted an important five-panel mural at the Department of Justice in 1936. During and after the war, he worked as an artist-correspondent for *Life* magazine, and traveled through Italy and Germany. Biddle moved to a teaching position in Colorado Springs after the New Deal period. He also taught at Columbia, the University of California, and the American Academy of Rome. He authored seven books and several articles, including an autobiography and a few theoretical works. He retired to Croton-on-Hudson, New York, in 1973.

SOURCES: McKinzie, *The New Deal for Artists*, pp. 5–10, 18, 58, 60, 63–64, 188; Martha Pennigar, *The Graphic Work of George Biddle*, Washington, D.C.: Corcoran Gallery of Art, 1979; Hills, *Social Concern and Urban Realism*, pp. 34–35; Berman and Wechsler, *Realism and Realities*, pp. 4–5, 49.

SELECTED WRITINGS BY BIDDLE: *An American Artist's Story*, Boston: Little, Brown and Company, 1939; *Artist at War*, New York: The Viking Press, 1944; *The Yes and No of Contemporary Art*, Cambridge, Massachusetts, 1957.

LUCIENNE BLOCH (DIMITROFF) was born in Geneva, Switzerland, in 1909. Her family emigrated to the United States in 1917, and she studied at the Cleveland School of Art from 1924 to 1925. Bloch returned to Europe to study sculpture at the Ecole Nationale des Beaux-Arts in Paris from 1925–29; she worked at this time with Emile-Antoine Bourdelle, André Lhote, and Andrew Wright. In 1929, Bloch designed a series of figures for the Leerdam Glassworks in Holland and had plans to exhibit them back in the States, but her opening coincided exactly with the crash of the stock market. Two years later, she began her involvement with fresco painting as Diego Rivera's assistant from 1931 to 1934. Bloch worked as color grinder on Rivera's Detroit Institute of Arts frescoes in 1932, and assisted on both his Rockefeller Center murals and the series of portable murals at the New Workers School in New York. Bloch made a few lithographs with artist Frida Kahlo in this period. Employed by the FERA (Federal Emergency Relief Administration) art project and the WPA/Mural Division from 1935 to 1939, Bloch completed two independent murals. At the Madison House of Detention for Women in New York City, she painted *Childhood*, the first in an intended but never realized series, *The Cycle on Woman's Life*. She also painted a series of frescoes (completed in 1938), titled *The Evolution of Music* for the George Washington High School. Among her other projects were plans for a ceramic tile mural intended for a New York subway station, and a mural for the Swiss Pavilion at the New York World's Fair (1939). Bloch (now Dimitroff) moved to her husband's hometown of Flint, Michigan, during the war and taught at Flint Art Institute from 1941 to 1945. They moved to Mill Valley, California, in 1948 and together the couple has completed seventeen murals in mosaic tile, acrylic, oil, and fresco. They taught a mural course at Evergreen College in Olympia, Washington, in 1976. Lucienne Bloch Dimitroff continues to live in California.

SOURCES: *Who's Who in American Art*, 1937 and 1940; Archives of American Art: Holger Cahill papers, rolls 1109–1110 and roll NDA3; Lucienne Bloch, "Murals for Use," in Francis V. O'Connor, *Art for the Millions*, pp. 76–77; Marling and Harrison, *Seven American Women*, pp. 21–24; Park and Markowitz, *New Deal for Art*, pp. 33, 44–45, 56, 164; *Master Prints of Five Centuries: The Alan and Marianne Schwartz Collection*, p. 51; *Graphic Excursions*, plate 59, p. 140; Francey, *American Women at Work*, p. 14; Michele Vishny, "Lucienne Bloch: The New York City Murals," *Women's Art Journal* 13 (Spring/Summer 1992): 23–28.

HARRY BRODSKY was born in Newark, New Jersey, in 1908. He studied at the Philadelphia College of Art (formerly the Philadelphia Museum School of Industrial Art) and the

University of Pennsylvania. Brodsky worked as an art director in Philadelphia for the Atlas Photo-Engraving Company, the J.B. Liebman Company, and later as art director of *TV Guide*. Brodsky's employment disqualified him from engagement in federal relief art programs during the Depression, but allowed him to take time off from his career and devote himself to printmaking. He taught advertising design at the Murrell Dobbins Vocational School and maintained a lithography studio in his home. Brodsky has exhibited actively in Philadelphia, New York, and Boston, as well as in museums and print clubs elsewhere in the United States since 1934. In 1960, his work was selected by the U.S. Department of Information for an internationally toured show of American graphic art, and two of Brodsky's works from this exhibition were purchased by the Israeli state museums. Brodsky has completed over 100 lithographs and woodcuts. He lives with his wife in Philadelphia and continues to make and exhibit prints.

SOURCES: *Who's Who in American Art*, 1936–1953; artist files, Department of Prints and Drawings, Philadelphia Museum of Art.

LETTERIO CALAPAI (1904–1993) was born in Boston and studied at the Boston School of Fine Arts and Crafts and the Massachusetts School of Art before moving to New York in 1928. Calapai continued his studies at the Beaux Arts Institute of Design, the Art Students League, and the American Art School, where he learned the fresco technique from Ben Shahn. He had one-man shows of painting in 1933 and 1934, and worked in the Mural Division of the New York Federal Art Project. In 1939, Calapai completed his most important project under federal sponsorship, a three-panel mural entitled *The Historical Development of Signal Communication,* which is now installed in the U.S. Army Signal Museum in Georgia. During the war, Calapai worked at the American Locomotive Company in Auburn, New York; a wood engraving arising from this experience, *Labor in a Diesel Plant,* won third prize in the "America in the War" competition and marks the formal beginning of Calapai's printmaking career. He worked with the innovative graphic artist Stanley Hayter at Atelier 17 from 1946 to 1949, while teaching at the Riverside School and the Brooklyn Museum of Art School. Like other Hayter students, Calapai was influential in dispersing modern graphic techniques in post-war America. Calapai moved to the University of Buffalo in 1949, where he set up and ran the graphics department at the Albright School of Art for six years. Thereafter, he returned to New York City and helped to establish the Contemporary (now the Pratt) Graphic Arts Center with Margaret Lowengrund, and in 1960, founded the Intaglio Workshop for Advanced Printmaking. He also taught at the New School, New York University, and Brandeis University before 1965. Calapai ultimately settled outside of Chicago in Glencoe, Illinois, where he maintained a studio and gallery until his death in 1992.

SOURCES: Letterio Calapai papers 1932–1977, George Arents Research Library for Special Collections at Syracuse University, Syracuse, New York; Arthur W. Heintzelman, *Wood-engravings by Calapai*, Boston: 1948; Chester Clayton Long (essay), *Letterio Calapai: 20 Years of Printmaking,*

Chicago: Illinois Arts Council, 1972; Landau, *Artists for Victory*, pp. 25–27; *Letterio Calapai: A 50-Year Retrospective (1934–1984)*, Chicago: Landfall Press, 1984; North Shore Productions, *Letterio Calapai: Master Artist*, (video recording), Highland Park, Illinois: Highland Park Public Library, 1989.

FEDERICO CASTELLON (1914–1971) was born in Alhabia, Spain, in the province of Almeria. His family moved to Brooklyn when he was seven. Castellon's only formal education in art consisted of his classes at Erasmus High School in Brooklyn, from which he graduated in 1933. He had painted three murals by the age of seventeen—one in a private home, and two at Erasmus High School titled *Sources and Influences of Modern Art* and *The Study of Academic and Cultural Subjects*. Through the influence of Diego Rivera, young Castellon had a one-man show at the Weyhe Gallery in 1934 and received a fellowship from the Spanish government to travel and study in Europe. During that 1934–37 trip, he had a one-man show in Madrid and exhibited his work in Paris alongside Spanish masters Picasso, Gris, Miró, and Dali. Following his return to New York, Castellon made his first lithograph at George Miller's studio and exhibited in the next two Whitney Annuals. Among the foremost of the American surrealists, Castellon received other honors in this period, including a 1939 invitation from the Peabody Foundation to work at the Yaddo Colony in Saratoga Springs, New York, and in 1940, the first of two Guggenheim Fellowships. In 1943, Castellon was drafted, and beginning in 1945, did artwork for the Office of Strategic Services in Washington, China, and India. Following the war, Castellon began a teaching career that included appointments at Columbia, Pratt Institute, the New School, the National Academy of Design, and Queens College. He continued to paint, make etchings and lithographs, illustrate, and exhibit until the end of his life; he also worked and traveled abroad with his family, particularly during the 1960s. His lifelong honors include membership in the National Academy of Design (academician 1963) and the National Institute of Arts and Letters (elected 1968).

SOURCES: "Young Castellon, Who Recalls Poe and Redon," *Art Digest* (May 15, 1939): 25; Wechsler and Spector, *Surrealism and American Art*, pp. 32–33, 71–72; August L. Freundlich, *Federico Castellon: His Graphic Works, 1936–1971*, Syracuse, New York: Syracuse University, 1978; *Federico Castellon: A Memorial Exhibition of Prints*, New York: Associated American Artists, 1978; Paul Cummings (essay), *Federico Castellon: Surrealist Paintings 1933–1934 Reconsidered*, New York: Michael Rosenfeld Gallery, 1992.

JAMES HENRY DAUGHERTY (1889–1974) was born in Asheville, North Carolina. He began his training in 1903 at the Corcoran School of Art in Washington, D.C., and continued at the Pennsylvania Academy of Fine Arts under William Merritt Chase (1904–5), and with Frank Brangwyn in London (1905–7). Daugherty returned to New York in 1907 and worked as an illustrator, while he continued to paint and exhibit his work. Daugherty was involved in the painted camouflaging, or "dazzling," of ships during World War I. Pivotal to the development of his modernist, or "synchromist,"

style was a friendship begun in 1915 with artist Arthur Burdett Frost, Jr., son of the famous illustrator. Frost had recently returned from study in Paris with Patrick Henry Bruce, the Delaunays, and Matisse. Daugherty exhibited his work with the Society of Independent Artists at the Société Anonyme, and elsewhere between 1920 and 1927. He completed a major mural for the Loew's State Theater in Cleveland in 1920. During the Depression, he was again at work as a muralist, with federally sponsored projects at the Stamford, Connecticut, high school (1934); at Fairfield Court, a low-cost housing project in Stamford, Connecticut (1937); and at the post office in Virden, Illinois (1939). Daugherty continued his illustration work for magazines, and beginning in 1939, wrote and illustrated a string of children's books on American historical subjects. His *Daniel Boone* of 1939 won the 1940 John Newbery Medal for children's literature. He also illustrated more than 80 books by other authors. In his Weston, Connecticut, studio, Daugherty continued painting canvasses based on the theory of simultaneous color contrasts well into the 1960s.

SOURCES: "James Daugherty's Murals of America," *Life* magazine (October 25, 1937); *James Daugherty*, (motion picture) Weston, Connecticut: Weston Woods Studio, 1972; *James Daugherty Retrospective Exhibition*, Montclair, New Jersey: Montclair Art Museum, 1973; Lynd Ward, Edward Kemp, and Elaine Kemp, *James H. Daugherty, 1889–1974*, Eugene, Oregon: University of Oregon Library, 1975; Marling, *Wall to Wall America*, pp. 34–35, 73; Park and Markowitz, *Democratic Vistas*, pp. 94, 138, 166, 168, 209; William C. Agee, *James Daugherty*, New York: Salander-O'Reilly Galleries, 1988; Janet Marqusee, *James Daugherty (1887–1974): American Modernist Works on Paper from the New Deal Era*, New York: Janet Marqusee Fine Arts, 1992.

ADOLF ARTHUR DEHN (1895–1968) was born in Waterville, Minnesota. He studied at the Minneapolis Art School with Gustav Goetsch from 1914 to 1917, then won a one-year scholarship to study at the Art Students League in New York, where he worked with Kenneth Hayes Miller. Dehn spent the years 1921 to 1929 in art-related travel in Europe, primarily in Vienna and in Paris, where he made lithographs at the Atelier Desjobert. Throughout this time, Dehn exhibited his work at the Weyhe Gallery in New York and contributed drawings both to magazines abroad and to the radical journal *The Masses*. Once resettled in New York, Dehn was a leading figure in printmaking circles. He established the Adolf Dehn Print Club in 1934 to publish and market his own work, and in the same year, began selling his prints through the Associated American Artists. Dehn was engaged by the Federal Art Project for a brief period in 1937. Dehn had worked exclusively in black and white until 1937—or halfway through his career—when he began to work in watercolor. Lithography and watercolor remained his two primary media, and his subjects ranged from social satire to landscape. He authored a treatise, *Water Color Painting* (New York: Studio Publications, 1945), and two other instructional books on lithography and watercolor in 1950 and 1955. Dehn taught on occasion and traveled extensively throughout his

life: to Asia, the Middle East, Mexico, and throughout the United States. He was twice the recipient of Guggenheim Fellowships (1939 and 1951), was elected an academician of the National Academy of Design (1961), and a member of the National Institute of Arts and Letters (1965).

SOURCES: Whitney Museum of American Art, vertical file material on Adolf Dehn, 1939–(ongoing); Woodstock Artists oral history collection, 1962–1975, Woodstock Library, Woodstock, New York; Carl Zigrosser (intro.), *Adolf Dehn Drawings*, Columbia, Missouri: University of Missouri Press, 1971; Richard W. Cox, "Adolf Dehn: Satirist of the Jazz Age," *Archives of American Art Journal* 18 (1978): 11–18; Douglas Dreishpoon (intro.), *Watercolors and Drawings of Adolf Dehn*, New York: Hirschl and Adler Galleries, 1986; Jocelyn Pang Lumsdaine and Thomas Sullivan, *The Prints of Adolf Dehn: A Catalogue Raisonné*, St. Paul, Minnesota: Minnesota Historical Society, 1987.

JOSEPH DELANEY (1904–1991) was born in Knoxville, Tennessee—the ninth of ten children including artist-brother Beauford Delaney—to a Methodist minister father. After completing ninth grade, Delaney worked as a bellhop in Knoxville. He left Tennessee at age eighteen and spent some years as a hobo, traveling throughout the Midwest, gambling and working odd jobs. He returned home briefly in 1929 but was lured to New York the following year by the success of his brother Beauford. Joseph studied at the Art Students League, first with Alexander Brook, and, more significantly, with Thomas Hart Benton and George Bridgman. Beginning in 1931 and for many years thereafter, Delaney showed his work in the Washington Square Outdoor Art Exhibit, where he sold his work and drew portraits of many prominent artists and acquaintances. Delaney received intermittent employment through the WPA; he assisted on Edward Laning's mural at the New York Public Library and contributed documentary drawings to the Index of American Design. In 1942, Delaney received a Julius Rosenwald grant to travel the Eastern seaboard. Following the years of New Deal support, Delaney supported his artwork through various odd jobs, and in 1978–80, through CETA funding, served as artist-in-residence at the Henry Street Settlement. He maintained a lifelong membership in the Art Students League, and regularly attended their life drawing classes.

SOURCES: *Who's Who in American Art*, 1947; Archives of American Art: Joseph Delaney papers; Greta Berman, *Joseph Delaney Parades*, New York: Henry Street Settlement, Louis Abrons Arts for Living Center, 1982; *Joseph Delaney*, Newark, New Jersey: Robeson Center Gallery, 1984; Sam Yates, *Joseph Delaney, Retrospective Exhibition*, Knoxville, Tennessee: Ewing Gallery of Art and Architecture, University of Tennessee, 1986.

WERNER DREWES (1899–1985) was born in Canig, Germany. He studied architecture and design before entering the Weimar Bauhaus in 1921, where he studied with Johannes Itten and Paul Klee. Following his two years in Weimar, he traveled extensively and worked for a period of time in the United States. In 1927, he was back in Germany and studying at the

Dessau Bauhaus, this time with Wassily Kandinsky and Oskar Schlemmer. In 1930, Drewes and his family moved to the United States. One of the few American painter-printmakers schooled in abstraction, Drewes was among the founding members of American Abstract Artists and also exhibited with the Société Anonyme, a short-lived circle of abstract artists that included Josef Albers and Katharine Dreier. He taught printmaking, painting, drawing, and photography over the years, most notably at the Brooklyn Museum School (1934–36); at Columbia University (1937–40); in the Graphic Division of the New York Federal Art Project (1940–41); at Stanley Hayter's Atelier 17 (1944–45); at the Institute of Design, or "New Bauhaus," in Chicago (1946); and finally at the School of Fine Arts, Washington University, in St. Louis (1946–65). He retired to Virginia in 1972.

SOURCES: Caril Dreyfuss, *Werner Drewes Woodcuts*, Washington, D.C.: National Collection of Fine Arts, Smithsonian Institution, 1969; Martina Roudabush Norelli, *Werner Drewes: Sixty Five Years of Printmaking*, Washington, D.C.: Smithsonian Institution Press for the National Museum of American Art, 1984; Ingrid Rose, *Werner Drewes: A Catalogue Raisonné*, Munich and New York: Verlag Kunstgalerie Esslingen, 1984; Acton, *Color in American Printmaking*, pp. 156–57, 260.

MABEL DWIGHT (1876–1955) was born in Cincinnati, Ohio, but spent her youth in New Orleans and California. She studied at the Hopkins School of Art in San Francisco, traveled throughout Europe and the Orient, and in 1927 (at the age of 50) made her first lithograph in Paris with the printer Duchâtel. A social satirist, Dwight is best known for her lithographs and was well represented in galleries and collections during her lifetime. She worked on both the graphic and easel projects of the New York City Federal Art Project, completing over 25 prints under federal sponsorship. Dwight died September 4, 1955, in Sellersville, Pennsylvania.

SOURCES: Mabel Dwight, "Satire in Art" (1936), reprinted in O'Connor, *Art for the Millions*, p. 275; *Who's Who in American Art*, 1937–1940; Archives of American Art: Holger Cahill papers, roll 1106, PWAP records, roll DC112; McKinzie, *The New Deal for Artists*, p. 85; Park and Markowitz, *New Deal for Art*, p. 87; The University of Michigan Museum of Art, *The Federal Art Project*, pp. 35–36; *Master Prints of Five Centuries: The Alan and Marianne Schwartz Collection*, p. 58; Francey, *American Women at Work*, p. 20; Robert Henkes, *American Women Painters of the 1930s and 1940s: The Lives and Work of Ten Artists*, Jefferson, North Carolina: McFarland Publishers, 1991.

PHILIP EVERGOOD (1901–1973) was born in New York City, but was raised and educated in England. He attended Eton and Cambridge before determining upon a career in art and entering the Slade School in London in 1921. Upon his graduation in 1923, he moved to New York, where he studied drawing at the Art Students League with George Luks, and learned etching from Philip Reisman and Harry Sternberg. Evergood studied in Paris on two occasions: in 1924–25 with André Lhote and in 1930 with Stanley Hayter at Atelier 17. In 1934, he

exhibited at the first of many Whitney Annuals and began his years of involvement with federally funded art programs. A painter of social subjects, Evergood was one of the leading voices among the politically engaged artists of his generation. He contributed articles to the journals *New Masses* and *Art Front*, participated in the "219 Strike" to protest layoffs by the Federal Art Project, served as president of the Artists Union and was an active member of the John Reed Club, the Artists' Congress, and several other artists groups. He supervised the easel division of the New York WPA in 1938 and executed three important murals during the Depression years: *The Story of Richmond Hill* at the Richmond Hill Public Library (1936–38), *Cotton from Field to Mill* at the Jackson, Georgia, post office (1938), and *The Bridge to Life* at Kalamazoo College in Michigan (1940–42). In 1943, Evergood was rejected for participation in the War Department art project because of his ties to progressive causes, and despite his withdrawal from social involvement in the late 1940s, he was called before the House Un-American Activities Committee in 1959. Evergood suffered frequent health problems, but continued to paint, draw, contribute illustrations, and exhibit his work until his death in 1973.

SOURCES: Philip Evergood, "Sure, I'm a Social Painter," *Magazine of Art* 36 (November 1943): 254–59; Herman Baron (foreword), *20 Years [of] Evergood*, New York: ACA Gallery, 1946; John I. H. Baur, *Philip Evergood*, New York: Whitney Museum of American Art, 1960; Lucy Lippard, *The Graphic Work of Philip Evergood*, New York: Crown Publishers, Inc., 1966; Shapiro, *Social Realism*, pp. 149–183; John I. H. Baur, *Philip Evergood*, New York: Harry N. Abrams, Inc., 1975; Kendall Taylor, *Philip Evergood: Never Separate From the Heart*, London and Ontario: Associated University Presses, 1986.

JARED FRENCH (1905–1988) was born in Ossining, New York, but grew up in Bradley Beach and Rutherford, New Jersey. He attended Amherst College from 1921 to 1925, then worked as a clerk on Wall Street while attending classes at the Art Students League with Kimon Nicolaides and Boardman Robinson. He met his lifelong friend, Paul Cadmus, in an etching class at the League, and the two toured Europe together from 1931 to 1933. They returned to New York in 1933, where French became involved in the Mural Section of the Public Works of Art Project and began exhibiting his paintings and etchings. His mural credits from this period include a Brooklyn high school mural (1934), post office murals in Plymouth, Pennsylvania (1938), and Richmond, Virginia (1939), and a series of seven panels for the New York State Vocational Institute in West Coxsackie (1939). In 1937, he married fellow artist Margaret Hoening. Over the next several years, the Frenchs and Cadmus maintained summer studios on Fire Island and collaborated on a series of figural photographs (titled PAJAMA, from their three first names) which were critical to French's painted compositions. French began working in egg tempera (vs. oil) in 1939—a shift in technique that accompanied the shift from a figurally based "American scene" style to the more enigmatic and monumental style that characterizes the bulk of his *oeuvre*. French met George Tooker, another master of tempera, in 1944.

Tooker thereafter joined the Frenchs and Cadmus at summer studios in Nantucket and Provincetown, and the four artists traveled together to Europe in 1949. It was also in 1949 that French began exhibiting his work with the Edwin Hewitt Gallery. Between 1950 and 1953, the Frenchs and Cadmus again made an extensive tour of Europe. They bought a house in Vermont in 1956, but relocated permanently to Rome in 1961, where Jared died in 1988.

SOURCES: Miller and Barr (eds.), *American Realists and Magic Realists*, pp. 36–37; Jared French, "Artists on Their Art," *Art International* 12 (April 20, 1968): 54; Wechsler and Spector, *Surrealism and American Art*, pp. 38–39; *PAJAMA Photographs, 1937–1954*, New York: Robert Samuel Gallery, 1980; Berman and Wechsler, *Realism and Realities*, pp. 13, 21, 24–26, 63, 65, 82, 89, 90, 93, 95–99; Josephine Gear, *Cadmus, French, & Tooker: The Early Years*, New York: Whitney Museum of American Art at Philip Morris, 1990; *Close Encounters: The Art of Paul Cadmus, Jared French, George Tooker*, New York: Midtown Payson Galleries, 1990; *The Rediscovery of Jared French*, New York: Midtown Payson Galleries, 1992; Nancy Grimes, *Jared French's Myths*, San Francisco: Pomegranate Artbooks, 1993.

HUGO GELLERT (1892–1985) was born in Budapest, Hungary, and emigrated with his family to the United States in 1907. He studied at the National Academy of Design and the Cooper Union in New York, and in 1914, at the Académie Julian in Paris. While his earliest work is of a design nature (movie posters and stained glass), he devoted his artwork to forwarding his leftist political beliefs upon his return from Paris in 1915. Throughout the late 1910s and the 1920s, he drew cartoon illustrations, designed posters, and contributed artwork to journals such as *The Masses* and *The Liberator*. In 1926, Gellert was also a contributing editor to *The New Masses*. He began his mural career in the late 1920s; his notable projects include the Workers' Cafeteria in Union Square (1928), a fresco at Rockefeller Center (1932), and a World's Fair mural under federal sponsorship (1938). Gellert's important graphic projects include a lithographic portfolio illustrating Marx's *Das Capital* (1934) and a portfolio of nineteen screenprints entitled *Century of the Common Man* (1943). Gellert was politically active throughout this period: he co-founded the earliest anti-fascist group in America, chaired the Artists Committee of Action, and was a founding member of the Mural Artists Guild of the AFL-CIO and the American Artists' Congress. During the war, Gellert belonged to the group Artists for Victory and designed several war posters. Following the war, Gellert continued to use his art toward political ends in the design of posters, banners, and murals against racism and militarism. Retrospectives of his work were held at the Marx-Lenin Institute in Moscow (1967) and the National Gallery in Budapest (1968).

SOURCES: Don Brown, "Hugo Gellert—A Happy Rebel," *Liberator* 6 (1923); Rebecca Zurrier, *Art for the Masses (1911–1917): A Radical Magazine and its Graphics*, New Haven: Yale University Art Gallery, 1985; Mary Ryan and Jeff Kisseloff, *Hugo Gellert*, New York: Mary Ryan Gallery, 1986; Acton, *Color in American Printmaking*, pp. 150, 264–65; Virginia

Hagelstein Marquardt, "Art on the Political Front: From Liberator to Art Front," *Art Journal* 52 (Spring 1993): 73–77.

BORIS GORELICK (1909–1984) was born in Russia and emigrated to the United States in 1913. He lived in New York and studied at the National Academy of Design, the Art Students League and Columbia University. Among his significant instructors were Nicholai Fechin, Sergie Soudekin, Leon Kroll, Sidney Dickinson, and Hugh Breckinridge. Gorelick received a Tiffany Scholarship and studied for a while at Oyster Bay, Long Island, as well as at the Yaddo Colony in Saratoga Springs, New York. Like Ribak and others of his generation, Gorelick was employed in the early 1930s by the Morgan Committee—a philanthropic organization set up during the early years of the Depression that paid artists to decorate New York City churches and synagogues. Gorelick and others from the hundred or so artists on the Morgan team were the core group behind the formation of the Artists Union, which in turn was instrumental in fomenting the Federal Art Project under the wing of the Works Progress Administration. Gorelick was president of the Artists Union for a number of years, contributed to the union's journal, *Art Front*, and addressed the American Artists' Congress in February of 1936. In 1933, he was involved in Treasury Section murals at Riker's Island and King's County Hospital with Michael Loew and O. Louis Guglielmi. Gorelick was a member of the New York lithography workshop from its inception, and in 1935–36, traveled to Phoenix to set up the local FAP school of art and design there. He moved to California in 1942, and during the war, did industrial design for Lockheed and the Hughes Corporation. Around 1945, Gorelick began working in the movie industry as an animator and designer. He taught part-time at the Otis Art Institute and was involved in several mural projects for leading California architectural firms.

Sources: Archives of American Art: Betty Hoag interview, May 20, 1964; Park and Markowitz, *New Deal for Art*, pp. 9, 88; Fowler, *New Deal Art*, p. 46.

WILLIAM GROPPER (1897–1977) was born in New York City and studied at the National Academy and New York School of Fine and Applied Art with George Bellows, Robert Henri, and Howard Giles. He began his career as a cartoonist and illustrator in 1919 at the *New York Tribune*, and over the years contributed drawings to several journals, including *Morning Freiheit*, *The New Masses*, *Vanity Fair*, and *Fortune*. An acknowledged social commentator, Gropper traveled to the Soviet Union with Sinclair Lewis, Theodore Dreiser, and Scott Nearing in 1927; he published his drawings of Russia in 1929. Gropper began his association with the progressive ACA Gallery in 1930, where he exhibited paintings, prints, and drawings throughout his life. Under Depression-era federal sponsorship, Gropper painted murals at the Freeport, Long Island, post office (1936), at the Department of the Interior building in Washington (1938), and at the Northwestern Station post office in Detroit (1939). Gropper received a Guggenheim Fellowship in 1937, and traveled to the devastated dust bowl area of Oklahoma and to the site of the Boulder Dam, which was under construction. Gropper

was able to support himself with his painting and illustration work following the Depression, and enjoyed international exhibitions of his work. Like other socially engaged artists of his generation, Gropper was called before the Senate during Senator McCarthy's "Red Scare," an event that had an adverse effect upon his career. In 1968, however, he was elected to the National Institute of Arts and Letters.

SOURCES: William Gropper papers, 1918–1968, George Arents Research Library for Special Collections at Syracuse University, Syracuse, New York; Joe Jones (text), *Gropper*, New York: ACA Galleries, 1940; August L. Freundlich, *William Gropper Retrospective*, Los Angeles: Ward Ritchie Press, 1968; Anthony J. Gahn, "William Gropper—Radical Cartoonist," *The New York Historical Society Quarterly* 54, no. 1 (January 1971): 111–14; Shapiro, *Social Realism*, pp. 184–213; Park and Markowitz, *New Deal for Art*, pp. 96–97; Louis Lozowick, *William Gropper*, New York and London: Associated University Presses and Cornwall Books, 1983; Park and Markowitz, *Democratic Vistas*, pp. 21–22, 53, 55, 137–38, 160, 162–66, 214, 220, 234.

GEORGE GROSZ (1893–1959) was born (and died) in Berlin. He studied at the Dresden Academy and the Kunstgewerbeschule under Emil Orlik before traveling to Paris and coming into contact with draftsman Jules Pascin. Grosz had served intermittently during World War I, but a mental collapse released him permanently from military service. In 1916, he co-founded *Neue Jugend*, the first German Dada periodical. Grosz was also active contributing drawings and publishing print portfolios laden with social criticism and satire, for which he was three times tried for defamation of public morals. He was for a time an active Communist, but became disenchanted following a 1922 visit to the Soviet Union. One of the leading commentators of the period, Grosz later wrote "I considered all art senseless unless it served as a weapon in the political arena." Grosz left Germany by necessity in 1938, became a United States citizen, and taught at the Art Students League. Perhaps the most influential of the German artists to seek refuge in America, Grosz nonetheless practiced a far less engaged form of artwork once settled in New York. Watercolors of Provincetown and New York cityscapes characterize the work of his American years.

SOURCES: George Grosz, *A Little Yes and a Big No: The Autobiography of George Grosz*, New York: The Dial Press, 1946; John I. H. Baur, *George Grosz*, London: Thames and Hudson, 1954; Uwe M. Schneede, *George Grosz: His Life and Work*, New York, Universe Books, 1975; Peter Nisbet (ed.), *German Realist Drawings of the 1920s*, Cambridge: Harvard University Art Museums, Busch-Reisinger Museum, 1986, pp. 49, 222–23; M. Kay Flavell, *George Grosz: A Biography*, New Haven: Yale University Press, 1988; Sherwin Simmons, "War, Revolution, and the Transformation of the German Humor Magazine, 1914–1927," *Art Journal* 52 (Spring 1993): 46–54.

O. LOUIS GUGLIELMI (1906–1956) was born in Egypt to Italian parents. His father was an orchestral musician, and the family lived in Milan and Geneva before emigrating to New York in 1914. Guglielmi attended night classes at the National Academy of Design from 1920 to 1921, took sculpture classes at the Beaux-Arts Institute from 1921 to 1923, and began four years of full-time study at the National Academy in 1923. He was guest artist at the Yaddo Colony in Saratoga Springs, New York, in 1928 and spent the first of eleven summers at the MacDowell Colony in 1932. During this time he worked as an assistant to a mural painter, a store clerk and commercial artist. Guglielmi had to qualify for home relief before he was employed by the easel division of the Public Works of Art Program from 1935 to 1939. During the Depression years, and later, he exhibited at the Museum of Modern Art and the Downtown Gallery. He was selected as one of twenty-eight contemporary artists for the 1943 show, American Realists and Magic Realists. That same year, Guglielmi was drafted into the army and served in the Army Engineer Corps until 1945. He taught at Louisiana State University in 1950, again in 1952–53, and at the New School for Social Research in 1953. He died in 1956 while traveling in Italy.

SOURCES: Miller and Barr (eds.), *American Realists and Magic Realists*, pp. 38–39; O. Louis Guglielmi, "I Hope to Sing Again," *Magazine of Art* (May 1944): 173–77; *O. Louis Guglielmi Memorial Exhibition*, New York: Nordness Gallery, 1958; Wechsler and Spector, *Surrealism and American Art*, pp. 39–42, 80; Park and Markowitz, *New Deal for Art*, p. 77; John Baker, *O. Louis Guglielmi: A Retrospective Exhibition*, New Brunswick, New Jersey: Rutgers University Art Gallery, 1980; Hills, *Social Concern and Urban Realism*, p. 53; Ilene Susan Fort, "American Social Surrealism," *Archives of American Art Journal* 22, no. 3 (1982): 8–20.

JAMES GUY (1910–1983) was born in Middletown, Connecticut. He studied at the Hartford Art School with Albertus Jones and Kimon Nicolaides. By the late 1920s, Guy was exhibiting his work, primarily landscapes and still-lifes, in the annual exhibition of the Wadsworth Atheneum in Hartford. He had a one-man exhibition at the Atheneum in 1932, and moved to New York in the same year. Through his artist-friend Anton Refregier, Guy became involved in the John Reed Club and taught in its art school. Guy, together with fellow club member and friend Walter Quirt, were among the few American artists who employed surrealism for revolutionary social commentary art. In 1933, Guy was one of the founding members of the Unemployed Artists Group, which, in common with the Artists Union, lobbied for federal support of public art. It is during this period that Guy became involved in the production of a labor play, *Strike*, in Provincetown, Massachusetts. At some point, Guy apparently studied mural painting in Mexico with Orozco and visited the Mexican muralist when he was painting at Dartmouth College (1932–34). Guy himself painted a now-lost political mural for the Thirteenth Street Communist Worker School. In 1935, Guy again exhibited his work in Hartford, at the Museum Annex, which was followed by one-man exhibitions at the Boyer Gallery (1939) and the Ferargil Gallery (1941–1944). For the WPA/FAP, he worked on the easel project and completed two murals: one for Hartford High School and the second for

an elementary school in Meriden, Connecticut. During the war, Guy worked in an aircraft factory. Fascinated with the abstract forms of the air equipment, Guy radically changed his art. He abandoned his earlier surrealism and social commentary for increasingly non-objective compositions. Guy's teaching career began soon afterward. He was on the faculty at Bennington College, Bennington, Vermont, from 1945 to 1946; MacMurray College, Jacksonville, Illinois, from 1946 to 54; and Wesleyan University, Middletown, Connecticut, from 1963 to 1975.

SOURCES: Wechsler and Spector, *Surrealism and American Art*, pp. 40, 42, 81; Ilene Susan Fort, "American Social Surrealism," *Archives of American Art Journal* 22, no. 3 (1982): 8–20; Ilene Susan Fort, "James Guy: A Surreal Commentator," *Prospects* 12, (1987): 125–148; Cummings, *Dictionary of Contemporary American Artists*, pp. 299–300.

ROBERT GWATHMEY (1903–1988) was born in Richmond, Virginia. He studied at North Carolina State, Maryland Institute, and the Pennsylvania Academy of Fine Arts, and secured a teaching position at Beaver College in Jenkintown, Pennsylvania, in 1930. Gwathmey's job disqualified him for relief employment with the Federal Art Project, but during this period he was actively involved in the Artists Union (vice president for a time), exhibited at the ACA Gallery, and was much involved in the social activism of the period. Gwathmey's southern upbringing led him to explore the particular themes of rural poverty and African-American life. In 1939, he was a winner in the 48 States Mural Competition and painted a mural for the Eutaw, Alabama, post office. Gwathmey was also involved in several war-related art exhibitions and projects, including the "Artists for Victory" events of 1944 and the ACA Gallery's "Artists in the War" group show. Gwathmey received Rosenwald Fellowships in 1944 and 1945, and spent this time working alongside black laborers on a southern tobacco farm. From 1938 to 1942, he taught at Carnegie Tech in Pittsburgh, and from 1942 until his retirement in 1968, he taught at the Cooper Union in New York. A painter as well as a printmaker specializing in screenprints, Gwathmey exhibited his work throughout his lifetime and was occasionally engaged in commercial projects. He was elected to the National Academy of Design in 1976, and passed his retirement at his Long Island home and studio.

SOURCES: Paul Robeson (intro.), *Robert Gwathmey*, New York: ACA Gallery, 1946; Archives of American Art: Paul Cummings interview, March 5, 1968; Jonathan Ingersoll (essay), *Robert Gwathmey*, St. Mary's City, Maryland: St. Mary's College of Maryland and New York: Terry Dintenfass, Inc., 1976; Landau, *Artists for Victory*, pp. 44–45; Judd Tully, "Robert Gwathmey," *American Artist* 49 (June 1985): 46–50; Charles K. Piehl, "Robert Gwathmey: The Social and Historical Context of a Southerner's Art in the Mid Twentieth Century," *Arts in Virginia* 29, 1 (1989): 2–15; Acton, *Color in American Printmaking*, pp. 164, 265.

EDWARD HAGEDORN (1902–1982) was born in San Francisco and was self-taught as an artist. A prolific draftsman, painter, and printmaker, Hagedorn described himself as a "clam digger by profession" in a 1946 article in *The Skylight*. He worked in a cartoonlike manner centered in political, social, and often apocalyptic imagery. Hagedorn was employed by the Bay Area Works Progress Administration in the late thirties, and created a number of large drypoints and relief prints in response to the war. These latter works, including his entry to the 1944 "Artists for Victory" exhibition, earned him several prizes and some critical notice. In 1952, he published a portfolio of ten nude etchings in conjunction with the poetry of Oscar Vladislas Milosz for Peregrine Press in San Francisco.

SOURCES: Landau, *Artists for Victory*, p. 46; *Edward Hagedorn* (exhib. notice), New York: The Old Print Shop, 1991.

ELLA SOPHONISBA HERGESHEIMER (1873–1943). SOURCES: James C. Kelly, *Landscape and Genre Painting in Tennessee, 1810–1935*. Nashville: Tennessee Historical Society, 1985; Estill Curtis Pennington, *Morris Museum of Art: A Southern Collection*, Augusta, Georgia: Morris Communications Corporation, 1992.

JOSEPH HIRSCH (1910–1981) was born in Philadelphia. He studied at the Philadelphia Museum School of Industrial Design and later, with George Luks in New York. In 1935, he was awarded the Woolley Fellowship to study in Paris, and returned to the United States by way of the Far East. Hirsch had his first one-man show at ACA Galleries in 1937. One of the leading members of the Philadelphia Federal Art Project, Hirsch executed three large murals during the late 1930s: at the Benjamin Franklin High School (1938), the Amalgamated Clothing Workers Building (1939), and the Municipal Court Building (1940). His contribution to the 1939 New York World's Fair, the painting *Two Men* (now in the Museum of Modern Art), received the popular vote for the best painting of the show, as did his entry, *Daybreak*, in the 1964 fair. Among his many honors in this period, Hirsch had sixteen paintings in the Museum of Modern Art's exhibition "Americans 1942," and soon after won two successive Guggenheim Fellowships (1942–43; 1943–44). During the war years, Hirsch worked for Abbott Laboratories; his commissions for Abbott yielded one of the most reproduced War Bond posters of the period (*Till We Meet Again*), and Hirsch's accreditation as a war artist-correspondent. In this last capacity, he toured training facilities in Pensacola, Florida, and battle areas in the Pacific and Italy for the Abbott Collections of Naval Aviation and Naval Medicine Paintings. Hirsch continued to paint, draw, and exhib-it throughout his life. He was elected to the National Insti-tute of Arts and Letters in 1967, and received a major retrospective at the Georgia Museum of Art in 1970. He visited numerous art schools, including the Art Institute of Chicago, and taught at the Art Students League for the fifteen years preceding his death.

SOURCES: Dorothy C. Miller (ed.), *Americans 1942: 18 Artists from 9 States*, New York: Museum of Modern Art, 1942, p. 60; Frank Getlein (intro.), *Joseph Hirsch*, Athens, Georgia: University of Georgia, 1970; Sylvan Cole, *The Graphic Work of Joseph Hirsch*, New York: Associated American Artists, 1970; Diane G. Cochrane, "The Vision of Joseph Hirsch," *American Artist* 36 (October 1972): 26–31, 75–76; Hills, *Social*

Concern and Urban Realism, p. 59; *Realism and Realities*, pp. 49–50, 89, 163.

JOE JONES (1909–1963) was born in Saint Louis, Missouri. His father was a house painter and Jones continued the family trade, while teaching himself easel painting. By the early 1930s, Jones had won local awards, sold a few paintings, and instructed local art classes. Jones spent the summer of 1933 in Provincetown, where his working class beliefs grew into avowed communism through contact with like-minded artists. Soon after his return, Jones joined the rolls of the Public Works of Art Project in St. Louis and was later commissioned to paint a mural at the City Hospital. Jones also led art classes at the courthouse for the unemployed on a volunteer basis, and in December 1934, was evicted from the courthouse studios for a propagandistic mural and posters resulting from his class. He left for New York soon after and mounted a successful one-man show at the American Contemporary Art Gallery in the spring of 1935. Throughout the 1930s, Jones's artwork evolved from a very pointed social realism into a lyrical midwestern regionalism. He traveled the back roads as a documentarist for the Resettlement Administration, painted five post office murals under federal sponsorship, and even directed a summer art school in Missouri with compatriots James Turnbull and Thomas Hart Benton. Jones completed two important private mural projects in these years: a political mural at Commonwealth College in Mena, Arkansas, and *The Story of Grain* for a St. Louis merchant (now installed at the Haggerty Art Museum, Marquette University). He won a Guggenheim Fellowship in 1937. In 1943, Jones joined the War Art Unit just a few months before it was disbanded and was quickly picked up as a *Life* magazine correspondent. He also designed war posters in these years, and under the management of the Associated American Artists Gallery began his postwar career in commercial art. Jones painted for the collections (and advertising campaigns) of Standard Oil, Abbott Laboratories, Encyclopaedia Brittanica, and other corporations. He also contributed illustrations to leading magazines and designed four murals for cruise liners before his 1963 death in Morristown, New Jersey.
SOURCES: Archives of American Art: Associated American Artists scrapbooks, roll D256; Herman Baron (intro.), *Joe Jones*, New York: ACA Gallery, 1937; *Who's Who in American Art*, 1940; Detroit Institute of Arts, *Ben Shahn, Charles Sheeler, Joe Jones*, Detroit: 1954; Park and Markowitz, *Democratic Vistas*, pp. 16, 49, 114–16, 134, 137–38, 158, 202, 210–11, 216; Hills, *Social Concern and Urban Realism*, p. 60; Joe Jones, "Repression of Art in America," in Baigell and Williams, *Artists against War and Fascism*, pp. 75–76; Karal Ann Marling (essay), *Joe Jones and J. B. Turnbull: Visions of the Midwest in the 1930s*, Milwaukee, Wisconsin: Haggerty Museum of Art, Marquette University, 1987.

MERVIN JULES was born in 1912 in Baltimore, Maryland. He graduated from Baltimore City College in 1930, studied painting at the Maryland Institute of Fine Arts, and in 1933, continued his studies in New York at the New School and with Thomas Hart Benton at the Art Students League. Jules taught first at the Educational Alliance in his native Baltimore, at which time the Phillips Collection purhased one of his paintings. He returned to New York in 1937, and had his first one-man show at the Hudson Walker Gallery. Jules continued to be represented by Hudson Walker and the ACA Gallery. While engaged by the Federal Art Project in the late 1930s and early 1940s, Jules was involved with the innovative Silkscreen Group at the Workshop School on East 10th Street. In 1941, he was one of the participants in the call to congress in defense of culture against fascism, and the associated publication, *Winter Soldiers*. During the war, he made posters and exhibited in both the "Artists for Victory" and "America in the War" exhibitions. Jules had an extensive teaching career. He taught at the Fieldston School, the Museum of Modern Art, the War Veteran's Center in New York City, and in 1946, began a twenty-three year career at Smith College in Northampton, Massachusetts. He left Smith to chair the art department at the City College of New York in 1969, where he remained until his retirement in 1980.
SOURCES: Archives of American Art: ACA Galleries records, 1917–1966; Hudson D. Walker papers, 1920–1982; Whitney Museum of American Art, vertical file material on Mervin Jules, 1944–(ongoing); *Who's Who in American Art*, 1947, 1953; Landau, *Artists for Victory*, pp. 53–54; James Watrous and Andrew Stevens, *American Color Woodcuts: Bounty from the Block, 1890s–1990s*, Madison, Wisconsin: Elvehjem Museum of Art, 1993, p. 116.

ROCKWELL KENT (1882–1971) was born in Tarrytown, New York. His art teachers, within and outside of institutions, included William Merritt Chase, Abbott Thayer, Robert Henri, and Kenneth Hayes Miller. He attended Columbia University (1900–02) and the New York School of Art in 1904. Kent traveled widely throughout his life—most notably to Newfoundland (1914–15), Alaska (1918–19), Tierra del Fuego (1922), and Greenland (1926). One of America's most popular and successful illustrators, he documented these travels for magazines and his own publications. Kent was also active politically and a member of many if not all of the leftist organizations and artists' cooperatives that proliferated during the 1930s. A painter as well as a printmaker, Kent's federally sponsored mural in the Washington, D.C., post office (1937) caused a furor when it was discovered he included an incendiary political message in Eskimo dialect within his composition. These activities, and his travels to Russia, later led to his harassment by Senator Joseph McCarthy during the "Red Scare." Kent's colorful life has been amply documented in his illustrated travel books, his three autobiographies, and the many publications related to his prolific career, including an active journal, *The Kent Collector*.
SOURCES: Dan Burne Jones, *The Prints of Rockwell Kent*, Chicago and London: The University of Chicago Press, 1975; David Traxel, *An American Saga: The Life and Times of Rockwell Kent*, New York: Harper & Row, 1980; Fridolf Johnson, *Rockwell Kent, An Anthology of His Works*, London: Collins Publishers, 1982; Richard West, *An Enkindled Eye: The Paintings of Rockwell Kent*, Santa Barbara, California: Santa Barbara Museum of Art, 1985.

SELECTED WRITINGS BY KENT: *N by E*, Cornwall, New York: Blue Ribbon Books, 1930; with Carl Zigrosser, *Rockwellkentiana: Few Words and Many Pictures*, New York: Harcourt, Brace & Co.; *How I Make a Woodcut*, Esto Publishing Company, Pasadena, California: 1934; *This is My Own*, New York: Duell, Sloan & Pierce, 1940; *It's Me O Lord: The Autobiography of Rockwell Kent*, New York: Dodd, Mead, 1955.

HENRY KOERNER (1915–1994) was born in Vienna, Austria, to a middle-class Jewish family. He graduated from the Graphic Academy of Applied Art in Vienna in 1937, and worked for poster artist Viktor Slama until Hitler's invasion of Austria in 1938. Koerner went first to Italy, then emigrated to the United States in 1939; his parents remained in Vienna and were ultimately killed in a Nazi concentration camp. In the United States, Koerner worked as a commercial artist and won many poster competitions—earning him a job in the Office of War Information making posters. Here he met Ben Shahn and Bernard Perlin, making his first paintings at their encouragement in egg tempera, gouache, and casein. Drafted in 1943, Koerner was assigned to the Office of Strategic Services, and in 1944 traveled to England and later, Germany. After the war, he spent two years in Berlin, working as a civilian with the Graphics Division of U.S. Military Government. This was an important moment in Koerner's artistic and personal career; he revisited his native Vienna and learned of his parents' demise, and he worked on a group of paintings that resulted in a very well-received 1947 exhibition in Berlin. He then returned to New York and his paintings were successfully shown at Midtown Galleries. Koerner and his work were featured in *Time, Life,* and *Fortune* magazines at this time. He lived in Manhattan from 1947 to 1952, and in 1949 won the Temple Gold Medal for best painting in the Pennsylvania Academy Award Exhibition. In 1952–53, Koerner served as artist-in-residence at Chatham College in Pittsburgh and married Joan Frasher there. He later taught at the California College for Arts and Crafts and Munson-Williams-Proctor Institute School of Art in Utica, New York, before returning to live in Pittsburgh. Throughout the 1950s, he continued to show at Midtown Galleries, exhibited in the Whitney Annuals, and enjoyed several one-man shows and group exhibitions. Between 1955 and 1967, Koerner contributed forty-one painted portraits as published covers to *Time* magazine.

SOURCES: *Austellung Henry Koerner USA 1945–1947: Gemalde und Graphik*, Haus am Waldsee, Germany: Amt fur Kunst Kehlendorf, 1947; "Henry Koerner," *Life* (10 May 1948): 77; Paul Chew, "A Taped Interview between Henry Koerner and Paul Chew," *Henry Koerner Retrospective Exhibition*, Greensburg, Pennsylvania: The Westmoreland County Museum of Art, 1971; Berman and Wechsler, *Realism and Realities*, pp. 65, 67–69, 78, 80, 82, 89–91, 114; Gail Stavitsky, *From Vienna to Pittsburgh: The Art of Henry Koerner*, Pittsburgh: Museum of Art, Carnegie Institute, 1983.

JACOB LAWRENCE was born in 1917 in Atlantic City, New Jersey. His family moved to Harlem when he was a teenager, and in after-school classes at the Utopia House, Lawrence was encouraged to paint by artist Charles Alston. Lawrence's first formal art classes began in 1932 at the 135th Street Public Library under Alston. He continued his education at the WPA-sponsored Harlem Art Workshop and earned a scholarship to the American Artist's School in 1937, where he studied with Anton Refregier, Sol Wilson, and Eugene Morley. Lawrence had his first one-man show in 1938 at the Harlem YMCA, and the following year began an eighteen-month stint with the easel division of the New York Federal Art Project. His first of many one-man shows at the Downtown Gallery was held in 1940. Lawrence's early paintings focused on life in the community of Harlem. He soon began working on a series format to address historical figures and aspects of the African-American experience, as well as genre subjects. Carefully researched and accompanied by often lyrical text, his important series include: *Frederick Douglass* (1938–39), *Harriet Tubman* (1939–40), *Migration of the Negro* (1940–41), and the *Harlem* series (1942). Lawrence served in the Coast Guard during the war. In 1944, his one-man show at the Museum of Modern Art was the first ever accorded to a black artist. His various series also began touring nationally at this time, and in 1946, he received a Guggenheim Fellowship. Lawrence began teaching in the 1950s, and over the years he has taught at Black Mountain College in North Carolina, the Pratt Institute, the New School for Social Research, the Art Students League, and, beginning in 1971, the University of Washington. Through Lawrence's career as a major painter, printmaker, designer of murals, and author-illustrator, he continues to address issues of racism and black life in America.

SOURCES: Jacob Lawrence papers, 1937–1971, George Arents Research Library for Special Collections at Syracuse University, Syracuse, New York; Shapiro, *Social Realism*, pp. 215–247; Milton W. Brown, *Jacob Lawrence*, New York: Whitney Museum of American Art, 1974; Hills, *Social Concern and Urban Realism*, pp. 64–65; Ellen Harkins Wheat, *Jacob Lawrence: American Painter*, Seattle: University of Washington Press in association with the Seattle Art Museum, 1986; Richard Powell, *Jacob Lawrence*, New York: Rizzoli Books, 1992; Elizabeth Hutton Turner (ed.), *Jacob Lawrence: The Migration Series*, Washington, D.C.: Rappahannock Press in association with the Phillips Collection, 1993.

JOSEPH LEBOIT was born in New York City in 1907. He studied at the College of the City of New York and at the Art Students League with Thomas Hart Benton and Jean Charlot. Between 1935 and 1939, LeBoit worked in the silkscreen unit of the New York Graphic Division and was a project administrator. His total print production under federal sponsorship numbered twenty-five prints in a variety of graphic media. During the war, LeBoit was elected corresponding secretary of both the Artists Societies for National Defense and Artists for Victory, of which he was also one of the directors. As a program chairman for this latter organization, he directed the "America in the War" exhibition, which toured nationally. LeBoit showed his own work in the ACA Gallery's 1942 "Artists in the War" exhibition and enjoyed a one-man show

at that gallery in 1946. He was employed as staff artist at *PM* magazine during the 1940s. LeBoit was later a teacher at the Newark and Jamaica high schools.

SOURCES: Joseph LeBoit and Hyman Warsager, "The Graphic Project: Revival of Printmaking," *Art Front* 3 (December 1937): 9; *Who's Who in American Art, 1940–1947;* Archives of American Art: Artists for Victory, Inc., records, 1942–1946; Landau, *Artists for Victory,* p. 64; Fowler, *New Deal Art,* p. 66; University of Michigan, *The Federal Art Project,* p. 98.

JACK LEVINE was born in 1915 in Boston, where he was also raised and educated. Levine studied with Harold Zimmerman at a Boston settlement house and privately with the important collector and theorist Denman Ross—then retired from Harvard—who also helped support the young artist from 1929 to 1931. Levine worked on the Federal Art Project in Boston from 1935 to 1940, during which time he also showed his work at the Downtown Gallery, the Metropolitan, the Muse-um of Modern Art, and the Carnegie Annuals. During the war, he was deployed as an artist-correspondent to Ascension Island, St. Helena, and received second purchase prize for his painting *String Quartette* at the 1943 Artists for Victory exhibition. He returned to New York in 1945 and received a Guggenheim Fellowship that year and again in 1947. He had a major retrospective at the Whitney in 1955. His many prizes include a Fulbright Fellowship (1950–51) and election to the National Institute of Arts and Letters (1956).

SOURCES: Archives of American Art: Ruth Gikow papers, 1936–1982; *Americans 1942: 18 Artists from 9 States,* New York: Museum of Modern Art, 1942, pp. 86–87; Whitney Museum of American Art, vertical file material on Jack Levine, 1944–(ongoing); Fred S. Wight (essay), and Lloyd Goodrich (foreword), *Jack Levine,* New York: Whitney Museum of American Art, 1955; Frank Getlein, *Jack Levine,* New York: Harry N. Abrams, Inc., 1966; Shapiro, *Social Realism,* pp. 248–277; Berman and Wechsler, *Realism and Realities,* pp. 11, 27–29, 31, 49, 115, 165; Kenneth Wade Prescott and Emma-Stina Prescott, *The Complete Graphic Work of Jack Levine,* New York: Dover Books, 1984; Jack Levine (commentary), *Jack Levine,* New York: Rizzoli International Publications, Inc., 1989.

LOUIS LOZOWICK (1892–1973) was born in the Ukrainian town of Ludvinovka. He studied at the Kiev Art School from 1903 to 1906, the year in which he emigrated to the United States. Lozowick returned to his studies in 1912 at the National Academy of Design and continued at Ohio State University, graduating in 1918. He served in the Army Medical Corps from 1918 to 1919, traveled cross-country upon his discharge, and spent the following five years abroad in Paris, Moscow, and Berlin. During this formative period, he began exhibiting his *Machine Ornament* drawings and abstract paintings based upon American cities. He made his first lithograph in Berlin in 1923. Lozowick returned to New York in 1924, where he lectured on modern Russian art for the Société Anonyme, took on various design commissions, and continued to explore lithography. An eloquent writer, he joined the executive board of the radical journal *New Masses* in 1926.

Lozowick also participated in organizing the 1927 Machine Age Exposition. He held his first one-man exhibition of lithographs—primarily soaring urban and industrial scenes—at the Weyhe Gallery in 1929. During the Depression, Lozowick's subject matter shifted to more human and less optimistic imagery. The secretary to the American Artists' Congress and an active member of the John Reed Club, Lozowick also participated in the various artistic offices of the WPA between 1935 and 1940. Under federal sponsorship he made prints in various media and painted, including a pair of murals for a Manhattan post office (circa 1937). Lozowick and his family moved to South Orange, New Jersey, in 1943, and the remainder of his career included some teaching and lecturing, a great deal of travel, and the continued production of lithographs. Lozowick was elected to membership in the National Academy of Design in 1972.

SOURCES: Archives of American Art: Louis Lozowick papers; Louis Lozowick, "The Americanization of Art," *Machine Age Exposition,* 1927; Louis Lozowick, "Lithography: Abstraction and Realism," *Space* 1 (March 1930): 31–33; William C. Lipke, *Abstraction and Realism, 1923–1943: Paintings, Drawings, and Lithographs of Louis Lozowick,* Burlington, Vermont: Robert Hull Fleming Museum, University of Vermont, 1971; Esther Forman Singer, "The Lithography of Louis Lozowick," *American Artist* 37 (November 1973); Barbara Zabel, "Louis Lozowick and Technological Optimism of the 1920s," Ph.D. dissertation, University of Virginia, 1978; Janet Flint, *The Prints of Louis Lozowick,* New York: Hudson Hills Press, 1982.

NAN LURIE was born in 1910. Little is known of her life and career beyond her participation in the graphic division of the New York Federal Art Project between 1935 and 1942. There she produced many lithographs, as well as prints in other media, some of which concern the experience of African-Americans during the Depression years.

SOURCES: Park and Markowitz, *New Deal for Art,* p. 92; Helen A. Harrison and Lucy R. Lippard, *Women Artists of the New Deal Era: A Selection of Prints and Drawings,* Washington, D.C.: National Museum of Women in the Arts, 1988.

GEORGE MARINKO (1908–1989) was born in Derby, Connecticut. He studied at Yale with Louis York and at the Waterbury Art School. Marinko painted in the surrealistic manner, and completed at least one painting, *Moon Ring Fantasy,* while engaged on the Federal Art Project in Connecticut. He is also credited with creating a decorative map mural in the Aldermanic chamber of the Waterbury City Hall and exhibiting one painting in the 1939 New York World's Fair. Marinko taught at the Waterbury Art School. He apparently stopped working in the surrealist style in the 1940s.

SOURCES: *Who's Who in American Art,* 1937–1940; Ryerson and Burnham Libraries, Art Institute of Chicago, WPA archives; Wechsler and Spector, *Surrealism and American Art,* pp. 34–35, 94; Peter H. Falk, *George Marinko, 1908–1989: Pioneer American Surrealist* (memorial exhibition at the John Slade Ely House, New Haven, Connecticut), Madison, Connecticut: Sound View Press, 1989.

KYRA MARKHAM (1891–1967), née Elaine Hyman, was born in Chicago. Around 1907, she studied at the School of the Art Institute of Chicago. Two years later, she began acting at Chicago's Little Theater, and in 1913 met the author Theodore Dreiser. She moved to New York and lived with Dreiser in Greenwich Village from 1914 to 1916 while continuing her work on the stage. Her next move was to Provincetown, Massachusetts, where she was a member of the Provincetown Players until the mid-1920s. Throughout this time, Markham wrote poetry and plays, and supplemented her stage salary with design work for the publishing industry and as an art director for the Fox and Metro film companies. In 1927, she married the scene designer David Stoner Gaither, and returned to painting herself. She painted murals in New York restaurants and bars, and studied with Alexander Abels at the Art Students League in 1930. In 1934, she began working in lithography, and in 1935, she received the prestigious Mary S. Collins Prize at the annual exhibition of the Philadelphia Print Club. Markham worked in the lithography workshop of the New York Federal Art Project in 1936, and her prints appeared in *Fine Prints of the Year* in 1937 and 1938. Markham continued making prints throughout the late 1930s and 1940s, many of which were sold through the American Artists, Inc. At the New York World's Fair in 1939, she painted over forty dioramas in the Hall of Inventions. Markham moved to Vermont in 1946, where she resumed painting and began making ceramics. After her husband's death in 1957, she moved to Port-au-Prince, Haiti, where she continued to paint and exhibit until her death in 1967.
SOURCES: *Who's Who in American Art,* 1935–53; Archives of American Art: Elizabeth McCausland papers; Merna Popper, *Kyra Markham Graphic Works, 1934–35,* Bronxville, New York: Sarah Lawrence College Art Gallery, 1977; Lee D. Witkin (intro.), *Kyra Markham: American Fantasist (1891–1967),* New York: The Witkin Gallery, 1981; *Graphic Excursions,* plate 68, p. 148; Francey, *American Women at Work,* p. 32.

JACK MARKOW (1905–1982) was born in England, but apparently moved to the United States some time before 1935. He studied at the Art Students League in New York with Boardman Robinson, Richard Lahey, and Walter Jack Duncan. Between 1936 and 1939, Markow participated in the Graphics Division of the New York City Federal Art Project, and made at least twenty-five prints, some of which were color lithographs. He had a one-man show at the ACA Gallery in 1938. Among Markow's published works from this period is a caricatural lithograph included in *12 Cartoons Defending WPA by Members of the American Artists Congress,* published in 1939. Markow taught at the School of Visual Arts in New York from 1947 to 1955, but the larger part of his career was as an illustrator and cartoonist. He was cartoon editor of *Argosy* magazine from 1950 to 1952, and his work was published in *The New Yorker, McCalls, Saturday Evening Post, Harper's* magazine, and many other national publications. He wrote three books on drawing and selling cartoons, which have posthumously been published in one volume.
SOURCES: Archives of American Art: Correspondence of managing editor of *Harper's* magazine, Russell Lynes, with artists, 1946–1962; *Who's Who in American Art,* 1958–1964; McKinzie, *The New Deal for Artists,* p. 150; University of Michigan, *The Federal Art Project,* p. 116; Jack Markow, *The Art of Cartooning,* New York: Perigee Books, 1990.

REGINALD MARSH (1898–1954) was born in Paris to American parents, both of whom were artists. He studied at Yale and, beginning in 1920, at the Art Students League in New York with John Sloan, George Luks, George Bridgman, and Kenneth Hayes Miller. Marsh supported himself throughout the 1920s as an illustrator and theater curtain designer. Marsh's own artwork focused on the bawdy street life of New York City and the vibrant rail yards and shipyards of the greater metropolis. In the late 1920s and early 1930s, he was considered a member of the Fourteenth Street School, or Whitney Studio Club—a group of artists including Alexander Brook, Peggy Bacon, and Yasuo Kuniyoshi who had studios in the Fourteenth Street neighborhood and often exhibited together. He furthered his anatomical knowledge by attending classes at the College of Physicians and Surgeons in 1931 and at Cornell University Medical College in 1934. Marsh worked in virtually all media: he sketched thousands of figure studies and in 1945 published a treatise, *Anatomy for Artists;* he taught himself etching, took photographs, and painted in oil and fresco. During the Depression era, he painted several murals under federal sponsorship, including projects for the Washington, D.C. post office building (1936) and the Custom House in New York City (1936–37). He taught at the Art Students League from 1935 until his death in 1954.
SOURCES: William Benton, "Reg Marsh—American Daumier," *Saturday Review,* (December 24, 1955): 8–9; Lloyd Goodrich, *Reginald Marsh,* New York: Whitney Museum of American Art, 1955; *East Side, West Side, All Around the Town: A Retrospective Exhibition of Paintings, Watercolors and Drawings by Reginald Marsh,* Tucson: University of Arizona Museum of Art, 1969; Norman Sasowsky, *The Prints of Reginald Marsh,* New York: Clarkson N. Potter, Inc., 1976; Marilyn Cohen, *Reginald Marsh's New York,* New York: Whitney Museum of American Art in association with Dover Publications, 1983; Hills, *Social Concern and Urban Realism,* p. 69.

PAUL MELTSNER was born in New York City in 1905. He attended classes at the National Academy of Design in New York from 1920 to 1927, and studied with Ivan Olinski and Charles Courtney Curran. He won several awards with the academy and was also the winner of a Tiffany Foundation Fellowship. Meltsner worked in oil, watercolor, and lithography; he also drew illustrations. Several of his works of the early 1930s dealt with themes of labor and industry; he later focused on portraiture, and, in particular, celebrity portraits. Under federal sponsorship, Meltsner painted a post office mural in Bellevue, Ohio, in 1937. He enjoyed several one-man shows at the Midtown Galleries in New York, and twice organized exhibitions and sales for the benefit of the war effort.
SOURCES: *Who's Who in American Art,* 1937–40; Ryerson and Burnham Libraries, Art Institute of Chicago, Artists pamphlet file; Park and Markowitz, *Democratic Vistas,* p. 223.

CLAIRE MAHL MOORE (1910–1988) was born in New York City. She studied at the National Academy of Design and at the Art Students League with Harry Wickey, Charles Locke, and Thomas Hart Benton. Moore also attended the workshop of David Siqueiros upon the encouragement of classmate Jackson Pollock. Between 1934 and 1942, she was intermittently supported by government funding, and produced at least twenty prints in the New York graphics division. During the 1940s Moore worked with Fernand Leger at his New York studio and at the New School for Social Research. In 1946, she had a one-woman show of watercolors and gouaches at the ACA Gallery. Moore moved to California in the 1950s, where she studied with David Park at the San Francisco Art Institute, founded *Artist's View* magazine, and taught at the Marion Hartwell School of Design. She had been engaged in book arts since the 1940s, and after her return to New York in the 1960s, founded the Children's Underground Press. Her late years were highly productive. Moore drew, painted, and created artists' books and children's games. She taught at Brooklyn College (1970–74) and the College of Staten Island (1980–88), and won MacDowell Colony Fellowships (1977 and 1979) as well as Tiffany and Gottlieb Foundation grants. She actively exhibited her work until the end of her life.

SOURCES: University of Michigan, *The Federal Art Project*, p. 126; Edith Isaac-Rose, "Claire Moore, 1912–1988," *Women Artists News* 13, no. 4 (Winter 1988/89): 33; *A Memorial Exhibition, Claire (Mahl) Moore, Work on Paper: The WPA to the 1980s*, New York: Susan Teller Gallery, 1989; *Graphic Excursions*, plate 90, p. 149; Francey, *American Women at Work*, p. 34.

ELIZABETH OLDS (1897–1991) was born in Minneapolis, Minnesota. She studied at the University of Minnesota, the Minneapolis School of Art, and the Art Students League in New York with George Luks. Olds was the first woman artist to receive a Guggenheim Fellowship. With that 1926–27 grant, she studied in Paris, Belgium, Holland, and Italy. Olds lived in Nebraska from 1932 to 1935, during which time she made her first lithograph and worked in the Omaha Public Works of Art Project. She returned to New York, joined all of the important artist coalitions, began her exhibition career at the ACA Gallery, and participated in the Federal Art Project from 1936 to 1940. During that time, she created lithographs, woodcuts, and was among the seven artists involved in the development of the silkscreen process at the New York Federal Art Project graphic workshop. Olds was also a founding member of the Silk Screen Group, later the National Serigraph Society. She published the first of her six children's books in 1945. Throughout the 1950s and 1960s, Olds traveled frequently to Central America and worked at the MacDowell Colony and the Yaddo Colony, as well as in her Long Island studio. She moved to Sarasota, Florida, in 1971.

SOURCES: Archives of American Art: Elizabeth Olds papers; Elizabeth Olds, "Prints for Mass Production," (1936), printed in O'Connor, *Art for the Millions*, p. 144; O'Connor, *The New Deal Art Projects*, p. 168; Marling and Harrison, *Seven American Women*; Park and Markowitz, *New Deal*, p. 93; University of Michigan, *The Federal Art Project*, p. 108; Kenneth W. Prescott and Susan E. Arthur, *Elizabeth Olds Retrospective Exhibition: Paintings, Drawings, Prints*, Austin, Texas: The RGK Foundation, 1986; Francey, *American Women at Work*, p. 36.

BERNARD PERLIN was born in Richmond, Virginia, in 1918. Beginning in 1934, he studied at the New York School of Design, the National Academy of Design, and the Art Students League in New York City. Perlin received a Kosciuszko Foundation Scholarship in 1938 and traveled to Poland in the summer of that year. In 1939, Perlin painted a mural for the South Orange, New Jersey, post office under the Treasury Relief Art Program. From 1942 to 1943, Perlin worked with Ben Shahn in the Graphics Division of the Department of War Information in Washington, D.C. This experience with Shahn was critical for the development of Perlin's tempera technique. In the remaining years of the war, he worked as a war correspondent for *Life* and *Fortune* magazines, covering the Middle East and the Pacific. From 1946 to 1948, Perlin taught at the Brooklyn Museum Art School, then spent the following six years in Italy, partially financed by the Chaloner Prize in 1948 and a Fulbright Scholarship in 1950. He received Guggenheim Fellowships in 1954 and 1959. He exhibited at Catharine Viviano Gallery throughout the 1960s, and taught briefly at the Wooster Community College in Danbury, Connecticut.

SOURCES: *The New Decade: Thirty-Five American Painters and Sculptors*, New York: Whitney Museum of American Art, 1955; Katharine Kuh, *American Artists Paint the City* (28th Venice Biennale), Chicago: Art Institute of Chicago, 1956; Park and Markowitz, *Democratic Vistas*, p. 218; Berman and Wechsler, *Realism and Realities*, pp. 6, 23, 26, 31, 78, 80, 86, 90, 107–8, 163.

ALTON PICKENS was born in Seattle, Washington, in 1917. He studied at Reed College from 1936 to 1938, where he was encouraged in his artwork by an English professor, Lloyd J. Reynolds. On Reynolds' advice, Pickens enrolled in the Portland Museum Art School, but left for New York City after only one semester. Beginning in 1939, he took classes at the New School for Social Research and studied the collections of the Metropolitan and the Museum of Modern Art. He worked part-time in a union office, taught WPA art classes, and contributed political prints and cartoons to the journals *Now* and *The New Masses*. Throughout the 1940s and 1950s, Pickens developed his particular brand of "symbolic realism" which he often expressed in the form of political allegories. In 1944, he submitted a woodcut to the landmark "Artists for Victory" exhibition. In 1946, Pickens' paintings were featured in the Museum of Modern Art's "Fourteen Americans" exhibition. He received a similar honor in the Whitney's 1955 show, "The New Decade: Thirty-Five American Painters and Sculptors." Pickens was frequently represented by Herman Baron's ACA Gallery. Sculpture was his primary interest during the 1960s, under the influence of travel to Italy and Greece. Pickens again embraced painting as his primary medium in the 1970s, and this later work tended toward abstraction.

SOURCES: Dorothy C. Miller (ed.), *Fourteen Americans*, New York: Museum of Modern Art, 1946, pp. 49–53; Alton Pickens, "There Are No Artists in Hiroshima," *Magazine of Art* 40 (October 1947): 238; "Nineteen Young Americans," *Life* 28, no. 12 (March 20, 1950): 89; *The New Decade: Thirty-Five American Painters and Sculptors*, New York: Whitney Museum of American Art, 1955, p. 67; Wechsler and Spector, *Surrealism and American Art*, pp. 39, 98; Peter Morrin, *Alton Pickens: Paintings, Prints, Sculpture*, Poughkeepsie, NY: Vassar College Art Gallery, 1977; Berman and Wechsler, *Realism and Realities*, pp. 6, 59–60, 65, 70–71, 75, 84, 89, 103–4, 114, 145.

WALTER QUIRT (1902–1968) was born in Iron River, Michigan. He studied at the Layton School of Art in Milwaukee, Wisconsin, and taught there from 1924 to 1928. Quirt was invited to spend a year at the MacDowell Art Colony in 1928–29, and thereafter moved to New York City. In New York, he became an active member of the John Reed Club, contributed drawings and illustrations to the radical journal *New Masses*, and worked as illustrator for the magazine *New Pioneer*. Quirt was attracted to surrealist art, and along with fellow John Reed Club member James Guy developed a style that may be described as "social surrealism." He exhibited at Julien Levy Gallery—the primary venue for surrealist art in America—in 1936 and again in 1939 and 1940. Quirt was invited to work at the Yaddo Colony in 1934, and began teaching at the American Artists School in the same year. His involvement with the WPA/Federal Art Project began in 1935 and continued on and off until 1941, during which time he painted murals for the Psychiatric Pavilion at Bellevue Hospital and lectured on aspects of surrealism. Quirt's lectures on theoretical issues began to form a major component of his work, and in 1942, he published a series of four essays in the journal *Pinacotheca* concerning the form and content of social art in America. He taught from 1945 to 1947 at Michigan State College in East Lansing, and in 1947 began his lifelong position of professor in the Art Department at the University of Minnesota, Minneapolis. Quirt continued his theoretical writing, and exhibited frequently in New York, at the Walker Art Center in Milwaukee, at the University of Minnesota, and elsewhere, until his death in 1968.

SOURCES: *Who's Who in American Art*, 1947, 1953; Archives of American Art: Walter Quirt papers; Walter Quirt, "Art's Theoretical Basis," *College Art Journal* XII, no. 1 (Fall 1952): 12–15; Robert Coates, *Walter Quirt*, New York: American Federation of Arts, Thistle Press, 1960; Wechsler and Spector, *Surrealism and American Art*, pp. 40, 42–43, 99; Mary Towley Swanson, *Walter Quirt: A Retrospective*, Minneapolis: University Gallery, University of Minnesota, 1980; Ilene Susan Fort, "American Social Surrealism," *Archives of American Art Journal* 22, no. 3 (1982): 8–20.

ANTON REFREGIER (1905–1979) was born in Moscow, Russia. His family moved to Paris in 1920, where he studied briefly with the sculptor Vassiliev before moving on to the United States in the same year. Refregier studied at the Rhode Island School of Design from 1921 to 1925. In 1927, he spent some time in Munich studying drawing with Hans Hofmann. Refregier settled in New York thereafter and worked as a decorator. During the 1930s, he was active in the John Reed Club, the Artists Union and the American Artists' Congress. He contributed illustrations to the *New Masses* and various trade union papers, and also published pamphlets on the Tom Mooney case and the Scottsboro trial. One aspect of his social activism was the design of select stage productions and private murals, such as the interior of the racially integrated Café Society Uptown. Refregier was employed by various offices of the WPA from 1934 to 1940, during which time he painted murals at the Children's Ward of Greenpoint Hospital (1935–36), the Riker's Island Penitentiary (1937), and the Federal Works Agency Building at the 1939 New York World's Fair, for which he won second prize in the popular vote for best mural. In 1940, Refregier had the first of many one-man exhibitions at the ACA Galleries in New York. He also painted two murals for the Plainfield, New Jersey, post office (1940–42) and a series of murals for the SS *President Polk* in 1942. Refregier designed posters for the War Bond Drive in 1943 and attended the United Nations Organizational Conference in San Francisco in 1945 to provide illustrations for *Fortune* magazine. In 1941, Refregier won the national mural competition to decorate the Rincon Annex of the San Francisco post office, a $26,000, twenty-seven panel mural cycle that was the largest public commission of the period. The murals were not carried out until 1946–49, and were threatened with destruction during the 1950s because of their perceived leftist sentiment. Throughout the 1950s, 1960s, and 1970s, Refregier designed tapestries, murals, and mosaics, drew illustrations, and taught periodically. He received a retrospective exhibition at the Museum of Fine Arts, Moscow, and the Hermitage in Leningrad in 1966.

SOURCES: Archives of American Art: oral history collection; Whitney Museum of American Art, vertical file material on Anton Refregier, 1944–(ongoing); Anton Refregier, *An Artist's Journey*, New York: International Publishers, 1965; David B. Lawall and Brian N. Wallis, *Anton Refregier*, Charlottesville, Virginia: University of Virginia Art Museum, 1977; Park and Markowitz, *New Deal for Art*, pp. 6, 44, 55–56; Hills, *Social Concern and Urban Realism*, p. 75.

PHILIP REISMAN (1904–1992) was born in Warsaw, Poland. His family emigrated to the United States when he was twelve years old, and settled in New York City. In the 1920s and 1930s, Reisman worked as a waiter while studying at the Art Students League with George Bridgman, George Luks, and others. He and his studiomate, Harry Sternberg, took private lessons with the league's graphics instructor, Harry Wickey, in 1927–28. In 1932, Reisman held his first one-man show at the Painters & Sculptors Gallery in New York, and in 1933–34 he lived and worked at the Yaddo Colony in Saratoga Springs, New York. Reisman was employed by the Public Works Art Project (PWAP) in 1934, and traveled through the south recording regional architecture. Like many of his peers, Reisman was an active member of the John Reed Club, the Artists Union, and the American Artists' Congress in the

1930s. While employed by the WPA between 1935 and 1942, Reisman completed a mural for the psychiatric ward at Bellevue Hospital entitled *The Interdependence of Industry and Agriculture*, and prepared for a second mural (never executed) at the Rehabilitation Pier, a New York City center for homeless men. In 1944, Reisman's painting *Feature Act* was awarded the Pepsi-Cola award for painting at the "Portrait of America" Exhibition at the Carnegie Institute. During the 1940s and 1950s, Reisman contributed illustrations to magazines such as *Fortune*, and to book publishing concerns including Random House, Book-of-the-Month Club, and the Modern Library. He has also worked as an instructor at the American Artists School and the Educational Alliance. Reisman also continued painting, focusing on scenes of New York City street life. In 1982, Reisman was elected to the National Academy of Design.

SOURCES: Archives of American Art: ACA Galleries records, 1917–1966; Park and Markowitz, *New Deal for Art*, p. 50; Joseph Veach Noble (essay), *The Sixties and Seventies: Paintings of New York City by Philip Reisman*, New York: Museum of the City of New York, 1979; Patricia Van Gelder, "Philip Reisman: Manhattan Chronicles," *American Artist* 43 (October 1979): 68–73, 114–15; Hills, *Social Concern and Urban Realism*, pp. 76–77; Martin H. Bush, *Philip Reisman: People Are His Passion*, Wichita, Kansas: Edwin A. Ulrich Museum of Art, Wichita State University, 1986; George D. Bianco, *The Prints of Philip Reisman: Catalogue Raisonné*, Bedford, New York: Bedford Press, 1992.

LOUIS RIBAK (1902–1979) was born in the province of Grodino in Lithuania. His family emigrated to New York in 1912, and he began his art studies in 1920 at the Pennsylvania Academy of Fine Arts with the academic painter Daniel Garber. Ribak moved to New York in 1922, and studied at the Art Students League with John Sloan, who secured for Ribak a scholarship to continue his studies. He attended the Educational Alliance for two years, was financed for a time by the Whitney Museum, and found his subjects among the children and transients of the East River waterfront. Like Sloan, Ribak also drew political cartoons in this period. In 1932, Ribak exhibited with An American Group—a group of socially concerned artists such as Orozco, Marsh, Kuniyoshi, and Davis—who showed their work at the Barbizon Plaza Gallery. Ribak had his first one-man show there in 1933. Ribak also worked under the sponsorship of the Morgan Committee—a philanthropic organization set up during the Depression that paid artists to decorate New York City churches and synagogues. The hundred or so artists on the Morgan team were the core group behind the formation of the Artists Union, which in turn was instrumental in fomenting the Federal Art Project under the wing of the Works Progress Administration. Ribak was ultimately hired onto the Easel Division of the New York FAP in 1935, and he painted a post office mural in Albemarle, North Carolina, in 1936. With the American entry into the war, Ribak was drafted (overage) and served as a ranger in Alabama, Missouri, and upstate New York. He first came to New Mexico for health reasons exacerbated by his rangering, and eventually settled in Taos with his wife, the artist Beatrice Mandelman. Ribak's palette brightened with the change of climate, and his subjects shifted from Native American scenes to increasingly abstract compositions. In 1947, he opened the Taos Valley Art School. While in New Mexico, he enjoyed several local and traveling exhibitions. He worked primarily in casein, tempera, and oil on masonite, as well as in the watercolor medium.

SOURCES: *Who's Who in American Art*, vol. 1–4; Archives of American Art: oral history collection, Sylvia Loomis interview, July 20, 1964; Donald O. Strel, *Louis Ribak Retrospective*, Santa Fe, New Mexico: Museum of New Mexico, 1975; *Louis Ribak: The Late Paintings*, Roswell, New Mexico: Roswell Museum and Art Center, 1984.

PETER SAUL was born in 1934 in San Francisco. After studying at Stanford University, he attended the California School of Fine Arts from 1950 to 1952 and Washington University from 1952 to 1956. Saul followed his studies with several years of travel and residence abroad, in Holland, Paris, and Rome. Saul began exhibiting with dealer Allan Frumkin in 1961 and in 1962 won both the *Art in America* New Talent Award and a Copley Foundation grant. His work has always been subject-oriented as opposed to formalist, and his subjects have ranged from pornography and violence to politics, racism and sexism. Saul is both a painter and a draftsman, and his works often involve untraditional materials such as Day-Glo paint, magic markers, and children's crayons. In 1981, Saul began teaching at the University of Texas, Austin.

SOURCES: Archives of American Art: Peter Saul interview, 1972; Peter Saul, Dennis Adrian, and Joshua Kind, *Peter Saul*, DeKalb, Illinois: Swen Parson Gallery, 1980; Robert Storr, "Peter Saul: Radical Distaste," *Art in America* 73 (January 1985): 92–101; Cummings, *Dictionary of Contemporary American Artists*, pp. 567–68; Annette Dimeo Carlozzi (curator), *Peter Saul*, Aspen, Colorado: Aspen Art Museum, 1989; Dan Cameron, "The Trials of Peter Saul," *Artsmagazine* 64 (January 1990): 71–75.

EUGENE FRANCIS SAVAGE (1883–1978) was born in Covington, Indiana, and moved to Washington, D.C., at the age of fifteen. He began his art studies in night classes at the Corcoran Gallery of Art and in 1901 moved to Chicago. He worked in an engraving house during the day and attended night school at the Art Institute until 1909, when he entered daytime classes there and at the Chicago Academy of Fine Arts. Savage won a fellowship to study abroad in 1912 and spent the next three years at the American Academy in Rome and in European travel. He returned to the States in 1915. During the early 1920s, Savage won several awards including the Architectural League of New York gold medal (1921) and the Altman Prize from the National Academy of Design (1923) for his large decorative paintings. He began a long-term teaching career at Yale University in the 1930s as the Leffingweel Professor of Painting, but continued to travel, paint, and take on mural commissions and other architectural projects including sculptural projects. Savage helped administer the mural decorations of the 1939 New York

World's Fair, and in 1949, he designed the mosaic mural for the American Military Cemetery in Epinal, France.

SOURCES: Eugene Francis Savage papers, 1925–1966, George Arents Research Library for Special Collections at Syracuse University, Syracuse, New York; Eugene Savage, *On Art Education*, New York: Carnegie Corporation of America, 1929; *Who's Who in American Art*, 1935–1953; Archives of American Art: New York Public Library Art Division scrapbooks, roll N55; Art Institute of Chicago, Ryerson and Burnham Libraries, artists' pamphlet files.

PALMER SCHOPPE was born in 1912 and raised in Santa Monica, California. He served in the Merchant Marines for one year before entering the Yale School of Fine Arts. Schoppe continued his art education at the Art Students League in New York with Thomas Hart Benton and Jean Charlot. He returned to the West Coast in 1935 via the South Carolina Gullah community, New Orleans, and Texas, and he documented his travels in a series of drawings and, ultimately, lithographs printed by Lynton Kistler in Los Angeles. During the war, Schoppe was director of animation in the United States Signal Corps. He has also taught at Walt Disney Studios, the Chouinard School of Motion Picture Arts, the Art Center College of Design, and UCLA.

SOURCES: Archives of American Art: Palmer Schoppe printed material, 1936–1943; "Palmer Schoppe: Watercolors, Lithographs & Drawings," (mimeographed press release), Los Angeles, California: Tobey C. Moss Gallery, 1993.

KARL SCHRAG was born in 1912 in Karlsruhe, Germany. In 1931, his family moved to Zurich and he attended art school first in Geneva and then in Paris, studying at the Ecole Nationale Superieure des Beaux-Arts, the Académie Ranson, and the Académie de la Grande Chaumière. Schrag lived in Belgium from 1936 to 1938, where he had his first one-man exhibition at the Galerie Arenberg in Brussels. In 1938, Schrag traveled to the United States, and was introduced to the etching process by Harry Sternberg at the Art Students League in New York. His social commentary prints from this period were shown with the Society of American Etchers and at the 1942 Whitney Annual. In 1945, Schrag joined Atelier 17—an experimental graphic workshop founded in New York by the French master Stanley William Hayter. While Schrag's intaglio work moved increasingly toward abstraction at this time, his mature work is based upon studies of nature and distinguished by calligraphic marks. He has also worked in oil and watercolor, and showed his paintings at Kraushaar Galleries from 1947 onward. In 1950, Schrag served briefly as director of Atelier 17. He taught printmaking at Brooklyn College in 1953, and in 1954, began a thirteen-year teaching career at the Cooper Union. In 1962, Schrag produced eleven lithographs at the Tamarind Lithography Workshop on a Ford Foundation grant. He has received several retrospective exhibitions of his graphic work, and was elected to the National Academy of Design in 1981.

SOURCES: Archives of American Art: Karl Schrag papers, 1937–1970, and Karl Schrag interviews, 1970; John Gordon, *Karl Schrag*, New York: Whitney Museum of American Art, American Federation of the Arts, 1960; August Freundlich, *Karl Schrag: A Catalogue Raisonné of the Graphic Works, 1939–1970*, Syracuse, New York: Syracuse University, 1970; Joanne Moser, *Atelier 17: A 50th Anniversary Retrospective Exhibition*, Madison, Wisconsin: Elvehjem Art Center, 1977; August Freundlich, *Karl Schrag: A Catalogue Raisonné of the Graphic Works, Part II, 1971–1980*, Syracuse, New York: Syracuse University, 1980; Domenic J. Iacono (intro.), *Karl Schrag: A Catalogue Raisonné of the Graphic Works, Part III, 1981–1990*, Syracuse, New York: Syracuse University, 1990; Acton, *Color in American Printmaking*, pp. 206, 284.

BEN SHAHN (1898–1967) was born in Kovno, Lithuania, and in 1906, he emigrated with his family to the United States, where they settled in Brooklyn. Shahn apprenticed in a lithography shop while attending night classes, but began daytime classes in 1919, first at New York University and City College of New York, and then at the National Academy of Design. He traveled throughout Europe and North Africa between the years 1924 to 1929, and in 1930, had his first of many shows at the Downtown Gallery in New York. Perhaps the most prolific and important of the socially conscious artists of the New Deal era, Shahn expressed himself in several media. He was involved in a number of federally sponsored mural projects, including the design for the Riker's Island Penitentiary (1934–35, ultimately rejected); the fresco decorations for the federal housing project at Roosevelt, New Jersey, where he also lived (1938); with wife Bernarda Bryson, the post office murals for the Bronx Central Annex (1938–39); and a major series for the Federal Social Security building in Washington, D.C. (1940–42). Shahn was employed as a photographer and designer for the Farm Security Administration from 1935 to 1938. From 1942 to 1944, Shahn designed posters for the Office of War Information as well as the Political Action Committee of the CIO. By 1945, he directed the graphic arts division of the CIO. Shahn enjoyed one-man exhibitions of both paintings and graphics at major museums for the remainder of his life. In 1956–57, he served as Norton Professor of Poetry at Harvard University and his lecture series was published under the title *The Shape of Content*. Shahn also designed mosaic murals and stage sets. As with his Depression era works, Shahn's postwar *oeuvre* was often committed to exposing social injustice.

SOURCES: Ben Shahn, *The Shape of Content*, New York: Harvard University Press, 1957; James Thrall Soby, *Ben Shahn: His Graphic Art*, New York: George Braziller, Inc., 1957; James Thrall Soby, *Ben Shahn Paintings*, New York: George Braziller, Inc., 1963; John D. Morse, (ed.), *Ben Shahn*, New York: Praeger Publishers, Inc., 1972; Kenneth Prescott, *The Complete Graphic Work of Ben Shahn*, New York: Quadrangle Press, The New York Times Book Company, 1973; Shapiro, *Social Realism*, pp. 278–312; Frances K. Pohl, *Ben Shahn: New Deal Artist in a Cold War Climate*, Austin, Texas: University of Texas Press, 1989; Laura Katzmann, "The Politics of Media: Painting and Photography in the Art of Ben Shahn," *American Art* 7 (Winter 1993): 60–87; Frances K. Pohl, *Ben Shahn*, San Francisco: Pomegranate Artbooks, 1993.

MOSES SOYER (1899–1974) was born in Borisoglebsk, Russia, and emigrated with his family to the United States in 1912. The family settled first in Philadelphia and later in New York, where Moses—along with his brothers, Raphael and Isaac—attended a number of art schools. Moses studied for given periods at the Cooper Union, the National Academy of Design, the Educational Alliance, and informally with George Bellows and Robert Henri at the Ferrer Art Club. In 1926, he won a scholarship to study in Europe, where he visited the museums of Paris, London, Rome, and Amsterdam. Soyer began teaching upon his return in 1928, and was employed by the Educational Alliance, followed by the Contemporary Art School, the New Art School, and the New School for Social Research. During the Depression, however, Soyer was in a position to receive relief work. On the WPA easel project, he painted (among other things) a series of ten portable panels on the theme of child life for use in New York City libraries and hospitals. He also worked on a pair of panels for a Philadelphia post office with his brother Raphael. Moses enjoyed a successful painting career with a specialization in figure painting and in 1964, published a treatise on the subject. He became a member of the National Institute of Arts and Letters in 1966.

Sources: Archives of American Art: Moses Soyer papers 1920–1974, ACA Galleries records 1917–1966, Associated American Artists records 1934–1981; Moses Soyer, "Three Brothers," *Magazine of Art* 32, no. 4 (April 1939): 201–7, 254; Bernard Smith, *Moses Soyer*, New York: ACA Galleries, 1945; Charlotte Willard, *Moses Soyer*, Cleveland: World Publishing Co., 1962; Moses Soyer, *Painting the Human Figure*, New York: Watson-Guptill Publications, 1964; Alfred Werner, *Moses Soyer*, South Brunswick: A.S. Barnes and Co., 1970; Martin H. Bush (intro.), *Moses Soyer: A Human Approach*, New York: ACA Galleries, 1972; Hills, *Social Concern and Urban Realism*, pp. 86–87.

HARRY STERNBERG was born in New York City in 1904. He worked at a variety of odd jobs while taking classes at the Brooklyn Museum and Art Students League with George Bridgman and Harry Wickey. Wickey introduced Sternberg to printmaking in 1927 and worked with him until 1929. Sternberg had his first solo exhibition at the Weyhe Gallery in 1932, and showed his work at Herman Baron's ACA Gallery for many years. In 1933, Sternberg became the graphic arts instructor at the Art Students League, replacing Wickey. He received a Guggenheim Fellowship in 1936, which he spent among the coal and steel workers in Pennsylvania. In the same year, he won the Treasury Department (TRAP) competition for a post office mural in Sellersville, Pennsylvania; he also completed post office murals in Chicago and Chester, Pennsylvania, in 1938. A master technician in graphic processes, Sternberg was an early practitioner of offset lithography, and an important pioneer in the craft of silkscreen, or serigraphy. He actively promoted the use of silkscreen for the production of war posters. Sternberg served as advisor to the graphic arts division of the New York City FAP, and published the first successful handbook on screenprinting. Sternberg has also been an important educator. He continued to teach at the Art Students League, make prints, and exhibit his work throughout the 1940s and 1950s. In 1959, he moved to California to direct the art department at the Idyllwild School of Music and Art of the University of California. He taught at the Palm Springs Desert Museum from 1980 to 1983. He currently resides in California and continues to exhibit both paintings and prints.

SOURCES: Archives of American Art: Harry Sternberg papers 1928–1988, ACA Galleries records 1917–1966, sketchbook of New York City subway riders, circa 1925; Harry Sternberg, *Silk Screen Color Printing*, New York: McGraw-Hill, 1942; Carl Zigrosser, *The Artist in America: 24 Close-ups of Contemporary Printmakers*, New York: Alfred A. Knopf, 1942, pp. 62–69; James C. Moore, *Harry Sternberg: A Catalogue Raisonné of His Graphic Work*, Wichita, Kansas: Edwin A. Ulrich Museum of Art, Wichita State University, 1975; Landau, *Artists for Victory*, pp. 112–13; Acton, *Color in American Printmaking*, pp. 116, 286; Bella Lewitzky (foreword), *Sternberg: A Life in Woodcuts*, San Diego, California: Brighton Press, 1991.

GEORGE TOOKER was born in Brooklyn in 1920. He graduated from Harvard in 1942 with a degree in English literature, served for one year in the U.S. Marine Corps, and entered the Art Students League the following year. He studied with Reginald Marsh and Kenneth Hayes Miller at the league, and privately with Paul Cadmus, from whom he learned the egg tempera technique used in all of his painting. Tooker's friendship with Cadmus, as well as with Jared and Margaret French, formed an important element of his life and career; he both traveled and painted with this circle of so-called "magic realist" artists. Tooker had a precocious beginning and sold a painting to the Whitney Museum at the age of 29, two years before his first one-man show at the Edwin Hewitt Gallery. During the 1950s and 1960s, he enjoyed both one-man and group exhibitions in major galleries and museums. Tooker received a grant from the National Institute of Arts and Letters in 1960 and taught painting at the Art Students League from 1965 to 1968. A major retrospective of Tooker's paintings was organized in 1974 by the San Francisco Palace of the Legion of Honor. Tooker currently resides in Vermont.

SOURCES: Archives of American Art: George Tooker papers 1932–1973, George Tooker interview 1966; *The New Decade: Thirty-Five American Painters and Sculptors,* New York: Whitney Museum of American Art, 1956, p. 87; Thomas Garver, *George Tooker: Paintings, 1947–1973,* San Francisco: Fine Arts Museum of San Francisco; Merry Foresta, *George Tooker,* Los Angeles: David Tunkl Gallery, 1980; Berman and Wechsler, *Realism and Realities,* pp. 6, 9, 13, 19–21, 24, 26, 31, 40, 63, 65, 90–91, 93, 103, 110, 114, 165, 169; Josephine Gear, *Cadmus, French, & Tooker: The Early Years,* New York: Whitney Museum of American Art at Philip Morris, 1990; *Close Encounters: The Art of Paul Cadmus, Jared French, George Tooker,* New York: Midtown Payson Galleries, 1990; Thomas Garver, *George Tooker,* San Francisco: Pomegranate Artbooks, 1992.

STUYVESANT VAN VEEN was born in New York City in 1910. He studied at the Pennsylvania Academy of Fine Arts, the

National Academy of Design, the Art Students League, the New York School of Industrial Art, and Columbia University. His instructors include Daniel Garber and Thomas Hart Benton. Active as a muralist, Van Veen served with Biddle as officer of the Mural Artists' Guild. Van Veen was also active as a satirist and contributed illustrations to the *New Masses* and other radical publications. In 1937, Van Veen designed a mural for the Pittsburgh post office and courthouse that contrasted a class and a classless society based on Marxist principles. When the Treasury Section asked that he alter certain features of this design, he submitted an entirely new design that did not, however, alter his original intention. The result was a panoramic view of Pittsburgh in the shape of a hammer and sickle. It was Van Veen's last contract with the Treasury Section. During this same period, the artist also did anthropological drawings for Franz Boas at Columbia University. Van Veen taught at the Cincinnati Academy of Art from 1946 to 1949, and joined the Art Department of the City College of New York in 1953.

SOURCES: Archives of American Art: Stuyvesant Van Veen papers 1926–1979, Stuyvesant Van Veen interviews, 1981; *Who's Who in American Art*, 1947, 1953; McKinzie, *The New Deal for Artists*, p. 58; Park and Markowitz, *New Deal for Art*, pp. 14, 35; Park and Markowitz, *Democratic Vistas*, pp. 56–59, 227.

LYND WARD was born in Chicago in 1905. He studied at Columbia University, then traveled to Germany, where he studied with Hans Alexander Mueller at the Academy of Graphic Arts in Leipzig. Ward returned to the United States in 1927 and embarked upon a career in book illustration. His first book, *God's Man*, was published in 1929; it was the first of six "novels in woodcuts" (illustrated tales without text) in the manner of the German master Frans Masereel. Ward was politically active: he addressed the first American Artists' Congress in 1936 and his woodcut novels were pointed in their social commentary. After the war, Ward continued his work as an illustrator, working in woodcut, wood engraving, and lithography. He wrote children's books and articles about printmakers and printmaking. Ward also illustrated children's books by his wife, May McNeer, as well as hundreds of books published by Limited Editions, Heritage Clubs, and others.

SOURCES: Lynd Ward, *God's Man: A Novel in Woodcuts*, New York: Cape and Smith, 1929; Lynd Ward, *Wild Pilgrimage: A Novel in Woodcuts*, New York: H. Smith and R. Haas, 1932; Lynd Ward, *Wood Engravings 1929–1974*, New York: Associated American Artists, 1974; *Lynd Ward, Storyteller Without Words: The Wood Engravings of Lynd Ward*, New York: Harry N. Abrams, Inc., 1974.

SELECTED BIBLIOGRAPHY:

Acton, David. *A Spectrum of Innovation: Color in American Printmaking 1890–1960.* Worcester, Massachusetts: Worcester Art Museum, 1990.

Adams, Clinton. *American Lithographers 1900–1960: The Artists and their Printers.* Albuquerque: The University of New Mexico Press, 1983.

America Today: A Book of 100 Prints, Chosen and Exhibited by the American Artists' Congress. New York: Equinox Cooperative Press, 1936.

American Art Today: New York World's Fair. New York: National Art Society, 1939.

American Contemporary Art. Vol. I–III. New York: ACA Gallery, 1944–1946.

Archives of American Art, Smithsonian Institution, Washington, D.C.

Artists' pamphlet files, Ryerson and Burnham Libraries, Art Institute of Chicago.

Baigell, Matthew. *The American Scene.* New York: Praeger, 1974.

Baigell, Matthew, and Julia Williams, eds. *Artists against War and Fascism: Papers of the First American Artists' Congress.* New Brunswick, New Jersey: Rutgers University Press, 1986.

Baron, Herman, intro. *Thirty-One American Contemporary Artists.* New York: ACA Gallery, 1959.

Baur, John I. H. *Revolution and Tradition in Modern American Art.* Cambridge: Harvard University Press, 1951.

Beall, Karen, compil. *American Prints in the Library of Congress: A Catalog of the Collection.* Baltimore, Maryland: The Johns Hopkins Press for the Library of Congress, 1970.

Berman, Greta, and Jeffrey Wechsler. *Realism and Realities: The Other Side of American Painting, 1940–1960.* New Brunswick, New Jersey: Rutgers University Art Gallery, 1982.

Brown, Milton W. *American Painting from the Armory Show to the Depression.* Princeton, New Jersey: Princeton University Press, 1955.

Cummings, Paul. *Dictionary of Contemporary American Artists,* 5th ed. New York: St. Martin's Press, 1988.

de Hart Matthews, Jane. "Art and Politics in Cold War America." *American Historical Review* 81 (October 1976): 762–787.

Falk, Peter Hastings. *Who Was Who in American Art.* Madison, Connecticut: Sound View Press, 1985.

The Federal Art Project: American Prints from the 1930s in the Collection of the University of Michigan Museum of Art. Ann Arbor: The University of Michigan Museum of Art, 1985.

Field, Richard S. et al. *American Prints 1900–1950.* New Haven, Connecticut: Yale University Press, 1983.

Fort, Ilene Susan. "American Social Surrealism." *Archives of American Art Journal* 22, No. 3 (1982): 8–20.

Fowler, Harriet W. *New Deal Art: WPA Works at the University of Kentucky.* Louisville, Kentucky: University of Kentucky Art Museum, 1985.

Francey, Mary. *American Women at Work: Prints by Women Artists of the Nineteen Thirties.* Salt Lake City: Utah Museum of Fine Arts, 1991.

Goodrich, Lloyd and John I. H. Baur. *American Art of Our Century.* New York: Frederick A. Praeger for the Whitney Museum of American Art, 1961.

Graphic Excursions: American Prints in Black and White, 1900–1950: Selections from the Collection of Reba and Dave Williams. Boston: David R. Godine, Publisher, Inc., in association with The American Federation of Arts, 1991.

Hills, Patricia. *Social Concern and Urban Realism: American Painting of the 1930s.* Boston: Boston University Art Gallery, 1983.

Hills, Patricia, and Roberta K. Tarbell. *The Figurative Tradition and the Whitney Museum of American Art: Paintings and Sculpture from the Permanent Collection.* New York: Whitney Museum of American Art, 1980.

Kozloff, Max. "American Painting During the Cold War." *Artforum* (May 1973): 43–54.

Landau, Ellen G. *Artists for Victory: An Exhibition Catalogue.* Washington: Library of Congress, 1983.

Larkin, Oliver. *Art and Life in America.* New York: Rinehart and Company, Inc., 1949.

Marling, Karal Ann. *Wall to Wall America.* Minneapolis: University of Minnesota Press, 1982.

Marling, Karal Ann, and Helen A. Harrison. *Seven American Women: The Depression Decade.* Poughkeepsie, New York: Vassar College Art Gallery, 1976.

Master Prints of Five Centuries: The Alan and Marianne Schwartz Collection. Detroit: The Detroit Institute of Arts, 1990.

McKinzie, Richard D. *The New Deal for Artists.* Princeton, NJ: Princeton University Press, 1973.

Mendelowitz, Daniel M. *A History of American Art.* New York: Holt, Rinehart and Winston, 1970.

Miller, Dorothy C., ed. *Americans 1942: 18 Artists from 9 States.* New York: Museum of Modern Art, 1942.

Miller, Dorothy C., and Alfred H. Barr, Jr., eds. *American Realists and Magic Realists.* New York: Museum of Modern Art, 1943.

O'Connor, Francis V., ed. *Art for the Millions: Essays from the 1930s by Artists and Administrators of the WPA Federal Art Project.* Greenwich, Connecticut: New York Graphic Society Ltd., 1973.

O'Connor, Francis V., ed. *The New Deal Projects: An Anthology of Memoirs.* Washington, D.C.: Smithsonian Institution Press, 1972.

Original Etchings, Lithographs and Woodcuts by American Artists. New York: American Artists Group, Inc., 1936.

Park, Marlene, and Gerald E. Markowitz. *The New Deal for Art: The Government Art Projects of the 1930s with Examples from New York City and State.* Hamilton, New York: The Gallery Association of New York State, Inc., 1977.

Park, Marlene, and Gerald E. Markowitz. *Democratic Vistas: Post Offices and Public Art in the New Deal.* Philadelphia: Temple University Press, 1984.

Shapiro, David, intro. and ed. *Social Realism: Art as a Weapon.* New York: Frederick Ungar Publishing Co., 1973.

Shikes, Ralph. *The Indignant Eye: The Artist as Social Critic in Prints and Drawings from the Fifteenth Century to Picasso.* Boston: Beacon Press, 1969.

Wechsler, Jeffrey, and Jack J. Spector. *Surrealism and American Art, 1931–1947.* New Brunswick, New Jersey: Rutgers University Art Gallery, 1971.

Who's Who in American Art. Vols. I–IV. Washington, D.C.: The American Federation of Arts, 1935, 1937, 1940 and 1947.

Wye, Deborah. *Committed to Print: Social and Political Themes in Recent American Printed Art.* New York: The Museum of Modern Art, 1988.

LIST OF WORKS

* indicates works in exhibition.

* Ida Abelman
A MANHATTAN LANDSCAPE WITH FIGURES, 1936
Lithograph, 13 7/8 x 9 5/8 in
27

* Ida Abelman
HOMAGE TO THE SCREW, 1937
Lithograph, 12 x 9 3/4 in
28

* Ida Abelman
WONDER OF OUR TIME, 1937
Lithograph, 12 x 15 in
29

* Ivan Albright
THE CLIFFS REVOLVE BUT SLOWLY, 1965
Gouache on paper, 16 1/4 x 24 1/8 in
98

Peggy Bacon
RIVAL RAGMEN, 1936/38
Lithograph, 5 5/16 x 8 15/16 in
25

* Romare Bearden
LA PRIMAVERA, 1967
Collage and mixed media on board, 44 x 56 in
97

* Romare Bearden
WATCHING THE GOOD TRAINS GO BY, 1964
Photomontage and mixed media on paper, 13 3/4 x 16 7/8 in
26

* Fred Becker
JOHN HENRY'S DEATH, 1938
Wood engraving, 6 1/4 x 4 9/16 in

Thomas Hart Benton
STRIKE, 1933/34
Lithograph, 9 5/8 x 10 3/4 in
19

* George Biddle
ALABAMA CODE, 1933
(OUR GIRLS DON'T SLEEP WITH NIGGERS)
Lithograph, 13 3/8 x 9 7/16 in
48

* George Biddle
SPIRITUALS, 1937
Oil on canvas, 16 1/8 x 20 1/8 in
39

* Lucienne Bloch
LAND OF PLENTY, c. 1935
Woodcut, 10 5/8 x 8 3/4 in
23

* Harry Brodsky
TOMATO PICKERS, c. 1938
Lithograph, 19 1/2 x 13 3/4 in
22

* Letterio Calapai
HARLEM NIGHT, 1932
Wood Engraving, 5 1/2 x 6 1/4 in

* Federico Castellon
SPANISH LANDSCAPE, 1938
Lithograph, 9 1/4 x 14 1/2 in
67

* James Daugherty
STUDY FOR ILLINOIS PASTORAL, 1939
Charcoal on paper, 36 x 24 in

Adolf Dehn
LOVE IN BERLIN, c. 1930
Lithograph, 11 x 15 1/8 in
36

Adolf Dehn
THE RESIDENTIAL SECTION OF KEY WEST, 1942
Watercolor and gouache on paper, 19 x 27 1/2 in
46

Adolf Dehn
WE NORDICS, 1931
Lithograph, 13 1/2 x 10 15/16 in
37

* Joseph Delaney
REVIVAL, 1940
Oil on canvas, 34 x 23 3/4 in
38

* Werner Drewes
DISTORTED SWASTIKA, 1934
Linocut, 6 x 10 1/4 in
56

* Mabel Dwight
BURLESQUE, c. 1935
Lithograph, 9 1/2 x 8 in
35

Mabel Dwight
CHILDREN'S CLINIC, 1936
Lithograph, 9 1/2 x 12 in
30

* Philip Evergood
PORTRAIT OF A MINER, 1938
Etching, 7 3/8 x 6 1/2 in
18

* Philip Evergood
SPRING, 1934
Oil on canvas, 25 x 30 in
17

* Jared French
BUSINESS, 1959/61
Egg tempera on panel, 30 x 43 in
89

Hugo Gellert
PIECES OF SILVER, 1930s
Lithograph, 12⅝ x 11⅝ in
61

* Boris Gorelick
STRANGE FRUIT, 1939
Lithograph, 10⅜ x 13⅞ in
52

* William Gropper
AIR RAID IN SPAIN, c. 1937
Wash and watercolor on paper, 14 x 20¼ in
65

* William Gropper
DE PROFUNDIS, 1942
Oil on canvas, 30 x 20 in
70

* George Grosz
THE BUTCHER SHOP, 1928
(FLEISCHLADEN/ DER MENSCHLADEN)
Pen and ink, brush and watercolor on paper, 23 x 18 in
54

* O. Louis Guglielmi
MORNING ON THE EAST SIDE, 1939
Oil on canvas, 20 x 16 in
72

* James Guy
BLACK FLAG, c. 1940
Oil on masonite, 10 x 26 in
68

* Robert Gwathmey
CUSTODIAN, 1963
Oil on canvas, 46 x 38 in
91

* Edward Hagedorn
BULL'S EYE, 1938
Etching, 19¾ x 16 in
64

Ella Sophonisba Hergesheimer
JINNY MAE RESTING, 1930s
Lithograph, 17 x 13 ⅜ in
26

* Joseph Hirsch
THE SURVIVOR, 1945
Oil on canvas, 10 x 16 in
75

* Joseph Hirsch
SUPPER, 1963/65
Oil on canvas, 66 x 85 in
92 also back jacket

* Joe Jones
AMERICAN JUSTICE, 1933
(WHITE JUSTICE)
Oil on canvas, 30 x 36 in
51 also back jacket

* Mervin Jules
MODERN MEDICINE MEN, c. 1938
Oil on masonite, 16½ x 23½ in
59

* Rockwell Kent
HEAVY HEAVY HANGS OVER THY HEAD, 1946
Lithograph, 9 x 12 in
79

* Rockwell Kent
BOMBS AWAY, 1942
Oil on canvas, 34 x 44 in
66 also front jacket

* Henry Koerner
WOMEN CROSSING BRIDGE, 1946
Gouache on wood panel, 17 x 20 in
77

* Jacob Lawrence
INTERIOR SCENE, 1937
Tempera on paper, 28 x 33½ in
47

* Jacob Lawrence
STREET SCENE—RESTAURANT, 1936/38
Tempera on paper, 26½ x 35 in
46

* Joseph LeBoit
TRANQUILITY, 1936
Etching and aquatint, 14 x 11 in
63

* Jack Levine
OAK STREET, 1959
Oil on canvas, 40 x 35 in
85

Louis Lozowick
LYNCHING, 1936
Lithograph, 10 x 7¼ in
49

* Nan Lurie
HOUSE OF DETENTION, c. 1935
Lithograph, 18¾ x 12¼ in

* Claire Mahl
HAIL AND FAREWELL, c. 1935
Lithograph, 16¼ x 10 in

* George Marinko
APOCALYPTIC REVELATION, 1947
Graphite on paper, 7¾ x 9⅜ in
80

Kyra Markham
THE FIT YOURSELF SHOP, 1935
Lithograph, 13 x 10 in
31

* Kyra Markham
NIGHT CLUB, 1935
Lithograph, 13 3/4 x 10 1/2 in
33

* Jack Markow
DICTATION, 1936
Lithograph, 7 1/2 x 9 3/4 in

* Reginald Marsh
DANCE HALL SCENE, 1940s
Watercolor, mixed media (with Chinese ink) on paper
22 x 30 in
34

* Paul Meltsner
NIGHTCLUB SCENE, c.1935
Watercolor on paper ,25 x 20 in
42

Elizabeth Olds
NO UNEMPLOYMENT, 1936
Lithograph, 9 3/4 x 12 3/4 in
24

* Bernard Perlin
MAYOR DALEY, 1968
Oil on Canvas, 20 x 16 in
100

* Alton Pickens
THE PUPPETEERS, 1954
Oil on canvas, 46 x 34 in
87

* Walter Quirt
OBEISANCE TO POVERTY, 1936/38
Oil on gessoed panel, 11 3/4 x 15 1/2 in
58

* Anton Refregier
POLITICIANS AT WORK, c. 1946
Oil on canvas, 26 x 32 in
78

* Philip Reisman
GOD BLESS AMERICA, 1940
Oil on masonite, 25 1/2 x 17 1/2 in
71

* Louis Ribak
HOME RELIEF STATION, 1935/36
Gouache on paper, 10 x 16 in
20

* Peter Saul
FEEL IT (CHINA GOD), 1966
Colored crayon, felt-tip marker and ballpoint pen on paper,
41 x 58 in
99

* Eugene Savage
THE FISHERMAN, 1948
Oil on canvas, 26 1/4 x 30 3/4 in
81

* Palmer Schoppe
'SPERIENCES MEETING, 1935
Lithograph, 13 x 8 3/4 in
41

Karl Schrag
MADONNA OF THE SUBWAY, 1939
Etching and Aquatint, 9 3/4 x 11 7/8 in
29

* Ben Shahn
DISCORD, 1953
Watercolor on paper, 38 3/8 x 25 3/8 in
82

* Ben Shahn
FATHER COUGHLIN, 1939
Ink and wash on paper, 15 1/2 x 12 in
62

* Ben Shahn
STUDY FOR GOYESCAS, 1956
Brush, ink, and watercolor on paper, 25 1/2 x 30 in
84

* Moses Soyer
EMPLOYMENT AGENCY, 1940
Oil on canvas, 24 x 20 in
21

* Harry Sternberg
FASCISM, 1942
Screenprint, 15 1/4 x 20 1/2 in
74

* George Tooker
LUNCH, 1964
Egg tempera on gessoed panel, 20 x 26 in
94

* Stuyvesant Van Veen
PEACE CONFERENCE, 1932
Ink and watercolor on paper, 19 x 29 in
55

Lynd Ward
SPRING IDYLL, 1935
Wood engraving, 10 3/4 x 2 1/2 in
60

Lynd Ward
COMPANY TOWN, c. 1930
Wood engraving, 5 x 4 1/2 in
11

INDEX

*Works from the collection of Philip J.
& Suzanne Schiller are shown in italic
titles and bold page numbers.*

Abelman, Ida, 27, **27**, 28, **28**, **29**, 105
Abraham Lincoln Brigade, 65
African American artists, 38–52, 95
Air Raid in Spain, (William Gropper),
65, **65**
*Alabama Code (Our Girls Don't Sleep
with Niggers),* (George Biddle), **48**, 49
Albright, Ivan Le Lorraine, 97–98, **98**, 105
Alston, Charles, 44, 95
"America in the War" exhibit, 74
American Abstract Artists, 56
American Artists' Congress, 57, 65, 67
American Communist Party (CPUSA),
49, 57
American Contemporary Art Gallery
(ACA), 16
American Justice, (Joe Jones), 50, **51**
Amos, Emma, 95
Apocalyptic Revelation, (George
Marinko), 80, **81**
Art Front, 15. *See also* Artists Union.
Art Students League, 13
Artists for Victory, 73–74
Artists Group of Emergency Work
Bureau, 15
Artists Union, 15, 16

Bacon, Peggy, 25, **25**, 27, 105
Beardon, Romare, 95–97, **96**, 105–106
Becker, Fred, 106
Benton, Thomas Hart, 18–20, **19**, **39**, 43,
106–107
Berlin, 36–37, **36**, **37**, 76, 79
Biddle, George, 39–40, **39**, **48**, 49, 107
Black Flag, The, (James Guy), 68, **68**
Bloch, Lucienne, 22, **23**, 24, 27, 107
Bombs Away, (Rockwell Kent), **66**, 67
Brodsky, Harry, 20, **22**, 107–108
Bull's Eye, (Edward Hagedorn), **64**, 65
Burlesque,(Mabel Dwight), 35, **35**
Business, (Jared French), 88, **89**
Butcher Shop, The, (George Grosz), 53,
54

Cadmus, Paul, 88
Cahill, Holger, 15
Castellon, Federico, 67–68, **67**, 68, 108
Calapai, Letterio, 108
Children's Clinic, (Mabel Dwight), 30,
30
civil rights movement, 93, 95, 101
Civil Works Administration (CWA), 15
Cliffs Revolve But Slowly, The, (Ivan
Albright), 97–98, **98**
Cold War, 75–88
Company Town, (Lynd Ward), 10, **11**
Communist Party. *See* American
Communist Party.
Congress of Industrial Organizations
(CIO), 16, 18
Coughlin, Father Charles, **59**, 60
Custodian, The, (Robert Gwathmey),
90, **91**, 93

Dance Hall Scene, (Reginald Marsh),
34, **34**
Daugherty, James Henry, 108–109
Dehn, Adolf, 35–38, **36**, **37**, 45, 109
Delaney, Joseph, **38**, 39, 40, 43, 108
Democratic National Convention, 1968,
101
Depression, The, 22, 25, 30
Discord, (Ben Shahn), **82**, 82
Distorted Swastika, (Werner Drewes),
56, **56**
Double, The, (Jared French), 88, **89**

Douglas, Aaron, 44
Drewes, Werner, 56, **56,** 109–110
Dwight, Mabel, 30, **30**, 35, **35**, 110
Employment Agency, (Moses Soyer), **21**
"Entartete Kunst" (Degenerate Art), 54
Evergood, Philip, 16, **17**, 18, 110

fascism, 53–74
Fascism, (Harry Sternberg), 74, **74**
Father Coughlin, (Ben Shahn), 60, **62**
*Father Coughlin and His Flock. See
Pieces of Silver.*
Federal Art Project of the Works
Progress Administration (FAP/WPA),
15–16. *See also* New Deal.
Feel It (China God), (Peter Saul), 99, **99**
Fisherman, The, (Eugene Savage), 80, **81**
Fit Yourself Shop, The, (Kyra Markham),
31, 32
Franco, General Francisco, 65
French, Jared, 88, **89**, 110–111
Fulbright, Senator J. William, 99
Future Belongs to the Workers, The,
(Walter Quirt), 57

Gellert, Hugo, 60, **61**, 111
gender, images of, 15–36
God Bless America, (Philip Reisman),
71, 73
Gorelick, Boris, 50, 52, **52**, 111
Goyescas, Study for, (Ben Shahn),
83–84, **84**
Gropper, William, 65, **65,** 69, **70,** 111–112
Grosz, George, 36, 53, **54**, 55–56, 112
Guernica, (Pablo Picasso), 67
Guglielmi, O. Louis, **72**, 73, 76, 112
Guy, James, 57, 68, **68,** 76, 112–113
Gwathmey, Robert, 90, **91**, 93, 113

Hagedorn, Edward, 65, **65**, 68, 113
Harlem, 43, 44
Heavy Heavy Hangs Over Thy Head,
(Rockwell Kent), 79, 79–80
Helfond, Riva, 25
Hergesheimer, Ella Sophonisba, **26**, 27,
113
Hitler, Adolf, 37–38, 57, **59**, 60, 65,
68–69, 74, **74**
Hirohito, 68, 74, **74**
Hirsch, Joseph, 75–76, **75**, **92**, 93, 113–114
Hoening, Margaret, 88
Homage to the Screw, (Ida Abelman),
28, **28**
Home Relief Station, (Louis Ribak), **20**
Hoover, Herbert, 15
Hopkins, Harry, 15
House Committee on Un-American
Activities, 13
Huberman, Leo, 18
Hughes, Langston, 44

Interior Scene, (Jacob Lawrence), 44, 45,
47

Jinny Mae Resting, (Ella Sophonisba
Hergesheimer), **26**, 27
John Reed Club(s), 48, 57
Johns, Jasper, 88
Johnson, Lyndon B., 90, 93, 98–99
Johnson, William H., 90
Jones, Joe, 50, **51**, 114
Jules, Mervin, **59**, 60, 114
Jung, C. G., 88

Kennedy, John F., 90
Kennedy, Robert F., 101
Kent, Rockwell, **66**, 67, 68, **78**, 79–80,
114–115
King, Jr., Martin Luther, 95, 101
Koerner, Henry, 76, **77**, 115
Ku Klux Klan, 49–52, **51**, **52**, **59**, 60

La Primavera (Romare Bearden), 95–97,
96
Land of Plenty, (Lucienne Bloch), 22, **23**
Laning, Mary Fife, 32
Lawrence, Jacob, 44–45, **46**, **47**, 50, 90, 115
LeBoit, Joseph, 63, 65, **63**, 115
Levine, Jack, 84,**85**, 86, 116
Lewis, Norman, 95
Lewis, John L., 18
Love in Berlin, (Adolf Dehn), 36, **36**, 45
Lunch, (George Tooker), 93, **94**, 95
Lozowick, Louis, 12, 15, 49–50, **49**, 116
Lurie, Nan, 25, 116
Lynching, (Louis Lozowick), **49**
Lynes, George Platt, 88

McCarthy, Senator Eugene, 101
McCarthy, Senator Joseph, 83
McKay, Claude, 44
Madonna of the Subway, (Karl Schrag),
28, **29**, 30
Madonnas, images of, 28–30, 57–58
Marinko, George, 80, **81**, 116
Manhattan Landscape with Figures, A,
(Ida Abelman), 27–28, **27**
Markham, Kyra, **31**, 32, **33**, 34, 117
Markhow, Jack, 117
Marsh, Reginald, 34, **34**, 35, 117
Marshall, George C., 79
Mayor Daley, (Bernard Perlin), **100**, 101
Meeropol, Abel, 52
Meltsner, Paul, **42**, 43, 117
migrant workers, 20
Miller, Kenneth Hayes, 32
modern art, 75–88
Modern Medicine Men, (Mervin Jules),
59, 60
Moore, Claire Mahl, 118
Morning on the East Side, (O. Louis
Guglielmi), 73, **73**
Mussolini, Benito, **59**, 60, 65, 68, 74, **74**

National Art Council for Defense, 73
National Association for the Advance-
ment of Colored People (NAACP), 48
National Labor Relations Act. *See*
Wagner Act.
National Socialist Party, 54, 68–69
New Deal, 15–16, 20, 22, 40, 60
Night Club, (Kyra Markham), 32, **33**, 34
Nightclub Scene, (Paul Meltsner), **42**, 43
No Unemployment, (Elizabeth Olds),
24, 25

Oak Street, (Jack Levine), 84, **85**, 86
Obeisance to Poverty, (Walter Quirt),
57–58, **58**
Olds, Elizabeth, **24**, 25, 118

Parish, Betty, 25
Peace Conference, (Stuyvesant Van
Veen), 55, **55**, 56
Perlin, Bernard, **100**, 101, 118
Philadelphia Artists Union, 90
Pickens, Alton, 86, 88, **87**, 118–119
Pieces of Silver, (Hugo Gellert), 60, **61**
Politicians at Work, (Anton Refregier),
78, 79
Pollock, Jackson, 88
Portrait of a Miner, (Philip Evergood),
18, **18**
Potsdam Conference, 76, 79
Public Works of Art Project (PWAP), 15.
See also New Deal.
Puppeteers, The, (Alton Pickens), 86,
87, 88

Quirt, Walter, 56–57, **58**, 68, 76, 119

Rauschenberg, Robert, 88
Refregier, Anton, **78**, 79, 119

Reisman, Philip, 22, **71**, 73, 119–120
Residential Section of Key West, The,
(Adolf Dehn), 45, **46**
Revival, (Joseph Delaney), **38**, 39, 43
Ribak, Louis, 20, **20**, 120
Rival Ragmen, (Peggy Bacon), **25**
Rivera, Diego, 22, 40
Roosevelt, Franklin, 15, 40, 69–70

*Sacred Profession Is Open to College
Graduates, A,* (Elizabeth Olds). *See
No Unemployment.*
Saul, Peter, 99, **100**, 101, 120
Savage, Augusta, 44, 120–121
Savage, Eugene, 80, **81**
Schoppe, Palmer, 40, **41**, 43, 121
Schrag, Karl, 28, **29**, 30, 121
Scottboro Nine (trial), 48–49
Senate Committee on Government
Operations and Permanent Subcom-
mittee on Investigations, 83
Shahn, Ben, 60, **62**, **82**, 83–84, **84**, 101,
121
Soyer, Moses, 20, **21**, 32, 122
Spanish Civil War, 65, **65**, **66**, **67**, 67–68
Spanish Landscape, (Federico Castellon),
67–68, **67**
'Speriences Meeting, (Palmer Schoppe),
40, **41**
Spiral Group, The, 95
Spirituals, (George Biddle), **39**, 40
Spring, (Philip Evergood), 16, **17**, 18
Spring Idyll, (Lynd Ward), 60, **60**
Stalin, Joseph, 57
Sternberg, Harry, 74, **74**, 122
Strange Fruit, (Boris Gorelick), 50, 52, **52**
Street Scene—Restaurant, (Jacob
Lawrence), 44–45, **46**
Strike, (Thomas Hart Benton), 19–20, **19**
Supper, (Joseph Hirsch), **92**, 93
Survivor, The, (Joseph Hirsch), 75–76, **75**

Tennessee Valley Authority (TVA), 22
Tomato Pickers, (Harry Brodsky), 20, **22**
Tooker, George, 93, **94**, 95, 122
Tranquility, (Joseph LeBoit), 63, **63**
Treasury Relief Art Project (TRAP), 15.
See also New Deal.
Truman, Harry S, 79

Unemployed Artists Group (UAG). *See*
Artists Union.
United Nations Conference on Inter-
national Organization (UNCIO),79

Van Veen, Stuyvesant, 55, **55**, 122–123
Veteran's Bonus March, 15
Vietnam War, 90, 98–101

Wagner Act, 18
war on poverty, 90, 93
Ward, Lynd, 10, **11**, 60, **60**, 123
Watching the Good Trains Go By,
(Romare Bearden), 95, **96**
We Nordics, (Adolf Dehn), 37, **37**
We the People, (Leo Huberman), 18
White, Charles, 90
White Justice. See American Justice.
Wright, Richard, 44
Woman Slayer, The, (George Grosz),
54
Women Crossing Bridge, (Henry Koerner),
76, **77**
Wonder of Our Time, (Ida Abelman),
28, **29**
working, images of, 15–36
World War II, 25, 68–69, 73
Works Progress Administration (WPA),
15–16, 25. *See also* New Deal.
WPA Harlem Art Workshop, 44